D0554772

Pitseolak: Pictures out of my life

ᐱ�ᑦᓚᒃ: ᐅᓂᒃᑐᐊᒃ ᐃᓄᕐᓚᑐᐅᔪᒥᒃ

© Dorothy Eber, 1971
Published by the University of Washington Press by arrangement with
Design Collaborative Books, Montreal, 1972
ISBN-0-295-95228-8
Library of Congress catalog card number: 72-4111

Design:
Rolf Harder and Ernst Roch, Design Collaborative Montreal Limited
Printing:
RBT Printing Limited
Typesetting:
Metro Typesetters Inc. (English)
Department of Indian Affairs and Northern Development (Eskimo)
Printed in Canada

The drawing 'A bird for the doctor' is reproduced with the kind
permission of Dr. and Mrs. Samuel Adams.

© Dorothy Eber, 1971
Published by the University of Washington Press by arrangement with
Design Collaborative Books, Montreal, 1972
ISBN-0-295-95228-8
Library of Congress catalog card number: 72-4111

ᐊᑭᕐᓲᔪᑦ :
Rolf Harder and Ernst Roch, Design Collaborative Montreal Limited
ᐊᑭᕐᓵᐱᒥ :
RBT Printing Limited
Typesetting:
Metro Typesetters Inc. (English)
ᐃᓄᑦᑎᑐᖅᓄ ᐃᓄᑎᑎᑕᐅᑲᐅᒍᓐᖓ ᑭ
ᑲᓇᑕᒥ ᐊᑭᑕᐅᔪ

ᑎᑎᕋᒪ 'ᑯᒃᓄᐊᑭ ᐊᓄᐊᕐᓯᐅᑎᒍᓐᖓᑦ ' ᓇᒥᓂᕐᑲᐅᑎᔪᑭ

Pitseolak:
Pictures out of my life

From recorded interviews by Dorothy Eber

ᐱᓯᐅᑕᒃ

ᐅᓂᒃᑐᐊᒃ ᐃᓄᐱᐅᑕᐅᑐᒥᒃ

ᐊᑉᒃ ᓱᓇᓱ ᓇᐱᓕᐊᓇᐸᑕ ᐅᒪ ᑕᕈ ᐃᑯ

University of Washington Press, Seattle

Acknowledgments

The publishers wish to express their appreciation and thanks to
The Department of Indian Affairs and Northern Development for provision of the Eskimo text,
The Canada Council for a grant to assist with the tape-recording,
The West Baffin Eskimo Co-operative for its loan of stone cuts, engravings and original drawings,
The National Museum of Man for its loan of stone cuts and engravings,
Mrs. Alma Houston for advice and encouragement.

ᑲᐅᖅᓯᒥᒍᑎᒪ

ᑕᑯᐊ ᐊᑐᐊᓚᑕᐅᑐᖅᑦ ᐃᓄᑦᓇᐱᑯᓂ ᓇᑦᒥᒍᖢᕝ ᐃᓄ
ᐱᓇᕐᐊᑎᖅᖅ ᐃᓄᑎᐅᑦᓚᑎᕐᓚᐅᐲᓯᑦ ᑕᕐᒥᒪ,
ᐊᒪᖢ ᐊᕐᕐᑎᒃ ᓂᐱᑕᐅᓂᖢᒃ ᐃᑲᔭᑕᐅᑐ,
ᑲᒥᐊᖒᕐᐅᖢ ᖑᐳᐊᖕᒪ ᑎᑎᖅᓯᓚᑕᐅᐳᑎᖅᓂᖁ ᐊᑐᑎᖅᑕᐅᑐᖅᑦ,
ᖃᓇᑕ ᒥ ᓄᑕᐅᖢᖅᖢᓂ ᐱᒥᐱᐊᖅ ᑎᑎᖅᓯᓚᑕᐅᐳᑎᖅᓂᖁ
ᐊᑐᑎᖅᑕᐅᑐᖅᑦ,
ᐊᒪᖢ ᐊᖒᒪ ᕿᖅᑕᓴᖁ ᐃᒪᐃᖢᒪᕐᐊ ᑲᓄᖢᖁ ᐱᑎᐱᖢᖁᖢ,
ᑕᑯᐊ ᐃᓘᖃᓄᖅ ᐊᖅᖢᕐᐊᓘ ᐊᑐᑎᖅᑕᐅᑐᖅᑦ.

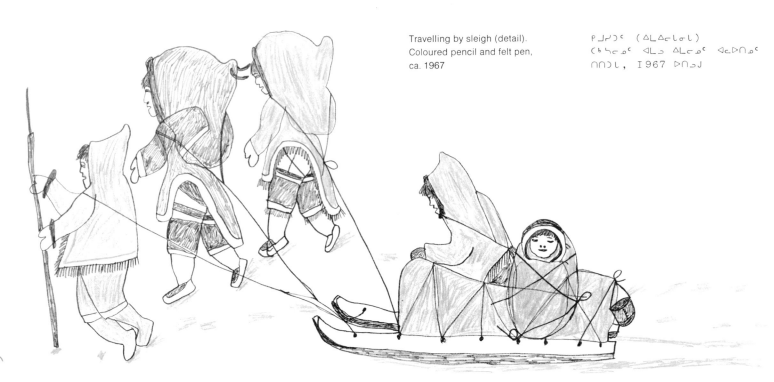

Travelling by sleigh (detail).
Coloured pencil and felt pen,
ca. 1967

ᑭᒍᕈᔭᑦ (ᐃᒪᐃᓗᑎᒐᓚ)
ᑕᖃᖦᓴᓂᑦ ᐊᒡᓗ ᐃᓚᓂᑦ ᐊᓕᕈᐅᓂᑦ
ᓐᓐᑎᒪ, 1967 ᐅᓂᒍ

Foreword

ᖃᐅᔨᓐᕈᐅᓐᕈᑦ

It is mid-July, 1970, and brilliant Arctic summer, when I ask
Pitseolak if I may tape her autobiography. I have come
to Cape Dorset on Baffin Island especially for the purpose
and, very soon after the Nordair Otter touches down, I go
looking for Quatsia Ottochie. Quatsia, nineteen and a
modern Eskimo beauty, knows at firsthand the story of
the Cape Dorset art movement. Her father, Ottochie
(whose name she has adopted now that Eskimos need
surnames), has worked in the craft shop of the West
Baffin Eskimo Co-operative since shortly after print-making
began, in the late fifties. Her English has been perfected
by a typing course in the south, and she agrees to interpret
and help put my proposition to Pitseolak. So, with tape
recorder, a big bag of tapes, notebooks and coloured pens
and drawing paper, we present ourselves at Pitseolak's
house. At the beginning of the sixties most Baffin Island
Eskimos still lived on the land in igloos and skin tents but
now, like Pitseolak, they live in clapboard bungalows.

ᐊᓗ ᑕᑉᓚᓂ, 1970-ᒥ ᐊᒡᓗ ᖃᐅᓚᕿᑐᓐᒍ ᐃᓄᐃᑦ
ᓄᓇᒐ ᐊᕐᖯᔪ, ᐊᐱᕐᑕᐅᕝᕙᒐ ᐱᓯᐅᓚᒥ ᓄᐱᓐᑎᐅᓭᒪᒡᒐ
ᐅᓂᖃᐅᕐᓓᐊᓗᓂ. ᑭᓗᓂᓂᐅᐅᒐ ᐃᓄᐃ ᓄᓇᓄ ᑕᕝᓚᔪᐊᔪᐊ
ᒍᓐᖳᕐᓚ; ᐊᒡᓗ ᖯᓚᓐᕿ ᐅᕐᓓᔪᐅᐊᒪ, ᒥᐊᔪ ᖃ ᐃᓄᐃ
ᓚᓂᖅᓕᐊᓂ ᓄᓇᒥ ᓚᓂᒐᕿᖯᐊᑦ ᐅᑕ ᖃ ᓄᓂᓂᑦ
ᓗᒐ ᐅᓚᕈᐊᓗ, ᑭᓂᔪᐅᐅᒐ ᑯᐊᕐᕿᐊ ᐅᖦᐅᑭᒥ. ᑯᐊᕐᕿᐊ 19-ᓂ
ᐅᑭᖃᔪᖯ ᐊᖯᓄᕐᐊᕐᑕᓂᒐ, ᖃᐅᓚᖯᐊᓐᕈᑯᐅᔪ ᓕᕤᒥ
ᐅᓂᖃᐅᐊᓗᓂ ᑭᓚᐃᑦ ᖃᒐᔪᐊᖯᑕᓂᕐᓂ. ᑯᐊᕐᕿᐅ ᐊᑦᑕᒪ,
ᐅᖯᐅᑭ (ᑕᕐᒐᒪ ᐊᓄᒥ ᑯᐊᕐᕿᐅᐅ ᓐᑐᐊᑦᐊᒥ ᓚ ᐃᓄᐃᑦ
ᐊᑭᖯᓐᐊᖯᑯᑕᐃᓂᑦ), ᐃᖃᐃᓯᕐᕿᑕᓯᔪ ᓚᓂᔪᐊᕐᕃᐊᓐᕐ ᐃᓄᐃᐊ
ᓄᓚᑕᓄ ᖃᐅᐊᔪᑕᓂ ᐱᓕᕐᕿᓯᖯᓐᓂᕐᑦ ᓐᓐᑐᖯᖃᐅᕐᓓᐊᖃᓐᑕᖯ,
ᐊᔪᔪᐊ 1950 ᐱᓕᕐᕿᒐᒐᓂᔪ. ᑯᐊᕐᕿᐊ ᖃᓇᓄᐅᐅᐊᕐᑕᓂ
ᐅᔪᖯ ᐃᓯᓂᐊᕐᒪᒥ ᓐᓐᓯᐅᓐᒥ ᓄᐊᑭᐅᒐ ᖯᓄᑕ ᓄᓚᓂ,
ᐊᒡᓗ ᐊᕐᓓᐅᔪ ᐅᔪᐊᐅᐅᐊᕐᕃᒐ ᐃᖯᑐᓂᓂ ᐅᑭᖃᐅᕐᕃᐅᕐᓓᐊᖯ
ᐱᕆᕐᓚᒍ. ᑕᕐᒐᓚ ᓂᐊᖯᐅᑐᐱᖯᑦ ᓂᐊᕿᓓᒥ ᐃᐱᐊᖯᔪ ᑕᑕᒍᒐ,
ᐊᒡᓗ ᓐᓐᑕᔭᖯᖃᓂᐊ ᐊᐱᕐᖃᖯᔪᓂᓂ ᓐᓐᑕᖯᐅᒥᔪ ᐊᒡᓗ ᐸᐊᖯᐊᓂ
ᓐᓐᑐᔭᖯᐊᓂᐊ ᓄᖯᕐᕃᓂ ᐃᐱᓪᓚᐅᐅᐊᒐ ᐱᕆᐅᓚᖯᑦ ᐃᖯᐅᓗᒐ.
ᐱᕆᐊᓗᖃᐅᕐᔪ ᐊᔪᔪᐊ 1960 ᐃᓄᖃᖯᖃ ᐃᓄᐃ ᓄᓚᓂᖯᐊ

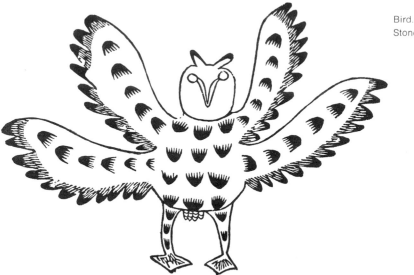

Bird.
Stone cut, 1967

ᐅᎦᏟ ᏂᏂᏓᏔ, I967

Pitseolak and I have met two years earlier and, with the help of Quatsia, we exchange greetings. Quatsia and I take off our rubber boots and walk into Pitseolak's warm kitchen. Quickly I realize that since our first meeting ''acculturation'', as the sociologists say, has proceeded at a speedy clip. Then, Pitseolak sat on the floor and drew as we talked; now she sits on a couch, there is a telephone on the wall and across the room is a bowl of plastic flowers. But there is soon no doubt that Pitseolak herself is the same: wise, humorous, a sage commentator on the sociology of change and, of course, the possessor of a remarkable talent which allows her to draw as many as six pictures a morning of vivid interest and beauty.

After preliminaries, Quatsia explains there are people in the south who would like to make a book with some of Pitseolak's drawings and prints and her life story, told in her own words. There is brisk talk back and forth and then Quatsia says, ''She doesn't mind to do it but she is getting old now. She is getting kind of shaky and the drawings

ᏒᏟ ᎠᎠᏟᏟᎠᎠ ᐃᏟ ᎠᎠᏞᎱᏟᏂ ᏢᏟᏆ ᎠᎠᏟᏂ ᏞᎠᏟ, ᎠᏟᏞᏟᏂᎠᏟ, ᐃᏟ ᎠᎠᏞᏟᏂ.

ᎠᏟᏞᏟᎠ ᏔᏂᏟᏆᎠᏟᏒᏞᏒᏃ ᎠᏢᎠ ᏞᎠ ᎠᏟᏟᎠᏟ ᐊᏞᎠ, ᐃᏟᏫᏂᏔᏟᏟᏞᏟᎠᏟ ᏃᐊᏟᏟᏟᏟ, ᎠᏔᏔᏂᏟᏟᏟ. ᏃᐊᏟᏟᎠ ᏔᏟᏟᎠᎠ ᏂᏢᏟᎠᎠᏞᎠ ᎠᏃᏟᎠ ᎠᏂᎠᏃ. ᏔᎠᎠᏞᎠᏂᏟᐊᏟᎠᏞ ᏟᐊᏞᏞᎠ ᏔᏂᏟᎠᏢᏞᏞᏃ ᏞᎠᏟᏟ ''ᐃᎠᐃ ᐃᎠᏟᎠᏔᐊᏂᎠᏟᎠ'' ᏔᎠᎠᏞᏂᎠ ᎠᏔᎠᏞᏂᏟᏞᏟᏟᏂᎠᎠ, ᏟᏔᎠᏟᎠᏟ ᐊᏟᎠᏟᏟᏞᏃ. ᏟᐊᏞ ᎠᏟᎠᏟ ᎠᏟᏟᎠᏃ ᎠᏂᏟ ᏂᏂᎠᏞᏟᏟᏃ ᎠᏔᏂᎠᏟ; ᏞᎠᏟ ᎠᏟᏟᎠᏟᏃᏟ ᎠᏟᏟᏟᏃ, ᎠᏔᏟᎠᏂ ᐊᏟᎠᏞᏃᏟ ᐊᏞᎠ ᐃᏟ ᎠᏃᏟᏢᎠ ᎠᏢᐊᏟ ᏢᎠᏟ ᎠᎠᏃᐊᏟᏔᏃᏟ. ᐃᏟ ᏟᐊᏢᏟᏞ ᎠᎠᏟᏟᏂ ᎠᏟᎠᏟ ᏟᎠᏞᐊᎠᏢᏟᐊᏞ: ᏟᏟᏃᏟ, ᏃᏂᐊᏟᏟᎠ ᎠᏃᏟ, ᎠᏟᏞᏟᐊᏃᏟ, ᏔᎠᏢᏟᏟᐊ ᐃᎠᐃ ᎠᎠᏞᏟ ᐊᏢᎠᏟ ᏟᏟᏞᏟᏂ ᐊᏞᎠ, ᏟᏔᐃᏞ ᐊᏢᏟᐊᏢ, ᐊᏟᏟᏟᏞᏟ ᏟᐃᏞᎠ ᏂᏂᎠᏞᏃᏟ ᎠᎠᏂᏔᏃᏂ ᏢᏞᏟᐊᏃᏟ ᐊᏢᏃᐊᏟᎠᏃᏟ ᎠᏔᏟᎠ ᐃᎠᏟᏟᏂᏂᏟ ᏢᎠᏟᏟᏃᏂ ᐃᎠᏃᎠᏂᏃ.

ᎠᏔᏔᏂᏟᏟᎠᏟᏟ ᏔᏟᐃᏃᏟᏟᐊᏟᏂᏃ ᏃᐊᏟᐊ ᎠᏢᏂᏟᏟᐊᏟᎠ ᏔᏃᎠᏟ ᎠᎠᏞᎠᎠᏟᏂ ᏂᐊᏟᏔᏃᏞᏞᏟ ᎠᏃᏔᏃᐊᏟᏂ ᎠᏟᎠᏟ ᏂᏂᎠᏞᏟᐊᏃᏟᎠᏂ ᐊᏞᎠ ᐃᎠᏟᏞᏟ ᎠᏃᏔᎠᏟᏞᏃ, ᎠᏔᏟᏞᐊᏃ

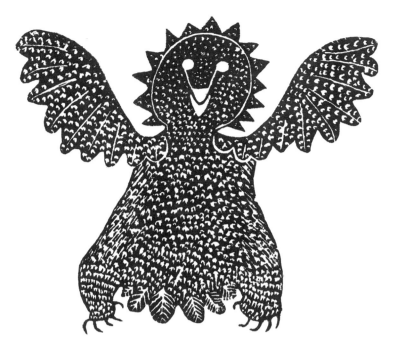

Joyful owl.
Stone cut, 1961

�ർᐃᐊᑭᑐᑉ ᐅᑉᐱᑉ
ᐅᖅᒋᒥ ᑎᑎᑐᒪ, 1961

are sometimes shaky. And she doesn't remember every-
thing though she remembers many things.''

All is arranged. For the next three weeks I spend nearly
every afternoon at Pitseolak's house. There are frequent
interruptions to these taping sessions. There are tele-
phone calls, and Pitseolak's grown-up children and her
grandchildren often come in to listen or to visit. One day
a son brings ice cream tubs, the greatest treat of the year.
They have arrived that day on the long awaited sea-lift.
He also brings molasses which Pitseolak says is to put in
the tea. ''I used to like it in the camps and I still like it,''
she says. All conversation stops while these good things
are relished.

Each day, when I arrive, Pitseolak brings out a large
sketch book and we look at the drawings she has done
in the morning — they are rarely shaky and always they
show Pitseolak's distinctive line and style. Then we
move on to reminiscences. Pitseolak's memories do not

ᓇᒥᓂ ᐅᑲᐅᕐᒥᓂ ᐊᑐᓗᓂ. ᕐᑯᑐᒥ ᐅᑉᑲᑎᑐᑉᑯᓄ ᑖᒪᓪ
ᑯᐊᕐᐊᑉ ᐅᑉᓄ "ᑲᓗ ᑲᓇᐃᓯᑐᑉ ᐅᓂᑉᐅᕐᐸᑉᕐᐊᑐᒐᑯᑉ
ᑭᕐᐊᓂᒍ ᒪᓇ ᓂᕐᐅᑉᐸᐊᑉᑐᑉ. ᑭᕐᕐᒍᑉᐊᑉᐊᓴᓄ
ᑎᑎᑐᑉᑭᕐ ᐊᓴᓄᑯ ᑭᕐᓄᑉᑉᑐ. ᐊᒪᓗ ᐊᑉᑲᑉᕐᑐᒪᓄᑉ
ᐊᓴᓂᕐᑉ ᐊᕐᕐᓄᑉ ᐊᑉᑲᕐᒪᓗᐊᕐᓂ".

ᐊᓴᒥ ᐊᑉᕐᒪᓇᓄ. ᐱᕐᐊᑉᕐᓂ ᐱᒪᕐᓂ ᑭᓂᐊᑲᒪᑭᑭ
ᐃᕐᐸᑉ ᐊᕐᓇᑉᑲᒃᑯᑉᑐ. ᓂᑉᐊᓇᑉᑭᑐᒍ ᑖᑯᒪᑉ
ᓂᐱᑉᐅᓄᑉ. ᐅᑉᑲᑉᐅᓇ ᕐᑭᓂᑉᑯᓄ, ᐊᒪᓗ ᐱᕐᐸᑉ
ᑯᐃᕐᑉ ᐊᓇᐅᑉᑐᐊᑉ ᐊᒍᑯᕐᓄ ᐊᓂᑉᒍᓂᑉ ᓇᑉᕐᐊᑎᐊᓂᑉ
ᐳᑉᓇᑉᓄᑉᓇᒍ. ᐊᑐᑉᕐᐸᐊᕐᓂ ᐊᑉᓂᒪ ᓂᑉᑐᑉᑲᑉᐅᑉᑯᑉ ᐊᒍᓂ
ᑯᐊᓂᑉ, ᑲᓇ ᐊᕐᓂᑉᕐᑉ ᐱᑉᑎᐅᑉᑐᑉᕐᑉ ᐊᑯᒍᕐ. ᑖᑯᐊ
ᑎᑭᑲᐅᑉᑐᑉ ᑖᐊᕐᒪᓂᑉᓄᒍ ᐊᑐᓂ ᐅᑯᑉᑭᑉᐊᑉᑎ ᕐᑯᕐᓂᒪᑉ.
ᐊᒪᑖ ᑲᓇ ᐊᑉᓂᒪ ᓂᑉᑐᑉᑲᑉᐅᑉᑲᕐᑭᑉ ᒪᑯᑭᕐᒥ ᐱᕐᐸᑉ
ᐅᑉᒍᓄ ᑎᒍᑉ ᐊᑉᕐᒪ. "ᒪᒪᓂᕐᑯᑉᐅᑉᑭᑉ ᓇᐊᓂᕐᑉᑉ ᕐᑯ
ᒪᒪᓇᕐᒍ". ᐅᑉᑯᓄ ᐱᕐᐸᑉ. ᐊᑉᓇᑎ ᐅᑉᑲᑉᐅᑉᑎ ᐅᑉᓄᑉ
ᑖᑯᐊ ᒪᒪᑖᐊᑉ ᓇᑉᕐᐅᒪᓂᕐ.

ᑭᑖᑕᒪᑉ, ᑎᑭᑲᒪ, ᐱᕐᐸᑉ ᐆᐊᕐᒍᓄ ᐊᕐᕐᓄ ᑎᑎᑐᕐᐊᕐᓄ
ᑭᒪᑉᓄᑖᑉ ᑎᑎᑐᕐᒪᕐᐊᒍᓄ ᐱᕐᐸᑉ ᑎᑎᑐᕐᑲᐊᓂᕐᒥ ᐅᑐᒍ--

usually concern the hunt or the harsh times many Eskimos experienced in the old days. Many of the hours we spend together are 'how-to' sessions — how to sew a sealskin tent, how to make mukluks, how to catch a goose without a weapon. She also speaks of domestic felicity and home-life in the camps. In fact, when Pitseolak speaks of difficulties, they are usually the ones the new times have brought along. Like people of the older generations all over the world, she often worries about her grandchildren and whether they can make their way in today's world.

But Pitseolak's story is also an account of how Cape Dorset, a remote point on the Hudson Strait, became an internationally recognized artists' colony. (Today there is hardly a European or North American public art gallery without a Dorset graphic.) Pitseolak makes mention of many of the Dorset artists; and she also speaks with great affection of two white men: the almost legendary James Houston, now an executive with Steuben Glass, New York, who during the fifties was the first civil administrator for

ᓴᐅᐱᐊᓂᐅᐸᐊᒍ ᑕᐊᒪᒪᓕᒐᒪᓗ ᑕᑯᖅᐅᓗᔪᓐ ᐱᕐᐃᐅᒐᐦ ᓐᓐᕐᓂᓕᑕ ᔪᑭᒍᐊᓂᒥ ᐊᑉᕐᒐᓂᕐᔪ. ᑕᐊᒪ ᐊᑲᐅᒥᒐᓂᐊᒥᕐᐊᔪᑭ. ᐱᕐᐃᐅᑕ ᐊᐅᑫᐊᓯᒐᓂᐊ ᐊᕐᒪᒐᒍᑭᐸᓕᕐ ᐅᒪᕐᔪᐅᓂᒪ ᐅᕐᔪᒪ ᐊᑲᐅᒪ ᓐᑯᐅᐸᔪᐃᓂᕐᒪ ᐊᒪᕐᑭ ᐃᓄᐃᑦ ᐊᔪᕐᓕᔭᕐᒪ ᐅᕐᔪᐸ ᓐᐅᔪ. ᐊᒪᕐᒪ ᐃᑲᐅᔪᓐ ᑳᓇᓪᓱᓐᑫᐅᑫ ᓐᓗ ᐅᑭᕐᑫᐅ-- ᑳᐅᐱᕐᒍᓪᓚᓐ, ᑳᐅᔪ ᒪᕐᕐᒍᓪᓚᓐ ᐊᕐᐅᐦ ᑭᕐᓕᓂ ᔫᐊᒪ ᑳᐅᔪ ᑳᒪᑲᐅᒐᒍᓪᓚᓐ ᑳᐅᔪ ᓄᑲᒐᕐᒍᓪᓚᓐ ᑯᕐᐅᓇᕐᔭᔪ·ᒍ. ᐱᕐᐃᐅᑕ ᐅᑲᐅᕐᑲᑕᐅᔪᓐ ᐃᑲᕐᓂᒪ ᑲᓇᕐᓂᕐᑕᐅᔪᒪᓐ ᐊᒍ ᐊᓇᓕᒍᓇ ᐃᐅᕐᒪᕐᑲ ᓄᒪᕐᓂᓐ. ᐊᔪᑕᔪᒪ, ᐱᕐᐃᐅ ᑲᐅᕐᑲᑕᐅᔪᒪ ᐊᑲᐅᑕᒍᑫᓂ, ᑳᑕᐊᔪᑳᑕ ᓕᑲᐅᑕᒍᒪ ᐊᔪᓐᑕᔪᒪ. ᑳᑕᐊᓐᑕ ᐃᓄᐃᑦ ᐃᓄᔪᑳᑕᓂᓐ ᓇᒪᓕᑕᐃᓇ ᕐᓕᕐᐊᒪ, ᐱᕐᐃᐅ ᐃᓗᒐᔪ ᐊᕐᒪᒍᑭᑲᑲᑕᐅᐸᔪ ᑯᔪᒪᕐᒪ ᒪᐦᓄ ᐊᒪᒍ ᐊᑭ ᔪᑕᕐᒪ ᒪᐦᓄ ᐸᔭᑲᓐᕐᐊᓪᓚᑕᒍᒍ ᐱᐅᕐᒥᒐᓂ ᓕᑲᐅᑕᒍᓐ ᕐᑲᑕᐊᓕᒪ.

ᐃᑲ ᐱᕐᐃᐅᑭ ᐅᑕᑳᒍᐊᓪ ᐅᑕᑳᑳᕐᒪᑲᐅᐸᑫᑕᒪᕐᑲᑕᐃ ᑭᓕᐊᓐ ᑳᐅᐊᓂᒐᓂ, ᑕᐊᕐᓂᒪᐊᔪᓐᑳᔪ ᐃᓄᐃ ᓄᐊᓕᒐ Hudson Strait ᒪ, ᑳᕐᓂᕐᐅᔪᕐᓂᓕᒪᑳ ᓐᓐᔪᕐᓇᑕ ᓄᐊᒪ. (ᓇᒪ ᐱᑲᐅᕐᔪᐅᕐ ᔪᑫ ᐊᐅᓐᐱᕐᐅᐊᓂᑲ ᐅᕐᔪᒍ ᐊᕐᔪᓐᑳᐱ ᓄᐊᓕᑲ ᑕᒍᓕᐊ ᓄᐊᑕᑫ ᓴᒪᕐᐦᔪᑭ ᑭᕐᑲᑯᐊᓇ ᐱᑲᐅᑕᓇᒍ ᑭᓕᕐᐅᑕ ᓐᓐ

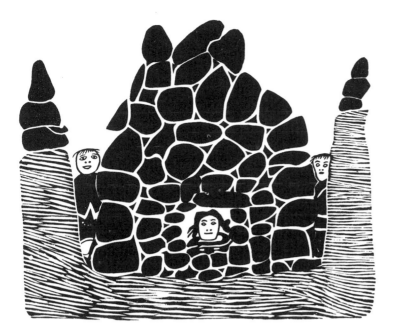

ᐅᐸᕐᐊᐳᐊᒍ�› ᐊᓗᖅᖳᐳᐸᑐᐱᓂᑲ

ᐅᖅᑕᒥ ᑎᑐᒐ, 1966

West Baffin Island; and Terrence Ryan, art director of the West Baffin Eskimo Co-operative.

Both have played major roles in the Cape Dorset story. It was James Houston who first encouraged Eskimos to send their carving south. They have a centuries-old tradition of craftsmanship in stone and bone; and in the nineteenth century they sold many small ivory carvings, often with incised drawings, to the crews of the whaling ships. Houston first saw their carvings in the late forties on a sketching trip he made to the North. He brought back examples to the Canadian Guild of Crafts and then, on expeditions he made to camps and settlements, first for the Guild and then as a Canadian government officer, he asked for carvings to sell in the south. He first visited Cape Dorset in 1951 and, perhaps impressed by the talent of the people, from 1957 until 1962 when he left the Arctic, made his headquarters there. In 1957, he and a small group of Dorset artists began their exciting experiments in print-making.

ᑐᖦᒥᖕᑲᑮᓗᒧᑲ). ᐱᕆᐳᑖ ᐅᑮᖳᐅᒐᖅᒍ ᐊᒡᕐᕐᐊᒐᑕ ᑎᑎᖅᖤᑎ ᕵᒧᒎ; ᐊᒧᖳᑕᑲᑮ ᐅᑮᐅᕐᕵᑮᐅᒐᕆ ᐱᐅᒥᖅᖳᐸᖤᒍᓂ ᒪᐳᒍ ᑮᓂᖁᓂᖀᖳ ᐱᐳᓂᑲᑮᖀ ᕵᐊᒅᕐᕆ ᖳᕆᑖ, ᒪᓇ ᐃᑮᓇᐊᕐᖳᑐ ᐊᒐᐳᑎᐱᐊᓂ, ᓂᐅᖤᐊᑮᒥ ᐊᒐᐊᑎᑮᐊ ᓂᐊᒧᓂ, ᐊᕉᒍᐊᑖ 1950 ᐱᕆᐊᒧᑎᐊᑮᕐ ᕇᐳᑎᐸᐅᕈᓂ ᐃᐅᓂᑎᐊᓂ ᐊᐅᐊᑕ ᓂᐊᒧᓂ ᓂᐊᕇᐊᕐ ᐊᒧᖳ ᑎᐸᑎ ᐅᖁᐊᖳᖬ ᖐᒍᐊᒧᖳ ᐊᒧᕻᑲ ᐊᐅᐊᑕ ᓂᐊᒧᒪ ᖤᐅᐊᖬᓂᖳ.

ᑕᕍᐊ ᑕᒪᖦᑲ ᐱᒍᐱᖬᒪᕍ ᐱᕆᐊᓂᖌᖀᕐ ᐱᒍᐱᖬᐅᑎᐲ ᕵᓂᐊᑮ ᐅᖁᖳᐅᖬᓂᖳ. ᕵᐊᒐᕇ ᕍᕇᖳ ᑕᓇ ᕇᐳᖤᕇᕐ ᐱᒍᐱᖬᒪᕍᑲ ᐊᐅᖤᕈᖎᐲᕇᓂ ᖤᐊᐳᓂ ᑲᐳᓇ ᓂᐊᒧᓂ. ᑕᕍᐊ 100-ᓂ ᐊᕉᒧᓂ ᐱᐅᕇᓂᖤᐅᐊᑕ ᐃᑮᐊᐊᖤᑎ ᐅᖤᒍᓂ ᖤᐱᓂᓂᖳ ᐊᒧᖳ ᐊᕉᒍᓂᑲ 19-ᓂ ᓂᐅᖁᐱᖤᐱᖫᐊᖳ ᐊᒌᕇᓂ ᒐᕇᖤᓂ ᑐᖦᓂ ᖤᐊᐳᓂ, ᐃᐃᒧᖅ ᐊᑲᐱᒍᕇᖬᓂ ᑎᑎᖤᓂ, ᓂᐅᖤᐱᑲᕇᓂᑲ ᐅᕇᐊᖬᐊᕐᐳᓂᖀ. ᕍᕇᖳ ᕇᐳᖤᕐ ᑕᑲᕇᐅᕇᖬᑲ ᐊᓂᖀ ᖤᐊᐳᖬᒧᖳ 1940 ᐊᕉᒍᐊ ᐱᕆᐊᕋᖬᖴᓂᕐ ᑎᑎᖤᕻᖬᕐᑕᕐ ᐊᐅᐊᑕ ᓂᐊᒧᓂ. ᑐᖀᖀᕇᓂᖤᐅᑐ ᑕᐊᖳᐊᑐᓂᖤ ᑲᐊᑖᕆᐅᓂᖀ ᖤᐊᒍᐊᑲᓂᐲᐅᖬᓂ ᐊᒧᖳ ᑕᐊᖳ ᐊᐅᓇᖳᐊ ᐊᓂᐊᑖ ᓂᐊᒧ ᐊᒧᖳ ᐊᑲᖬᑮᓇᓂᖀ, ᕇᐳᖤᕐ ᐊᑲᕇᐅᐳᖬᓂ ᐊᒧᖳ ᑕᐊᖳ ᑲᐊᑖᕆᐅᓂᖀ ᑲᕍᖬ ᐊᓂᖀᓂᖤᐱᖬᓂ, ᑕᓇ ᐊᕆᓂᖤᐅᑐᑲ

Going after fish (detail).
Felt pen, 1970

ᐃᑲᔪᓂᐊᑐᔅ (ᐃᒪᐃᓕᓗᒪ)
ᐊᒥᒡᔫ ᐊᓗᐳᒍᔅ ᑎᑎᒪᓗ, 1970

Terrence Ryan came later to Cape Dorset. He arrived
in 1960 as a summer art student and remained when the
Eskimos asked him to stay. Under his stewardship the
Co-operative has strengthened and demand and interest
in the Dorset graphics have greatly increased. As a result,
the Co-operative helps sustain the community as Eskimos
move from a hunting culture to the computer age.
Like Pitseolak, many of the artists feel great loyalty to their
'Co-op'. (The Co-operative's headquarters, a small
building in the centre of the community with a dazzling
white, yellow and blue optical colour scheme, is always
crowded with carvers and print-makers bringing in their
work and, like artists everywhere, looking quite critically
at the work of others!) As art director, Ryan, who doubles
as the area's justice of the peace, has made it his policy
to restrict his influence and, in assessing the accomplish-
ment of the print-making years, he says, "Perhaps for
the long term the great achievement has been in saving
a record of what the Dorset people have been able
to say graphically at this time."

ᓴᓄᐅᒪᑲᒪᒪ ᓂᐅᐳᑎ� ᑲᓄᑲᓐ ᓄᖄᓄ. ᑲᓇ ᕐᓄᕐᐸᒥ
ᓂᐅᐳᒥ ᐊᓗᑐᑎᐳᕐᒐ ᑭᓗᓄᓐ �I95I-ᒍᑎᓗᒍ ᐊᒡᓗ, ᐃᓚᑭ
ᐱᓇᕐᑐᕐᔭᓄ ᑲᐳᓴᓗᓂᓄ ᐃᓄᐃ, ᐱᒥᐊᕐᓂᑭ I957-ᒥ
ᓄᑲᕐᓐ I962-ᒥ ᐊᐳᓚᒪ ᓴᐳᒥ ᑭᓚᐊᕐᓄ ᐃᓄᐃ ᓄᓚᒪ,
ᑕᐃᑯᓇᒍᓄ I957-ᒥ ᕐᔪᕐᑲᓇ ᐊᒡᓗᓄ ᐊᑭᓄᓄᑭ ᑭᒥᒥᐳᕐ
ᓴᓄᒍᐊᑎᓯ ᐱᒥᐊᕐᐸᑐᔅ ᑲᐳᑭᕐᓐ ᑎᑎᕐᐸᓯᓄᒥ.

ᑎᑎᓐ ᐳᖅᐊᕐᕐᖁ ᑎᕐᓚᓯᐳᒥᕐᕐᑭ ᕐᐊᕐ ᑭᓗᒪ. ᑎᕐᓚᐳᕐᓚᕐ
I960-ᐳᑎᓗᒍ ᐊᐳᕐᒡᔅ ᑎᑎᓯᕐᒥ ᐃᓴᐊᕐᓴ ᐊᒡᓗ
ᑕᐃᑯᓂᒍᐊᓴᕐᐸᑐᒍ ᐊᓄᒪᓄ ᐊᐅᑎᕐᐳᒥᒥ ᑕᐃᑯᒡᕐᐳᒍᐊᓇ
ᓚᓄᒪ. ᑯᐊᕐᓄᑎᕐᐳᓴᓄᐳ ᑯᐳᐊᕐᓄ ᕐᒍᕐᓄᕐᐳᒥ ᐊᒡᓗ
ᐱᒍᓚᕐᐳᓴᓄᑎ ᐊᐳᕐᓯᐳᓴᓄᓯ ᑭᓄᒥ ᑎᑎᓯᕐᒥ ᐊᕐᕐᓴᒥᒥ
ᐊᕐᓴᑎ. ᐊᕐᓄᕐᓚᓚ ᑲᓇ ᒡᐳᐊᕐᓘ ᐃᑲᕐᒥᑕᑐ ᐱᒍᑕᐳᓴᒥ
ᓄᓇᓴᒪ ᐃᓄᐃᓯ ᐳᕐᓚᓴᓚᑭ ᐊᒍᓇᕐᐊᓄᐳᓯ ᐊᐳᕐᓚᒪ ᐊᑲᐳᓇ
ᓴᒍᕐᓐᕐ. ᐊᓚᒪ ᐱᐳᑲᓇᐳᔅ ᐊᕐᒥ ᑎᑎᓯᕐᓯ ᐊᕐᓪᓚᑭ
ᐊᕐᕐᕐᒡᓗ ᐃᑲᕐᕐᓯᐳᕐᒥᕐᒥᒥᒥᒥ ᒡᐳᐊᕐᒥᒥᒥ. (ᑲᓇ ᒡᐳᐊᕐᐊᓯ
ᐊᒡᕐᓴᒡᐳᐊᒥᒥ, ᒥᕐᒍᒡᔪᒋ ᐊᕐ ᔪ ᓄᓇᓯ ᑭᓐᓗᒍᓴ ᑲᒡᑕᕐᕐᓄᒥ
ᒥᒍᐊᕐᓯᔅ ᒡᕐᑭᒥ ᑐᒍᕐᑭᒥᒍ ᑕᒡᓴᐳᓇᒥ ᑕᕐᓚ ᒥᒍᐊᕐᓯᔅ
ᑕᐊᓪᓚᒥᓚ ᓄᓇᐳᓐᕐ ᓴᓄᒍᑎ ᑎᑎᓯᕐᓴᓯ ᑕᐊᒡᓚᐊᕐᓇ
ᐱᓇᕐᐊᒥᕐᒥ ᑭᒥᐳᕐᓚᒥᓯ, ᑕᐊᓪᕐᐊᓇ ᓴᓄᒍᑎ ᑕᐊᓚᐊᓪᕐ

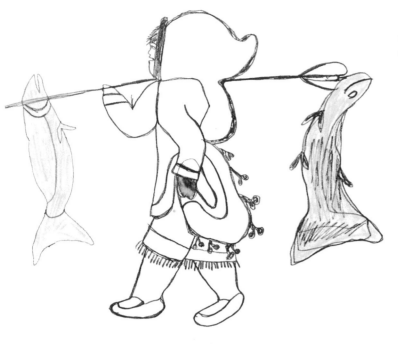

Bringing home the catch.
Coloured pencil and felt pen,
ca. 1967

ᓂᕆᓂᒃ ᐊᓂᑕᐅᐱᕆᒃ
�Kᖓᓴᓗ ᐊ�L ᐊᓗ ᐃᒪᓗᒍᑦ ᐊᓕᑎᕐᓂᐊᑦ
ᑎᑎᑐᒪ, I967 ᐅᑎᒍ

The first Dorset graphics were offered for sale in 1958 at
Ontario's Stratford Festival; each year since has seen an
edition of stone cuts, stencils and, after 1962, copper
engravings. The Eskimos' radically new style of life means
that for the first time they need paychecks and Pitseolak
makes no bones about what the prints have meant to her:
they have brought her money. But just as emphatically she
says they have made her happy. In these difficult times
they have provided the sense of pride that goes with work
well done.

Readers may notice that in her story Pitseolak never uses
dates. Like most Eskimos of her generation, she relates
all events to other important happenings – the building
of the first Hudson's Bay Company buildings (1913); the
sinking of the Hudson's Bay supply ship, the 'Nascopie'
(1947); the completion of what in Cape Dorset is known as
Pootagook's church (1953). Thus, the white people began
to appear in great numbers in the North in the fifties –
after the Nascopie went down.

ᓇᕐᒍᐃᓇ, ᓇᖐᑊᕕᒃᐅᑊᐳᕐᑎᓐᒃ ᐃᑲᓇᐃᐸᑎ(ᕐᓂᒃ ᐊᕐᕐᓂ!)
ᐊᒪᕐᖃᒍᕐᓇᐦ ᓴᓇᒍᐊᓇ ᐅᑕᐃᐸᓇ ᐃᒪᐃᐅᒌᐊᑯᓇᐅᐸᕐᒍᒃᐳᒃ,
ᐊᒪᓗ ᐊᕠᕐᓂᓇ ᐊᕠᕐᓂᒃ ᑕᐦᐊ ᐱᕐᐊᕠᕠ ᑕᐃᒪᖐᐊᕃ
ᑎᑎᑐᐳᐊᑦ ᖇᐦᕐᐅᓇᕐᓂᒃ ᐊᕐᒍᓇ, ᐅᑭᓗᓇ ᑕᓇ, "ᐃᓕᒃ
ᐊᒃᓇᐊᒍᒃ ᐃᑲᐅᓇᒍᐸᑯᓇ ᐅᑭᑕᐳᕐᐸᑊ ᐃᑲᐅᐸᒍᕐᒍᕐᒍ
ᒃᓇ ᐱᒪᕆᐸᕃ ᐃᓇᐃᑦ ᐅᑲᒍᐊᓇᕐᒪᒃ ᖇᐊᐸᓇ
ᒪᐊᐸᑐ".

ᑕᐦᐊ ᕐᐳᕐᓕ ᕠᐸ ᖇᐊᐸᐃ ᓂᐅᐳᑎᕐᐸᐅᒃᑐᐃ I958-
ᒍᑎᓗᒍ ᐊᖃᑎᐅᑎᒃ ᓇᐃᒃ ᐊᕐᒍᑕ ᑕᐃᑲᓇ ᑕᕐᖐᕐᐳᒪ
ᑎᐅ ᐊᕐᕐᒪᕐᓂᕃ ᐅᕠᖐᐊᕃ ᓇᑊᕐᒪᕗ ᑕᕐᐅᐊᒍᑎᐅ, I962-
ᒍᐳᕐᒪᑎᐅᒍ ᒃᐃᓐᕠᕒ ᐊᕠᐊᐅᐸᑎᕐᕠᒍ. ᐱᕐᐳᑕ ᕠᐊᐸᕃ
ᑎᕠᐊᕃᕐᖐᐊᒍ ᑕᐃᑲ ᑎᑎᑐᖃᐊ ᒥᖐᓇ; ᕠᐊᐸᕐᑎᑕᑕᐅᑕ).
ᐃᕃ ᓂᐦᑎᐃᐊᕐᒪ ᐅᑭᓗᓇ ᐸᐊᖐᕐᑎᕃᐱᒪᕐᒍ. ᐊᒃᐅᒍᐊᐃᕃ
ᓇᒍ ᐃᑲᖐᒃᑕᒪᕃ ᒃᐸᕐᒍᓂ ᐃᑲᓇᐃᐸᒍ ᕠᕐᐊᕐᒪᓇᕐ.

ᐅᒃᕠᒪᑎᕃ ᒃᐳᕐᕠᒪᕐᖐᐳᕃ ᐅᓇᒃᑐᐊᒪᕐᒃ ᕠᐸᐳᒃ, ᑕᕠᒥ
ᐊᑎᓇᐅᕐᖐᕐᒪ ᐅᒃᓗᓇ. ᑕᐃᐊᑎᑐ ᐃᓇᕐᒃᖐᕠ ᐃᓇᕃ
ᕠᐅᓇᖐᕐ, ᐱᕐᐳᕃ ᐃᓇᐅᑎᕐᖐᒃ ᐃᓇᒍᓇ ᐊᑎᑎᖐᒍᐊᕐᒃ
ᐊᕐᕐᓂ ᐱᓇᐊᒍᒥ ᐊᑎᑎᖐᐊᓇ -- ᑕᐃᓇ ᐃᒃᓗ ᕐᐳᒃᕠᒪ

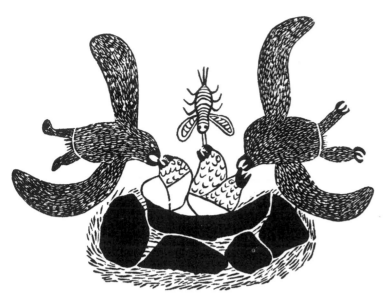

Three translators worked on Pitseolak's story. After the first day, Quatsia retired, explaining that she didn't know the Eskimo words for the old things and the old ways. Another young Eskimo woman, Annie Manning, took her place. Annie didn't know all the old words either, but she liked the work. "It's interesting," she remarked, "finding out about the old way." Finally, in order to preserve flavour and nuance as completely as possible, the taped interviews were re-translated word for word by Ann Hanson, justly famous in the Northwest Territories as an interpreter. Related to many of the Cape Dorset people, Ann was born in Lake Harbour and, after her parents died, went to school in Toronto. She translated for the Royal Family during their 1970 visit to Frobisher Bay.

As preparations for the publication of Pitseolak's story proceeded, it was decided that the book should appear in an Eskimo/English edition. The Eskimo text was prepared by Sarah Ekoomiak and Harriet Ruston of the Department of Indian Affairs and Northern Development.

ᓂᐅᐱᐊᔈᑦ ᐃᖅ ᔅᑲᐃᓯᒧ I9I3-ᒧᑎ�⅃ ᑭᐱᐊᓂᒉᖃ
ᓂᐅᐱᐊᔈᑦ ᐅᒉᐊᒐᐃᓗᖃᖦ ᓂᐅᐱᐊᕿᓂ ᐅᕇᔈᒋ, ᓂᕈᐱᐤᒣ,
I947-ᒧᑎᔈᔎ ᐱᔕᑎᔈᑎᖃᕈᓂ ᖃᓂᐊᔈᓂᗕᓂᖃᖦ ᑭᒥ ᖃᐅᐸᒷ
ᖦᐅᔈᖦ ᔈᔎᔈᖦ ᔈᕇᔈᓯ I953. ᖃᐃᗕᕊᖃᒷ ᖃᓂᓂᖦ
ᔈᒧᕇᕊᖦᕊᔈᕈᓂᔈ ᐃᓂᖃᖦ ᓄᓂᓯ I950-ᐅᓯᑎᓂᒥ ᔈᖐᔈᐃ
-- ᔈᒧᔎ ᓂᕈᔈᐱ ᑭᐱᔈᒉᓂᔈᔎ.

ᐱᒉᕇ ᔎᐞᔈᖦ ᐱᐃᕇᔈᓯᔈᔎ ᐱᕇᔈᖦ ᐅᓂᖃᔈᗕᓂ. ᐅᖦᔎᖦ
ᕇᔈᖃᖦ ᑭᔎᓂᗕᓂ, ᔈᔈᕇᔈ ᖦᖃᗕᔎ ᐅᖃᔎᓂ ᖃᐅᐸᒼᓂᒉᔎ
ᐃᓂᖃᖦ ᐅᓂᖃᐅᕇᓂᖦ ᐅᒉᕇᔈᔎᓂ ᔈᒧᔎ ᐃᔎᕉᔎᖦᖃᖦ.
ᔈᕇᗕᑕᖦ ᐃᔎᕉᔎ ᐃᔈᖦ ᔈᖃᓄ, ᔈᓂ ᒣᖃᖦ ᐃᔈᕇᕇᔈᔎᖦ
ᔈᔈᕇᔈᒣ. ᔈᓂ ᖃᐅᐸᒣᖃᐅᕇᕇᔈᖃᔎ ᔈᔎᐱᕉ ᐅᖃᐅᕇᖃᔎ
ᔈᖃ ᐱᔈᖦᖃᔎ ᐃᖃᓄᔈᖦᒉᓂᖦ. "ᔎᖦᔎᕇᔎᖦᔈᔈᑦ " ᔈᓂ
ᖃᖦᔎᖦ "ᖃᐅᐸᒣᒉᔈᔈᕈᓂ ᔈᓂᕉᔎᖦᑕᖦᖦ ᒣᖐᖦᖦ " ᐱᕇᔈ
ᖦᖃᗕᓂᔈᔎᖦ, ᔈᑭᕇᗕ ᔈᒧᔎ ᔎᑭᖦᔈᖦᔈᑎᔈᒧ ᔈᔈᖃᔎ
ᔈᖦᖦ, ᑭᕇᔎᒉ ᓂᐱᖦᔈᕇᒉᔈᑭᖦᖦ ᔈᔈᖦ ᕇᔎᔈᖦᔈᐃᖃᓄᖃᖦ
ᖃᔎᔎᗕᖃᖦᑎᖃᖦᖃᗕᖃᔎᖦ ᐅᖦᖦᑭᒣ ᔈᓂ ᔈᔎᕇᔎ ᐃᔎᒣᒣ
ᓂ ᖃᐅᐸᖦᔈᐅᕇᔈᔈ ᐃᓂᖦ ᓂᖃᓂᓂ ᓂᓂᕇᔈᒼ ᔎᖦᔈᐅᕇᔈᗕᗕ.
ᐃᖃᖐᓂ ᔈᕇᕇᓂ ᑭᒣᐅᒣᓂ ᐃᔎᖦᖦ, ᔈᓂ ᐃᓂᖦᖃᔎ ᑭᕇᒣᒼ
ᔈᒧᔎ ᔈᖃᖃᔎᕇᖦ ᔎᔈᒣᖃᔎᕇᖦ ᐃᓂᖃᔈᕇᖃᔎ ᔎᕇᔎᒣᒼ.

Readers may be interested to know that syllabics,
the phonetic system of writing used by the Eskimos, was
introduced by the missionaries in the late nineteenth
century. Long before schools came to the Eastern Arctic,
nine out of ten Eskimos could read and write in their
own language.

Perhaps, in fact probably, not all the people mentioned in
Pitseolak's account of her extraordinary life will remember
events exactly as she does. But, hopefully, many books
will come out of Cape Dorset. This is Pitseolak's story.

Dorothy Harley Eber
Montreal 1971

ᑕᓇᑕᒪ ᐅᕼᐸᕐᕾᐅᖓᐅᐊᐅᓯᐸ ᐊᑐᓂᐊᒍᐊᑉ ᒐᐊᓪ ᑭᑐᐊᓪᕐᐢ ᓄᐅ
ᑭᕐᒪᐅᖓᐢ ᐊᐳᓗᐅᖢ I970ᐧᕦ.

ᐊᐅ ᐊᐦᐃᐳᐅᐅᐊᒪ ᓯᐅᓯᐅ ᐊᐅᐊᑭᓴᐊᒍᓯᐊᐱᐊᕈᕐ ᐱᕐᐅᖞ
ᐅᓯᑲᐅᐊᓀᐊᐅᕆᕾᒐ, ᐅᑭᑕᐅᕐᐃᐅᐅ ᑕᓇ ᐅᓯᑲᐅᐊ ᐊᓄᐅᖞᐊ
ᒪᖒᐅᒍᕐᔅ ᑲᓀᐊᐅᖢᐢ ᐊᑭᕐᒪᓂᒪ. ᑕᕐᒪ ᐊᓄᑭᐊᐅᓂᒪ
ᐃᐅᑕᕐᒪᓂᒪ ᐊᑭᐸᐅᐊᐅᖞ ᕾᐊᕝ ᐊᐅᕦᐊᐸ ᑲᕾᐊ ᐅᑭᐢᑕ
ᐴᐊ ᐊᓄᐅᐃᕾᐊᖢᖒᐃᐊ.

ᐊᒪᐸ ᐊᓄᐊᕦᐆᐅᕴᐢᐱᐅᐴᐢ ᐊᓀᐆ ᐅᑭᕐᒪᑕᐸ ᐅᕐᐅᖢᖢ
ᐅᑭᐅᕐᐃᕾᐊ ᐊᓄᐅᑭᕐᐸᕝᕦᓇ ᐊᐴᕦᐹᐊᓯᖒ ᑲᕝᐅᐊᐸ ᐱᒍᐅ
ᕦᕾᐢᐆ.ᐃᕥ ᐊᕦᐅᖢᕦᐊᖒᐢᐅᐊ, ᐅᑭᕥᒪᒪᐊ ᑭᖢᐆ ᐱᕥᐅᐊ.
ᑲᐊ ᑕᐸ ᐱᕐᐅᖢᐢ ᐅᓀᐸᐅᐊᒪ.

ᑕᕜ ᕧᐃᕥ ᐊᐡ ᐳ
ᐊᑭᕦᐊᕾᐸ

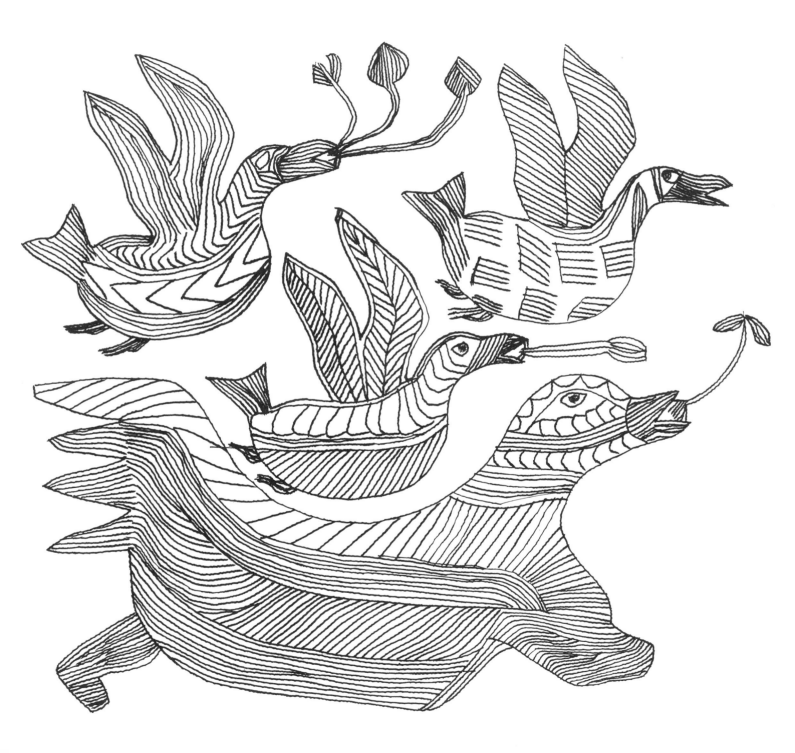

Birds of summer.
Engraving, 1964

ᐊᑉᕐᒥ �竿ᓄᐊᑦ

ᐅ�d竿ᕐ ᑎᑎᑐᒪ, I964

My name is Pitseolak, the Eskimo word for the sea pigeon. When I see pitseolaks over the sea, I say, "There go those lovely birds – that's me, flying!"

I have lost the time when I was born but I am old now – my sons say maybe I am 70. When Ashoona, my husband, died, my sons were not even married. Now they are married and having their children.

I became an artist to earn money but I think I am a real artist. Even when they are out of papers for drawing at the Co-op, they find papers for me. I draw the things I have never seen, the monsters and spirits, and I draw the old ways, the things we did long ago before there were many white men. I don't know how many drawings I have done but more than a thousand. There are many Pitseolaks now – I have signed my name many times.

I was born on Nottingham Island in Hudson's Bay. The year I was born my parents and three brothers began a long

ᐱᕆᐅᑖᒍᑉ ᐊᒪ ᑕᑦᒪ ᐱᕆᐅᓂ ᐊᒪᑐᖕᓂ, ᐅᖃᒪ, "ᐊᑯᐊᑕᒪ ᒍᖃᐊᑯᒍᖃᓄᐊᑦ ᐅᖅᑕᐱᐊ, ᑎᒋᓲᖅ!"

ᐊᖁᐅᒍᓂᕐᑐᒪ ᐊᓕᓂ ᐊᓄᓪᑕᐅᖅᒪ ᐊᓕ ᒪ ᓂᕐᑐᓲᒍᑉ ᐊᖁᓂ ᐅᖃᒪ ᐊᓕᖁ 70-ᓂ ᐅᖏᖁᖅᑐᒪ. ᒍᖁ ᕐᓈ ᐅᐊᒪ, ᑐᒍᓯᓲᒍ ᐊᖁᓂᖁ ᓄᓪᒍᖁᓄᑎᖃᐅᒍᓇᓂ. ᒪᓄ ᓄᓪᒍᖁᓄ>ᓲᑦ ᐱᒍᖃᖁᓄᑎᓂ.

ᐱᓄᐅᖅᓄᐅᖅᓂ ᐱᑕᒍ ᑎᑎᑐᖕᒍᑎᓄᐅᑐᒪ ᐊᓕ ᐊᖏᒪᒍᑉ ᑎᑎᑐᖕᓄᒍᑎᕐᒍᕐ. ᐸᒍᐊᒍᓂ ᓄᒍᒍᖁᐅᑐᒪᒍᒪᒪᓄᖁ ᑎᑎᑐᖕᐱᐊᓂᒍ ᒍᒍᐅᒪᕐᒪ, ᐅᖅᓄ ᓄᓂᕐᒍᒍᖁᐅᖁᐅᑉᐱ ᑎᑎᑐᖕᑉᑕᑦᒪ ᐱᕐᑐᐃᓂ ᒪᒍᑐᐅᕐᒪᓕᐱᓄᕐᒍᐃ, ᑐᒍᓂ ᒍᖁᒍᓂᓄᒍ, ᒍᒪᒍ ᑎᑎᑐᖁᓄᒍᒍ ᐱᐅᕐᐅᒍᐃᐅᓄᒍᐃᓂᕐᑉ, ᐸᒍᒍᐅᓂᕐᑉ ᒍᐅᐸᕐᒍᑐᒍᓂᕐᑉ ᐅᖅᕐᒍᐸ ᒍᒪᕐᒍᕐᑉ ᑉᒍᓄᑉᑕᐅᖃᓇᒍ. ᑉᐅᐊᒪᕐᑐᒪ ᑉᕐᒍ ᑎᑎᑐᖁᒍᒪᓄ ᒪᒪᒪ ᐊᓕ I000 ᐅᒍᓄᒍᓄ. ᒪᓄ ᒍᒍᕐᒍᒍ ᐱᕆᐅᑕᑉᒍ ᑎᑎᕐᒍᒪᒪᒪ ᒍᑎᓄᓂ ᒍᒍᕐᒪᕐᒪᒪ.

ᐊᓄᓪᒍᐅᖁᕐᒍᑐᒪ ᑐᖁᓄ ᐊᓕ ᐊᓄᒪᑉᑦ ᑕᖕᓄ. ᑕᓇ ᒍᖁᐅᑐᒍ ᐊᓄᓂ ᓄᕐᒍᐅ ᒍᑦᑕᒍᑉ ᒍᒪᒍ ᐱᒍᕐ ᒍᓄᑉ ᒍᐅᓂᒍᕐᒍᐅᖁᒍᕐ ᐅᒍᕐᒍᒍᐅᒍ. ᑉᒍᐊᒍ ᓄᒪᕐᓂ ᖂᒍᓄ

Blue insect.
Felt pen, 1970

ᑐᒡᕐᑕᒃ ᖁᐱᕈᒃ
ᐃᕐᒥᒍᔅ ᐊᒃᐅᑎᒍᔅ ᑎᑎᑐᒪ, I970

trip. They left their camp in Sugluk on the coast of Quebec
and set out for Baffin Island to join relatives. They left
in the spring and reached Nottingham Island where I was
born. The next spring they crossed the Hudson Strait
and arrived in the Foxe Peninsula, in the place where Cape
Dorset is today.

But our journey was not quite ended for, the next spring,
we continued along the Hudson Strait and reached
Frobisher Bay. That was when there were no white men
there at all.

These were long journeys and dangerous, too, when the
waters were rough, but I didn't know – I was still being
carried on the back of my mother.

We made all these travels in a sealskin boat. Such boats
had wooden frames that were covered with skins. They
used to be called the women's boats because they were
sewn by the women. Many women sewed to make one

�ᐃᑉ ᑐᑭᐊᓂ ᐊᒪᔭ ᓄᐊᑕᓄ ᐃᓄᐃ ᓄᐊᒪᓂ ᓄᐊᕐᐊᒥ
ᑲᑎᕐᓄᓂ ᐃᓚᕐᓂ. ᐊᐳ� ᐅᐱᒪᓴᓚᒥ ᐊᐅᒪᓂᓄᐣ
ᐃᓄᐊᑕ ᓄᐊᓚᑕ ᑭᑕᒍ ᐊᒪᓄ ᑎᑭᓄᑎ ᐳᐊᕐ ᐱᓂᕐᒪᒍ ᑲᓄ
ᓄᐊ ᑕᕐᓄ ᑭᐱᐊᒃᑐᒃ ᒪᓄ.

ᐃᓚ ᐊᐳᓄᑎᒪᐳᑕᔅ ᓄᕐᐊᑭ ᐅᐱᒪᔪᓄᐊᒪᕐᒍ,
ᐊᐳᑳᓄᐊᓄᒃ ᐃᓄᐃ ᓄᐊᓚᑕ ᑭᑕᒍ ᐊᒪᓄ ᑎᑭᓄᑕ ᐊᑳᓄᓄᕐ.
ᑕᕐᓚᓂ ᑲᓄᐊᑲᐳᕐᒪᕐᕐᐊᑐᕐ.

ᑲᑕᐊ ᐅᒪᕐᑐᒎ ᐊᐳᓄᑎᒪᐳᑕᔅ ᑲᐱᑲᑐᐊᓄᕐᔭ ᐃᒪᐊᑕ
ᐊᑲᐊᑐᐊᓄᑎᓄᕐ ᐃᓚ ᑲᐳᐊᒪᕐᔪᒪ -- ᕐᓂ ᐊᒪᑕᐳᑕᐳᕐᒪ
ᐊᓄᐊᓄᕐ.

ᑲᑕᐊᒪᓚᕐ ᐊᐳᓄᑎᒪᐳᑕᔅ ᓄᕐᐳᕐ ᑭᕐᓚᓂ ᐅᒪᐊᑲᕐᕐᑕ.
ᑕᐊᒪᐊᒍᕐ ᐅᒪᐊᑕ ᑭᕐᒥ ᐊᑕᒍᑎᑲᓄᓄ ᑭᕐᒥ ᐊᒪᐊᑕᓄᓄ.
ᑕᐊᕐᐳᐊᕐᑲᕐᑐᕐ ᐊᑕᓄᐊᑕ ᐅᒪᐊᒪ ᒪᕐᑕᐳᕐᒪᒪᓄᔅ ᐊᑕᓄᐊᓄᕐ.
ᐊᒪᕐᕐ ᐊᑕᓄᐊᑕ ᒪᕐᕐᐳᕐᑐᒎ ᐊᑲᐳᕐᒪ ᐅᒪᐊᑲᕐᐳᕐᑎ. ᐅᒪᐊᔅ

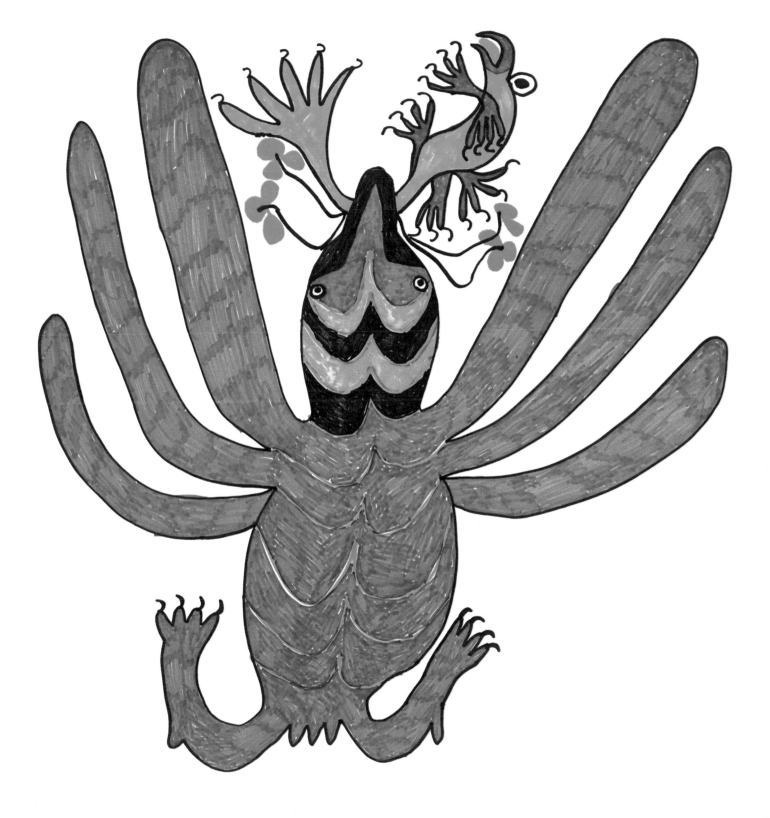

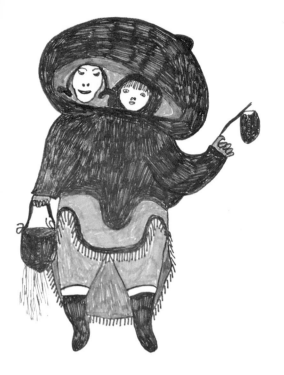

boat. Some boats had sails made from the intestine of the whale, but we had no sail and we had no motors then so my father and brothers rowed all the way. Later, I often heard them say the boat was very full!

But even in my childhood these sealskin boats were already disappearing. My first memory of life is when we stopped in Lake Harbour, on our way back from Frobisher Bay to Cape Dorset, to buy a wooden boat. There were many there. It was while my father bought the wooden boat that I first saw houses and that I saw the first white man. I was scared.

Only as a child was I ever in a sealskin boat, but I have put these boats into my drawings. Perhaps these boats were not really so big but to me, as a child, they seemed very big and I remember them well. I have been drawing the old ways since 'Sowmik' – Jim Houston – came, and many of the drawings have been put on the stone and turned into prints. Did I live all my remembered life in

ᐃᓕᒥ ᑎᒋᓴᐅᑕᖃᐸᓵᑐᐤ ᖀᓗᒪᐅ ᐊᕕᐊᕕᐊᓂᓗᓂ ᕿᕕᐊᓂ ᑎᒋᓴᐅᑕᖃᐸᓵᐅᕿᓂᑦ ᐊᐅᑕᖅᑎᑲᒍᓗ ᑖᒪ ᐊᑦᑕᒪ ᐊᓂᕕᓄ ᐸᐸᓄᓄᐅᑐᑦ ᑐᑐᒪᑲᓪᖑᓄᖅ. ᕀᐊᐅ ᑐᖅᕕᑦᑕᕕ ᐅᕀᓄᕀᑦ ᐅᒋᐊᑐᕕ ᐊᖃᕿᓗᕕ ᑦᑦᑲᐅᑐᕕᕙ!

ᐃᓗ ᐱᐊᓴᐅᑎᓗᓗᓂ ᑲᑐᐊ ᓂᕿᐅᑦ ᕿᕿᕕᑦ ᐅᕀᐊᑦ ᐱᑲᕕᐊ ᑐᓂᕿᐅᑐ. ᕀᐅᕀᐊᕙ ᐊᐅᕿᐅᐤᒪ ᐊᓂᕀᓄ ᐊᕀᓇ ᐤᕿᕿᑦ ᕿᕀᐤᕓ ᐊᕕᓄᓗᕀᑦ ᕿᓗ ᓂᐅᐊᑎᐊᕿᑦ ᕿᕀᕓ ᐅᕀᐊᕿᕕ. ᑖᐊᕕᓂ ᐊᕓᕿᕕᕀᐊᐅᑐᕕᕗ. ᐊᑦᑕᕀ ᐅᕀᐊᑲᕀᑎᓄᒍ ᕿᕀᕓᕕ, ᐅᕀᐊᕕ ᑲᕀᕿᐅᕕᐅᕀᒪᕀᒪ ᐊᕀᓗ ᐊᕕᓄᓗ ᑲᕀᕿᐅᕕᐅᕀᒪᕀᒪ ᕖᓗᕀᕕᕀ ᑲᕀᕿᐅᕀᕿᒪ ᕖᐊᕿᕕᐅᕀᒪᕀᒪ.

ᐱᐊᕿᑐᕀᒪ ᐅᕀᐊᑐᕀᕀᒑᑎᐊᓗᕀᕀᐅᑐᕀᒪ ᓂᕿᐅᑦ ᕿᕀᓗᕀ ᐅᕀᐊᒍ ᐃᓗ ᑲᑐᐊ ᐃᓗᕀᑦᑦᑕᕀ ᑎᑎᕐᕀᓄᕀᒪᕀᑕᕀᑦ. ᐊᕗᕀᒪᕀ ᑐᖅᕕ ᑲᑐᐊ ᕀᒪᕀᕀ ᕿᓪᕀᕕ -- ᕒᐊᕖᕒ ᕀᕗᕀᑕᕀ-- ᑎᕀᕿᐅᕀᒪᕀᒪ ᐊᕀᓗ ᐊᕀᕀᐊᐊ ᑎᑎᕀᕀᒪᕀ ᐅᕀᕀᕀᑐᐅᕀᕀᒪ ᐊᕀᓗ ᑎᑎᕀᕀᒪᕀᐅᕀᕀᒥᑦ. ᐃᐊᕀᒪ ᐃᓄᕀᓂᕀ ᐊᐅᕀᕀᒪᕀ ᐃᓄᕀᓂᕀ ᕒᐊᕀ ᐃᕀᕀᕀᒥ? ᐊᕀᒍᕀ! ᐊᕀᕀᐊᕀ ᒪᕀᐊᕀ:

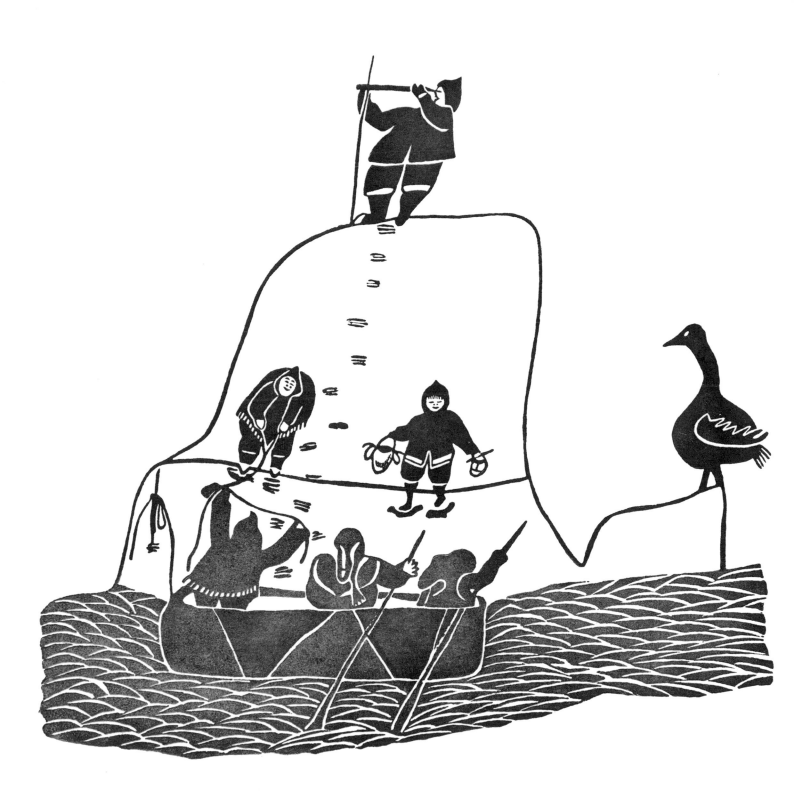

Both in summer and winter we used to
move a lot.
Felt pen, 1970

ᐊᐅᔭᒥ ᐅᐱᐅᒥᓗ ᐅᒃᑕᕋᓕᐊᔭᐅᔪᑐᓪ
ᐊᒪᓪᒐ ᐊᓯᐅᑎᒍᑦ ᑎᑎᒍᒃ, 1970

the Foxe Peninsula? 'Ahalona!' . . . Very definitely! And most of my life I lived in the camps. I remember Cape Dorset when there weren't any houses. I remember when they were building the Hudson's Bay post. The same warehouses that are here now were built when my father and mother were still alive – when I was just a little girl.

Timungiak was my mother; Ottochie was my father. I had a happy childhood. I was always healthy and never sick. I had a large family – three brothers and a sister – and we were always happy to be together. We lived in the old Eskimo way. We would pick up and go to different camps – we were free to move anywhere and we lived in many camps. Sometimes they were near Cape Dorset and sometimes they were far away . . . it depended whether a person wanted to go far or to be near a settlement. My father hunted in the old way, too – with a bow and arrow. He had a shotgun but he didn't use it. Sometimes there were bad winters and we would go hungry but there was no starvation.

ᐊᒪᑕᐅᒃ ᐃᓄᕐᓂᓕᒃᓴᒃ ᐃᓄᕐᒪᕐᓚ ᓄᐊᓂ ᐃᒃ ᔭᒃᑎᒥ
ᑕᐃᒃᓄᒪᓪᒐᒃᑕᐅᕐᓚ ᓄᐊᒥ. ᐊᐅᓚᕐᓚ ᑭᐃᑦ ᐃᒃ ᓴᑦ
ᑲᓇᒍ. ᐊᐅᓚᕐᓚ ᓂᐅᐱᑎᑯ ᐃᒃ ᓗᓂ ᐃᒃ ᓴᑕᐅᑕᒃ ᑲᓇᒍ.
ᑲᑯᐊᓴᐃᓇᐃᑦ ᑭᕐᑕᐃᓇᒃᑕᐅᑕᐅᕐᓚ ᒪ ᐃᒃ ᓴᑕᐊᔾᑕᐅᕐᓚᕝ
ᐊᑦᑕᒪ ᐊᓇᐊᓗ ᕐᓴ ᐃᓄᑎᒥ ᑕᒪᒃ -- ᐱᑭᑐᓗᓇᒪ
ᓂᐱᐊᕐᐊᔾᑎᓗ.

ᑎᒪᒃᐊᒃ ᐊᓇᒪᕐᑕᐅᕐᓚᑕᕐ; ᐅᒃ ᔭ ᑭ ᐊᑕᑕᕐᑕᐅᑉᕐᓚᑕᓪ.
ᕐᐅᐊᕐᑕᐅᒃᑐᓪ ᐱᐊᒃᓴᐱᕐᓪ. ᑭᓗᐊᕐᑭᕐᐊᕐᓇᒪᓪ ᑭᓕᐊᑕᐅᕐᓚᒥ
ᒪᓗᑕ. ᐃᒪ ᐅᓗᓇᑭᐊᑐᒪ ᐃᓯᕐᕐᑕ ᐱᒪᕐᓯᒃ ᐊᒃᑭᕐᓪ
ᐊᒪᓗ ᓄᒃᑭᓗ -- ᐊᒪᓗ ᑕᐊᒪᒪᓪᓇᒃᑕᒃ ᕐᐅᐊᕐᕐᑕᐅᑐᔾᑦ
ᑭᓇᒪᕐᑦᑕ. ᐃᓄᓪᑕᐅᑐᔾᑦ ᐃᓄᐃᑦ ᐃᓄᒃᑐᒃᑭᓪᓂᑐ. ᐊᐅᑕᓇᒃ
ᑕᐊᕐᑕᐅᑐᔾᑦ ᓇᓗᑕᐃᓇ ᐊᔾᐊᕐᕐᑕ ᓄᓇᓄ-- ᐃᕐᓯᓗᐃᓇᕐᐱᕐᑕᐅᑐᒃ
ᓇᓗᑕᐃᓇᑭ ᐃᒃᑕᕐᕐᑕ ᐊᒪᓗ ᐃᒃᐱᕐᑐᕐᑕ ᐊᐱᕐᕐᕐᑐᓄᑦ ᓄᓇᓄ.
ᐃᑐᓄ ᓄᓇᕝ ᑭᓄᑐᕝᑕᐅᑐ ᑭᓗᓄᑦ ᐊᒪᓗ ᐃᑐᓄ ᐅᓗᕐᑐᕝᑕᑦ
.. ᓇᓗᑕᐊᓄᑕᐃᓇ ᐃᓄᒃ ᐅᓗᕐᑐᒥᒍᒪᕐᐱ ᐅᕝᓗᓄ ᑭᓄᑐᒥᒍᒪᕝ
ᐃᒃ ᓴᒃᑐᒍᔾᑦ. ᐊᑕᑕᒪ ᐊᒍᓇᕐᑐᐊᔾᑕᐅᑐ ᐅᕐᕐᐊᑐᓄᑕᑕ --
ᐱᓂᕐᓗ ᐱᓂᑕᒍᓗ. ᑯᑭᑐᓇᑭᑐᐅᑉᕐᓚᕝ ᐃᑕ ᐊᑐᐸᕐᑕᕐᑕᓪ.
ᐃᑐᓄᑦᑦ ᐅᑭᑕᒃ ᐱᐅᕝᑕᑐᔾᑕᑦᑦ ᐃᑕᓗᓂ ᑭᐸᑕᐅᑐᑐ ᐃᑕ
ᐱᓇᑐᑭᑕᐅᕐᓚᒪᕐᑐᒃ.

In those days many of the women had tattoo marks on
their faces and my mother had them, too. They used to do
it with a needle and caribou thread soaked in oil and soot
from the 'kudlik' – the seal oil lamp. They used to pull
the thread through the skin and the skin would be swollen
for many days. I don't know exactly why people had
tattoos but I believe the women did it because they thought
it was pretty. I did, too. When I was young I tried a few
marks on my arm, as you can see.

My father used to tell stories about how he was once
almost killed by a powerful shaman. My father was a very
good hunter and that is why the shaman tried to kill him –
he was jealous. I don't know very much about shamans
– I don't like to think about them – but my family and my
mother's family all believed in shamans because we had
heard so many stories. They were Eskimos just like other
people but they had these strange powers. They had
power over the hunt – they could bring the animals – and
they had power to kill. Just as it is today, a long time ago

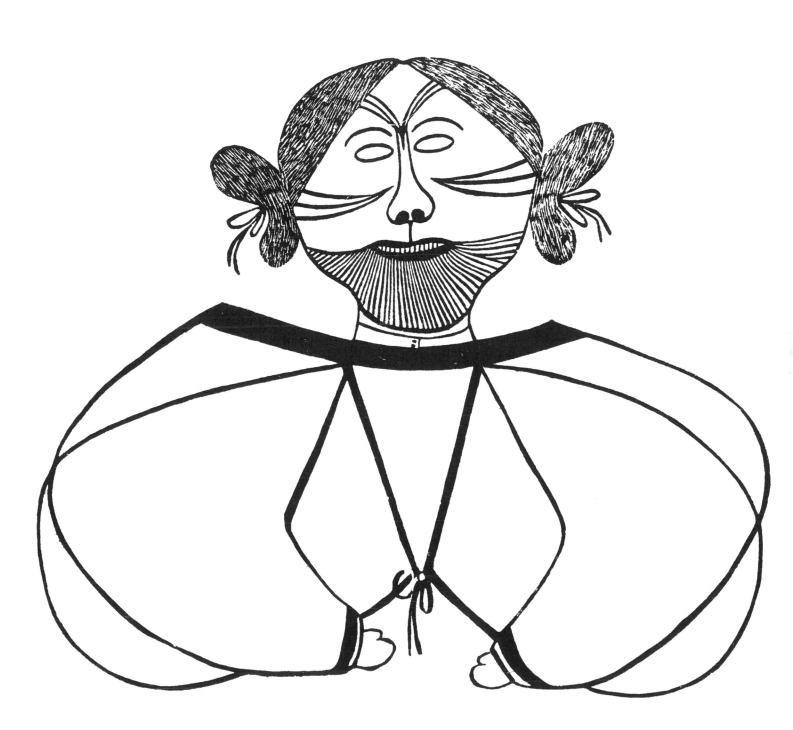

From skins we made buckets
to carry water.
Coloured pencil and felt pen,
ca. 1967

ᑭᓯᐊᓂ ᐃᒥᑦ(ᐅᑎᖅᐅᐸᓛᐅᒍᒡ)ᒍᒃ
(ᑲᕐᓚᓂᐅ ᐊᒡᓗ ᐃᒪᓕᒍ ᐊᓚᐅᑎᓄᒃ
ᑎᑎᒐᒪ, I967 ᐅᑎᓗᒍ

Bird attacking fish.
Coloured pencil and felt pen,
drawing for stone cut, 1969.

ᑯᐸᒐᐊᓕᒃ ᐃᖃᓗᒃᒥᓯᒃᒍᒃ
(ᑲᕐᓚᓂᓂᒃ ᐊᒡᓗ ᐃᒪᓕᓂᒃ ᐊᓚᐅᑎᓄᒃ
ᑎᑎᒐᒪ ᑎᑎᒐᐅᑎᒃᑲᓂ ᐅᖕᓯᒐ ᓴᓚᔅ
ᒪᐊᒃ I969

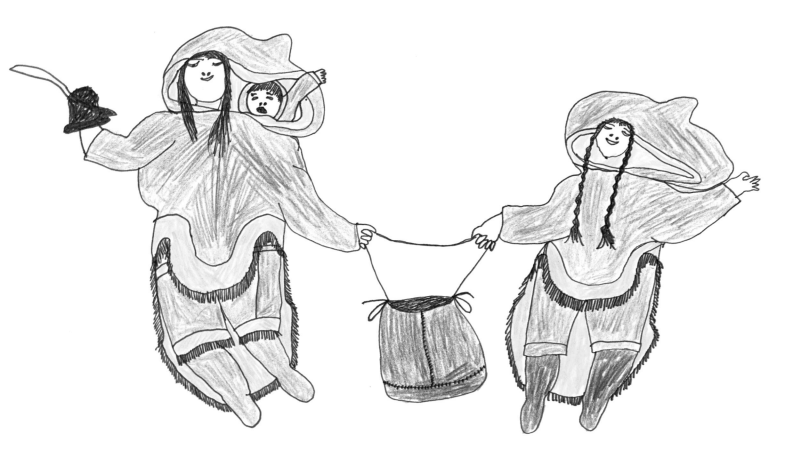

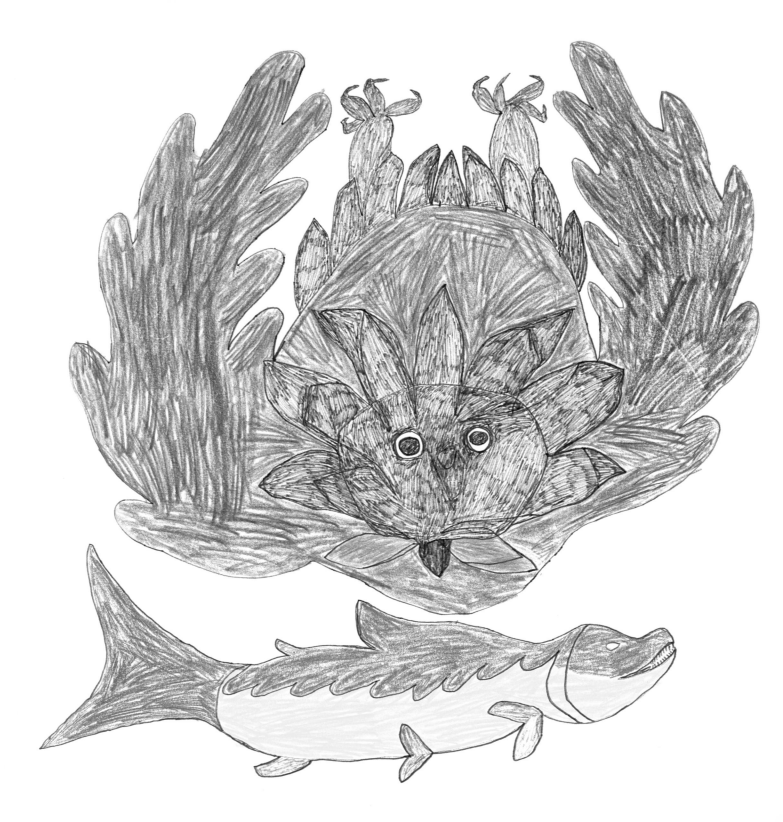

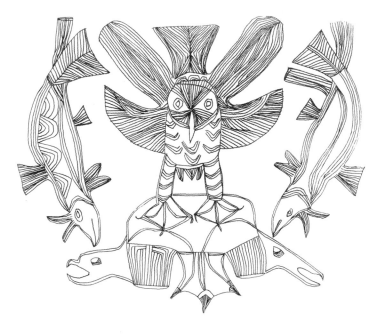

Composition.
Engraving, 1964

ᐅᑯᐱᓴᕐ ᓴᐳᐳᓂ, 1964

there was often hatred among people. When a shaman was jealous or hated another Eskimo, he would try to kill him and, sometimes, I think, if an Eskimo had an enemy in camp, he would go to a shaman friend and ask him to kill this man who hated him. But they were very good-looking people – you would really never believe they were shamans.

There were good shamans and bad shamans but most people feared them – in the old days there were many things to fear. Some people feared the animals, even the animals they ate. I always feared polar bears – they were scary.

When we were children we played lots of make-believe. We used to play igloo, we used to play dog-team. I think everybody plays these things. Perhaps children everywhere play the same things. We played a game in which other children would run after you; if they could catch you they would pretend to eat your eyes.

ᐃᓄᐃᑦ ᐃ�ᖐᑯᑦ. ᐊᒪᑯᐊᑦ ᐱᐳᓗᓴᑎᑐᐊᒥ ᐅᐸᓗᓂᑦ
ᐅᒥᒡᖐᑐᐊᒥ ᐃᓄᑲᖐᓂᓂᖕ ᑐᑯᐱᐳᐊᐸᑐᐱᐃᓂ ᐊᒪᓗ ᐃᓇᑐᑦ
ᐃᓄᖕ ᐅᒥᒥᐸᖃᑐᐊᒥ ᓄᐊᓇᑐᒥ, ᐊᒪᑯᑦ ᐊᐃᐸᓇᐅᑐ
ᐱᑲᓂᒥᐊ ᐅᖃᓄ ᑐᑯᐸᑯᑐ ᑕᒐᒪ ᐊᒍᓇᒥ ᐅᒥᒥᐳᒐᓂᖕ.
ᐃᓕ ᑕᑯ ᐃᓇᐊᓇᐅᐸᑖᐅᑐ ᐊᖅᐸᑐᓗ ᐃᓄᐃ ᐅᐱᐊᐳᒪᐅᓄᓕ
ᐊᒪᑯᒐᐳᖅᑦ.

ᐱᐅᖀᓂᖕ ᐊᒪᑯᑲᐸᓴᐅᒪᖀᖄᑎ ᐱᐅᒪᐅᐊᓗᓗ ᐊᒪᑯᑲᖕᖄᒥ ᐃᓕ
ᐃᓄᓕᑲᖄᖀᑦ ᐃᑲᓘᖀᐳᐊᐸᑐᐅᑐ -- ᐅᖀᐳᐊᐅ ᑕᐃᓂᓴᐅᐱᓇ
ᒍ ᐊᒐᓂᖕ ᕽᒍᐃᓇ ᐊᖂ ᐳᐊᐅᖕᖄᐸᑐᖕᖕ. ᐃᓕᖀᑦ ᐃᓄᐃ
ᐊᖕᐳᐸᑐ ᐅᒪᖄᓇ ᓂᑎᖄᖓᐊ ᐅᒪᖄᓇ ᐊᖕᐳᐸᑐᖀᑦ.
ᑕᐊᒪᒪᓕ ᓇᓄᓇ ᐃᖕᐳᖄ. ᓇᓄᐊᓇᐊᑦ ᐊᖕᐳᓇᐸᑯᐅᒪᓕ.

ᐱᐊᖀᐅᖄᐃ ᐱᒍᐊᖀᐳᐳᒍ ᐊᒐᓂᖄ ᐅᐱᐊᖄᓂ. ᐱᒍᐊᖀᐳᐳᒍ
ᐊᖕ ᖄᐳᒍᒍᐊᖄᖄᑦ, ᕽᒍᐳᒍᐊᖄᖄᐃᑲᖄ. ᐃᓄᖄᖔᖕᑎ ᐃᓄᐃ
ᑕᒪᑯᖄᓗ ᐱᒍᐊᖄᒍᑯᖂ. ᐊᒪᑲ ᐱᐊᖄᐊ ᓇᒥᖄᐊ ᐱᒍᐊᖄᒍᖄ
ᑕᒍᖄᓗᖄᖄᐊ. ᐱᒍᐊᖀᐳᐳᒍ ᐱᒍᐊᖀᓂᖀᖀᑦ ᐱᐊᖀᐳᖀᓂᓇ
ᐅᖀᖄᑕᐳᓂᕽᖀᑦ; ᐊᒍᖔᐳᒍᑦ ᐊᖔᐳᑕᐳᒍᐊᖀᕽᖀᑦ.

From my father we used to learn the Eskimo legends. There were many such stories and all children learn them, but I have forgotten most of them now. I remember the one about the blind boy who got back his eyesight when a bird took him on his back and dived with him under the sea three times. This blind young man lived with his mother who was cruel to him and, when he returned home and she saw he could see, this wicked mother was so frightened she jumped into the sea. Eskimos believe she became a white whale and is there still – they really believe it.

There were no teenagers in those days. The young people got married so early they didn't have time to make any trouble. Now there are so many young boys and girls and very often they are troublesome.

The year I married was the year my father died. He had a bad sickness – it was something with the lower back – and he died in our camp at Idjirituq. The year he died,

ᐊᑦᑕᓗᐊᕐᑦ ᑲᐅᕐᕋᖕᐸᑲᐅᕐᕋᒍᓕ ᐃᓄᐃᑦ ᐅᓂᑲᑐᐊᒍᕐᕋᓂᒃ.
ᐊᕐᕋᔪᖕᐸᑲᐅᕐᕐ ᑲᓄᐊᑐᑐᐃᓄᓂ ᐅᓂᑲᑐᐊᓄ ᐊᓚᓪ ᐱᐊᖕᑎᒪᓕ
ᑲᐅᕐᕋᖕᐸᑲᐅᕐᑎᕐᕐᐦ ᐃᑦ ᐳᐊᒍᕐᓕᕐᕐᑲᖕᐸ ᐃᓴᓚᑲᖕᕐᕐᐦ ᖃᓇ.
ᐊᐅᑲᐹᕋᓗ ᑕᐊᕐᕐᓪ ᕐᐳᕐᕐ ᑕᐅᑎᑐᕐ ᑕᐅᑐᔭᓴᕐᕐᕐᓄᕐᑦ
ᑐᓕᓪᔪᖕᑯ ᑐᓄᐊᔪᑦ ᑎᔪᖕᐅᕐᖕᓂ ᐊᓚᔪᑦ ᐱᓕᕐᐱᕐᓂ ᐊᖕᖕᑕᐅᑐ
ᑲᑕᓴᕐᓪ ᑕᐅᑐᔭᓴᕐᑕᓄᐦ. ᑕᓇ ᑕᐅᑐᕐᑐ ᐃᓴᕐᑐ ᕐᕐᕐ
ᐊᓴᓴᕐᓂᑐᓴᕐ ᐊᓴᓴᕐᓂ ᐃᑲᑕᖕᕐᕐᓂᕐ ᐊᓗᔪ ᑕᓇ ᕐᕐᕐᖕ
ᐅᑎᑲᑐᓴᕐ ᐊᖕᖕᓴᐃ ᐊᓴᓴᓪᑕ ᑕᐃᑲᑎᓴᐅᓕ ᑕᐅᑐᔭᓴᕐᑐᖕᕐᓴᖕ,
ᑕᓇ ᐊᓴᓴᓪᑕ ᐊᖕᕐᕋᓴᖕ ᑲᐱᐊᕐᑕᑕᕐᕐᕐ ᐊᓚᓴ ᕐᕐᔪᖕᓴᖕᕐ.
ᖃᓇᑕᓪ ᐃᓴᓴ ᐊᓚᕐᑐᖕᖕᐸᑕᖕᕐ ᕐᑕ ᐃᓴᓴ ᐅᖕᕐᖕᐸᑐᑐ.

ᒪᑐᔪᖕᐸᑲᐅᕐᑐ ᑕᐊᕐᕐᓴᖕᐅᑐᓴᔪ. ᒪᑐᔪᐃ ᐃᓴᐃ ᓯᑲᕐᑕᖕᐅ
ᓂᕐᐊᐱᑲᐅᑕᕐᑕ ᐱᕐᑕᓴᕐᕐᖕᐸᑲᐅᕐᑕᕐᑐᐃᑦ ᑲᓴᔪᓴᖕ. ᖃᓴᕐ
ᐊᕐᕋᔪᓴᐃ ᕐᕐᕐ ᓴᐱᕐᕐᔪ ᑕᐊᓚᓕᓴ ᐱᕐᑕᐃᓴᕐᕐᑐ.

ᐊᕐᔪᖕᓴᔪ ᐅᐱᑕᑲᑕᕐᕋᕐᑕᖕᓕ ᐊᑦᑕᓕ ᑐᔪᐱᕐᑲᕐᑕᖕᓕ. ᑲᓄᖕᓕᕐ
ᐸᓴᑲᐅᕐᓕᕐ -- ᑲᓄᓕᑲᐅᕐᓕᓕᕐ ᑐᐅᑕᑎᐊᓴᕐᕐᓴᖕ ᐊᓗᖕᕐ

A drawing out of my mind.
Felt pen, 1970

ᐃᓯᒪᓂ ᑎᑎᔫᒃ
ᐊᓚᒥᒍ ᐊᑕᐅᑎᒍ ᑎᑎᔫᒪ, I970

I remember, there was a ship caught in the freeze-up in the ice just outside our camp. It was a beautiful ship, all white, and owned by Americans. They lived in their ship and the white men spent the time trapping for white fox. They used to send my brothers to the Bay in Cape Dorset to sell the skins and get the money. In the spring when break-up came, after my father died, the ship left.

After my father died, Ashoona's father came to get me on a dog team. Ashoona had told my brothers he would marry me; Ashoona and I used to be little children together. I don't remember how old I was when I married but girls got married very young then; now they are older. Ashoona's father took my mother and me on the dog team to Ikirasaq which is near Sakbuk, a one-day trip from Cape Dorset.

We were married in the summer here in Cape Dorset. At that time of year all kinds of people from all the camps in the area used to come into Cape Dorset to see the ship

ᑐᑦᓴᐅᕐᒪᕐᖦᑎ ᓄᐊᓄ ᐊᖦ ᔪᖦᑐᒥ ᐊᖸᓅᑎᒥ. ᑐᑦᓄᒍ ᐊᑐᓯᓃᕐᓚᒥ ᐅᒥᐊᕐᖦᐊᖦᓄᒍᒋ ᕐᑯᔫᖦᒥ ᓄᐊᒃ ᓴᓄᑕᐊᒐᔪᐊᓄ. ᐅᒥᐊᕐᖦᐊᓄᖦᐅᕐᓄ ᐊᒥᐊᑎᖦᒥᐅᓄᖦ. ᐅᒥᐊᒥᓄᐊᐅᕐᖦᒪᕐ ᐊᒪᓄ ᖦᓄᐊᖦ ᒥᕐᒥᐊᓄᐊᖦᖦᒍᓄᖦ ᑎᑎᓚᐊᒍᓄ ᖦᒧᖦᐅᒧ. ᐊᓄᒍᓄ ᖦᓴᖦᐸᖦᖦᐅᑐ ᖦᖦᓄᐊᖦᓄᕐᕐᑎ ᓄᐅᐅᓄᕐᖦᐅᒍᕐᕐᑎ ᑎᑎᓚᐊᖦᓄ ᖦᓄᐅᖦᖦᑐᑎᒥᓄᐊᒍᕐᖦ. ᐅᐊᖦᖦᐅᑎᒍᒍ ᕐᑯᐊᒍᐊᖦᖦ ᐊᖦᖦᐅ ᑐᑦᖦᓄᒍᒍ, ᐅᒥᐊᕐᖦᐊᖦ ᐊᐅᓄᐅᕐᖦᒪᕐᖦ.

ᐊᖦᖦᐅ ᑐᑦᖦᓄᒍᒍ, ᐊᖦᕐᐊᖦ ᐊᖦᖦᐅᓄ ᐊᐊᖦᐅᓄᐅᕐᖦᒪᕐᖦ ᖦᒍᕐᑯᒍ. ᐊᖦᕐᐊᖦ ᐅᖦᓄᐅᕐᖦᒪᕐ ᐊᓄᖦᓄ ᐅᖸᓄ ᓄᖸᐊᖦᒍᒪ ᓄᒧᓄᖦᒥ; ᐊᖦᕐᐊᖦᖦ ᐱᐊᖦᖦᐊᖦᑎᕐᖦᖦᐊᖦᑐᒍ. ᐊᐅᓄᐅᕐᖦᑐᒪ ᖦᖦᕐᖦ ᐅᖦᖸᖦᓄᒪᒪ ᐅᐊᖦᕐᒪ ᐊᓄ ᓄᐊᖦᕐᐊ ᒪᖦᑐᓄᑎᐅᕐᑎ ᐅᐊᖦᖦᓄᖦᐅᑐᖦ ᖦᐊᕐᖦᓄᒥ, ᓚᐊᖦ ᐊᓄᐅᓄᖦᖸᐊᖦᑐ. ᐊᖦᕐᐊᖦ ᐊᖦᖦᐅ ᐊᐊᕐᖦᐅᕐᖦᒪᕐ ᓄᐊᓄᓄᖦ ᐅᖦᐊᓄ ᖦᒍᕐᒍ ᐊᖦᖦᓄᒍ ᖦᖦᐸᐅ ᖦᐊᒍᓄ. ᐅᓄᖦ ᐊᖦᐅᕐᖦᒥ ᐊᒥᖦᕐᐊᖦ ᖦᖦᓄ ᐱᕐᓄ.

ᐅᐊᖦᖦᐅᕐᖦᒪᕐ ᐊᐅᖦᖦᐅᑎᒍ ᖦᖸᓄ ᖦᖦᓄ. ᖦᐊᕐᖦᓄᐅᑎᒍ ᐊᖦᖦᖦ ᖦᐊᖦᖦᐊᖦ ᐊᐅᐊᖦ ᓄᖦᑐᐊᖦ ᓄᐊᓄ ᐱᖦ ᖦᖦᐊᖦ ᖦᐊᖦᐊᖦᖦᐅᖦ ᑎᖦᖦᐊᖦᑐᖦ ᖦᖦᓄᖦ ᖦᖦᐊᖦᐊᖦᑎ ᐅᒥᐊᖦᐊᖦᖦ ᓄᐅᐊᖦᖦᓄ ᐅᖦᒪ ᓄᐅᐊᐊᐅᖦ ᐊᖦᑎᖦᓄ. ᑎᖦᖸᖦᖦ ᐊᕐᕐᖦᐅᖦ

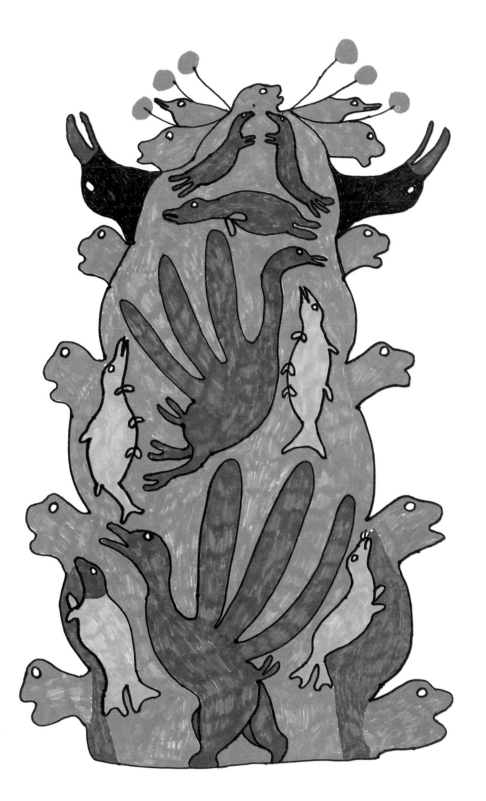

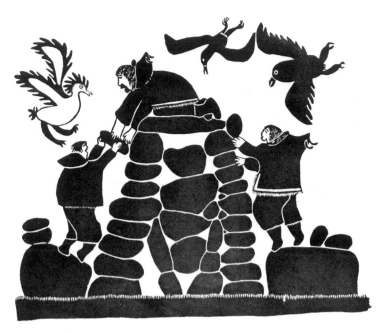

Inukshuk builders.
Stone cut, 1968

Woman with doll.
Stone cut, 1964

ᐃᓄᒃ ᕐᓚᑖᐅᑎᑦ
ᐅᔭᕐᒥ ᑎᑎᕐᒡ, 1968

ᐊᖃᓄᒃ ᐃᓄᕐᔪ
ᐅᔭᕐᒥ ᑎᑎᕐᒡ, 1964

that would bring the supplies to the Bay. When we arrived there were many people camped all over the hill where the Hudson's Bay post is, and all around the bay. We were married outside, by the flagpole near the Bay, by the Anglican clergyman whose Eskimo name is 'Inutaquuq', which means 'a new person'. All the people from the camps were there.

Because Ashoona was an inland hunter, at our wedding I had on caribou skin clothes – but they were just ordinary clothes. Here in the Arctic we did not bother with special dresses. But all through my married life, because Ashoona was such a good hunter, he brought me beautiful skins – all kinds of seal and caribou. Many women used to be jealous of me because I had such lovely clothes.

For a short time after we married, we lived in Ikirasaq but, before my first son was born, we moved to Akudluk Island. It was a long journey but it took us only one day by sail. It was windy and there was a good breeze on

ᒪᕐ ᐃᓄᐃᑦ ᑐᐱᕐᒪᕐᐊ�➔ᑎ ᓇᕐᑐᐃᓇᒪ ᒃᖃᐅ ᓴᐊᓐᓇ
ᓂᐅᐄᐊᐅᔅ ᓇᕐᑕᓐᓇ ᐊᒪ ᕐᕐᓚᒪᒡ. ᑲᑎᑎᑦᑕᐅᑎᓚᕐᔪᑦ
ᒐᐅᒡ ᓴᖃᒪᓴᐳᑎᑲᒪᒡ ᐃᒪᐅᑦ ᓴᐊᓇ ᐊᕐᖽᐊᑐᐱᕐᒡ ᑲᑎᑎ
ᐅᐱᓇ ᐃᓇᑎᑦ ᐊᐃᑲᑕᐅᑦ ᐃᓄᒡᒃᒥᕐ. ᐃᓇᒪᕐᒃ ᑐᐱᕐᒥᐅ
ᒪᕐᑐᐊ ᑕᐃᑲᓇᑲᐅᑦᑦᕐ. ᐊᕐᕐᓇᒃ ᓇᕐᒥ ᐊᔪᕐᐊᐊᑎᕐᒃ
ᑲᑎᑎᑦᕐᓂ ᑐᑐᓄᒃ ᐊᓇᓴᕐᒪᑕᐅᐱᕐᒡᕐ -- ᐃᓴ ᑐᑐᐃ
ᐊᓇᓴᑐᐃᓇᐅᑕᐅᑎᕐᒃ. ᒪᕐ ᐃᓄᐃᑦ ᓄᐊᓄᒪ ᒃᒪᕐᐸᓇᑦᑎᒡ
ᐊᓇᓴᑐᒪᑐᐊᒃᕐᕐᔅ. ᐃᓴ ᑕᒪᒡᒪᒡ ᐅᑳᐱᓇᓚᓇ ᐊᕐᕐᓇ
ᐊᔪᕐᐊᕐᑐᐸᕐᑲᑕᐅᑎᕐ ᐅᒪᕐᐅᑐᐸᕐᑲᑕᐅᑎᕐ ᕐᕐᐊᑯᓄᒃ
ᐱᐊᕐᕐᓇᒃ ᐱᑎᐸᓇᒡᒡ -- ᒃᓇᐊᑐᑐᒡᐊᕐ ᐊᕐᕐᕐᕐᒡᓇ ᓇᕐᕐᓇ
ᑐᑐᓇᓗ. ᐊᕐᕐᒡ ᐊᒃᓇᐃᑦ ᐱᕐᓯᒡᕐᑲᑕᐅᑦ ᐅᕐᓇ ᐱᐅᕐᕐᓚᓇ
ᐊᓇᓴᒃᕐᑲᐅᑎᒪ.

ᑲᑎᑎᑯᐅᒃᕐᒡᐅᕐᓚᓄ, ᓄᐊᒃᑐᐱᕐᓚᕐᐊ ᐃᐱᕐᓴᕐᒡ ᐃᓴ, ᐊᒡᕐᕐ
ᑯᑎᒪ ᐃᕐᐅᓂ ᐃᓄᓚᑕᐅᓇᒡ, ᓄᑐᐱᕐᓚᕐᐊ ᕐᕐᒡᓗᒡ. ᕐᕐᓇ
ᐃᕐᒐᓴᑐᐱᕐᓚᕐᐊ ᐃᓴ ᐅᕐᒃ ᓗ ᐊᑐᐱᕐᒡ ᕐᐅᕐᓇ ᐅᕐᕐᑐᑲᐅᑎ
ᒪᕐᐅ. ᐊᓇᓴᓄ ᕐᕐᕐᑐᐅᑐᒃ ᕐᑯᕐᕐᑎᒡᕐ. ᕐᐅᑲᐱᕐᒪ

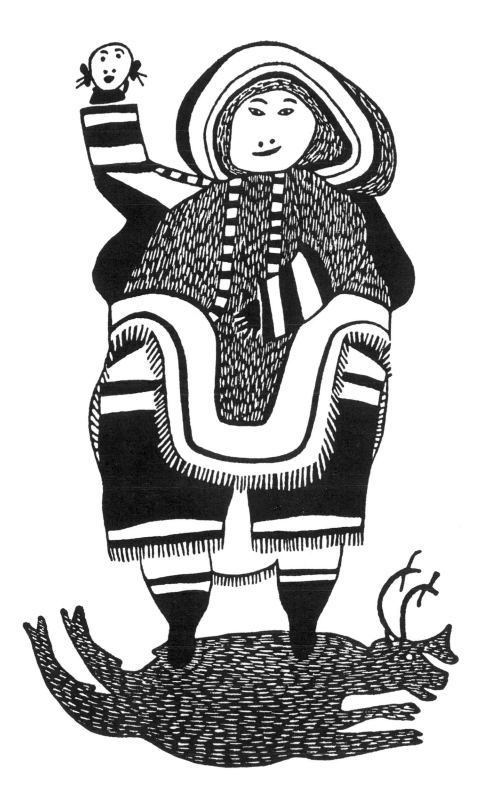

our necks. I remember it was autumn and it was snowing but there was no ice on the water. My husband's two brothers and their families came with us and we were in camp together for one year at Akudluk.

When Namoonie, my first son, was born, three women held me. It was like that in the old times — there were always women who helped. Afterwards, they would make magic wishes for the child — that a boy should be a good hunter, that a girl should have long hair, and that the child should do well at whatever he was doing.

I don't know if it is easier to have babies in a hospital. Ahalona! At any time it is hard. There is a saying, ''It is hard but it is well.'' I had 17 children — every year I had a baby — and many of them died as little children. In the Eskimo way, two sons were adopted, one by Peter Pitseolak and one by another Eskimo couple, and they died, too. Later, a daughter died from having a baby. My living children are Namoonie, Kaka, Kumwartok,

ᐅᑭᐊᕐᐅᑎᓗᒍ ᑲᓄᓂ ᐃᓓ ᕿᑯᕐᒥᕐᑲᒍᐊᓄ ᐃᒪ�b. ᐅᐱᒪ ᓄᑲᕐᓂ ᒪᕈᐊᑉ ᑭᑐᒪᕐᓄ ᒪᓓᑎ ᐅᕝᓂᓂ ᐊᒪᓗ ᑐᐱᕐᒪᑭᑎ ᒪᑎᑐᐊᓱᒥ ᐊᑕᐅᑎᒥ ᐊᑐᐅᕐᒥ ᐊᑐᓗᒥ. ᓇᐅᒪᐊᐃ, ᐊᒪᕐᓄᕐᐊᑎᓄ ᐊᓄᒐᐃᐅᕐᒪᕐᓴ, ᐊᖃᓇᓄᖃ ᐱᒥᕐᓄ ᐃᑲᕐᑎᐅᓄᒪ. ᑕᐅᒪᐊᖅ ᓚᐅᒪᖃ ᐅᕐᕝᐊᓄ - - ᐊᖃᓇᐃ ᑕᐊᒪᕐᕐᓴ ᐃᑲᕐᐊᕐᒪᕐᑐᓂᖅ. ᐃᖃᕐᓓᑲᓚ ᐊᕐᓴᐊᒍ ᐱᐊᕐᓴᐅᕐᐊᓱᑎ ᐱᐊᕐᑎᓄ ᓱᕐᐊᕐᑐᑎ ᐊᖃ ᓄᕐᐊᕐᐅᓱᒥᓄ ᕐᕝᕝᐊᑎ ᐊᒥᓄᕐᐊᕐᑎᐅᐃᓴᐅᕐᐅᓯᓄ, ᓂᖃᐊᕐᕝᐊᒥᕐ ᕐᖃᑐ ᕐᐊᕐᐅᓂᓄ ᐊᒪᓄ ᑕᓄ ᐱᐊᕐᐃ ᐱᕐᐊᑎᐅᕐᒥᒍ ᑲᐅᑐᐃᐊᓓᒪᖅ ᑲᐅᐊᓓᒥᕐᓂᖅ.

ᑲᐅᕐᓓᒥᕐᑐᒪ ᐊᑭᐅᓂᖃᐅᓓᒪᒪ ᐱᐊᕐᓴᑎᑎᕐᑎ ᐊᓄᐊᐊᒥᕐ. ᐊᑲᓄᐊ ᐊᖃᕐᕝᐊᓄ ᓚᑎᐊᕐᓄ! ᑲᓄᐃᐊᐃ ᐊᑲᐅᑐ.ᐃᓓᐊ ᐅᑲᕐᓓᕐᑲᑐ, ᐊᑲᐅᑐ ᐃᓓ ᑲᐊᓴᕐᒥᕐᐊᑐ. ᐱᐊᕐᓴᑎᐅᓓᓓᒪᒪ I7-ᓂ ᐊᓴᒍᑕᓓᕐ ᐱᐊᕐᓴᑎᕐᓴᐊᒪ ᐊᒪᓄ ᑐᐊᕝᒥᕐᐊ ᐊᒥᕐᐊ ᐱᐊᕐᓴᐅᕐ ᑎᖅ. ᐊᓄᑎ ᓚᕐᑉ ᑎᒍᐊᑕᐅᕐᕐᐊᒪ, ᐊᑕᐅᕝ ᐱᑕ ᐃᕐᐅᓂᓄ ᐊᒪᓄ ᐊᐊᕝᑎ ᑎᒍᐊᑐᒍᓄᓄ ᐊᓄᓄ ᓄᕝᐊᑎᓄ ᐊᒪᓄ ᑕᑕ ᑕᓓᕐᑉ ᑐᑕᕐᒥᓓᕐᕐᑕᐅᕐᑕᖅ.ᕐᐊᐅᓄᑐ ᐸᓄᓓ ᑐᑭᑐᐅᑐ ᐱᐊᕐᓴᒍ. ᐱᐊᕐᓴᖃ ᐃᓄᕝ ᒪᓇ ᓇᐅᒥᐊᐃ, ᑲᑲ, ᑯᒪᒪᕐᑕᖃ, ᑭᒍᐊᕐᒪ,

Kiawat, Ottochie and Nawpachee. Among those who are living I have only one daughter, Nawpachee. Except for Kaka who lives in camp in the old way, they all live here in Cape Dorset, and now I live with Kumwartok and his wife.

On Akudluk Island, where Namoonie was born, there was good hunting. There were no caribou but there were polar bear, walrus and seal. But I did not care for Akudluk – my relatives were all around Cape Dorset, and it was too hard to get the white man's food from the Bay. We had no tea, only meat. After a year we went back to Cape Dorset for a short time, and then to Ikirasaq where we were in camp with Peter Pitseolak and lots of families. I don't remember them all or how many there were; in those days we didn't bother counting people.

But my husband used to be a very busy man with the hunting and he didn't like to live with other people. There are many days in the year and we moved many times – maybe ten times a year. We would often camp at Natsilik,

ᑐᑭ, ᓇᐸᕐᐊᓗ. ᑕᑯᓂᓯ ᐃᓄᕐᓄ ᐊᑕᐅᑉᒥ ᐱᓂᕐᓂ
ᐸᓂᖅᑐᒪ, ᓇᐸᕐᒥ. ᑲᑲ ᐱᓂᕐᓂ ᐃᖕᓗᑕᑲᑐᕐᑕᒥ ᐅᕐᓄᐊᐳ
ᓂᑐᑦ ᐃᓄᕐ. ᐃᓄᐊᓐ ᑕᒥᓗ ᑭᓕᒥᐅᒍᕐ ᐊᒪᓗ ᒪᓄ ᑯᒍᐊᑐ
ᑐᓂᒥᐅᒍᕐᓗ ᓄᑲᓗᓂᓗ ᓇᓇᖅᑕᕐᒪ.

ᐊᑯᓗᒥ, ᑕᐃᑲᓂ ᓇᒍᐊ ᐃᓄᒐᑐᕐᒪᓘ ᑕᐃᑲᓂ ᐅᒪᓴᑲᕐᐊ
ᓚᑐᑐ. ᑐᑐᑲᖕᓗᓂ ᐃᓚ ᓇᓄᖕᐸᓗᑐᑐ, ᐊᑕᖕᓂ ᐊᕐᓂᓗ.
ᐃᓚ ᐊᑯᓗᖕ ᐃᔅᕐᓚᑐᕐᓚᑕᒪ -- ᐃᓚᖕ ᐃᓄᐊᓐ ᑭᓕᓂᓚᑐᒪᓚᑕ
ᐊᒪᓗ ᐃᔅᐊᕐᓗᓄ ᑲᓄᑦ ᓂᑭᓗᓂ ᐱᕐᐊᖕᖅ ᓂᑐᐃᓂᓄᑕᓂ.
ᓂᑲᑐᕐᑐᒍ ᑕᐃᑲᓂ ᓂᑭᒥ ᐱᓂᕐᓂ. ᐊᓲᒍ ᐊᑕᐅᕐ ᐊᓄᒍᒪ
ᐅᓂᑲᑐᕐᒍ ᑭᓗ ᑭᑕ ᑕᐃᑲᓂᕐᓯ, ᐊᒪᓗ ᑕᒪᒪ ᐃᑭᖕᓗᒍ
ᓚᑲᑐᕐᑐᒍᔅ ᑕᐃᑲᓂ ᑐᐱᖕᒪᑲᓂᑲᓗᒍ ᐱᔅ ᐃᔅᐳᑕᕐᒥ ᐊᒪᓗ
ᐊᕐᐸᐊᓗᖕᓂ ᐃᓚᕐᓂᕐ. ᐊᐳᓚᕐᕐᑲᑲ ᐃᓄᐊᓐ ᐊᒪᓗᓄ ᑲᑐᖕᐊᖕᓄ
ᒪᒪᑦ ᐊᐳᓚᕐᕐᑐᒪ, ᑕᐊᕐᓗᖕᓂ ᑭᓂᔅᕐᐊᖕᖅ ᑲᒪᕐᓄᒪᓇᑦ.

ᑭᓕᐊᓄᑕ ᐅᐊᒪ ᐊᖕᕐᐊᓗ ᓄᑭᓚᕐᐊᑐᔭᑲᑐᕐᕐᒪᒥ ᐊᒍᓇᕐᐊᕐᓂ
ᑕᒪᒪ ᐃᐳᖕᐸᓚᑲᑐᕐᑐ ᓄᓇᑲᓂᑲᕐᐊᖕ ᐊᕐᓄᓂ ᐃᓄᓂ. ᐅᑲᓘ
ᐊᕐᕐᕐᐊᑲᑐᕐᐅ ᐊᓲᒍᒥ ᐊᒪᓗ ᓄᐸᕐᑕ ᐊᕐᕐᕐᑕ -- ᐃᒪᑲ
ᑕᓴ ᐃᑲᖕᓄᑕ ᐊᓲᒍᒥ ᓄᑲᑦᕐᑕᑦ. ᑐᐱᖕᓚᕐᑐᑕ ᓇᕐᓯᒥ,

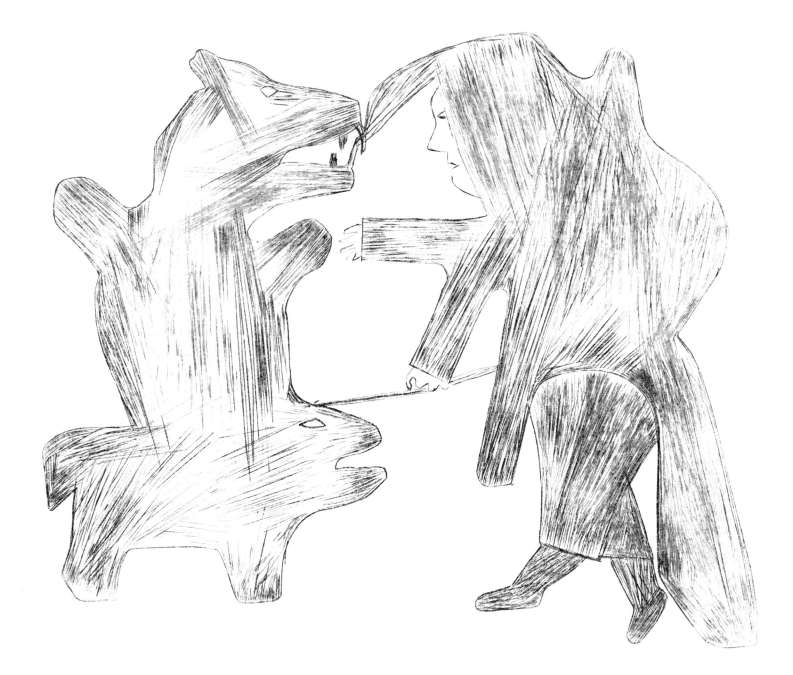

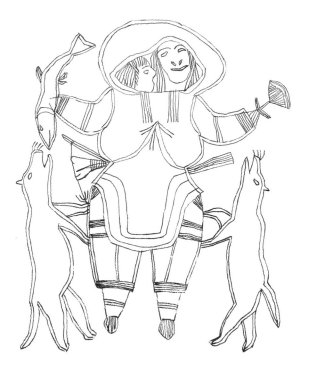

Woman and dogs.
Engraving, 1967

ᐊᖃᓇᖅ ᐱᕐᒍ
ᐅᑯᕐᓴᖅᒥ ᓴᔪᐊᒪ, 1967

a place about a week's journey from Cape Dorset, near many lakes. It had the most beautiful drinking water, the most beautiful water I have ever found. We often went to Natsilik to hunt fish; and at Natsilik, too, there were many geese. Later on, white people we met from the Department of Transport used to go there, too, and some of them called it 'Ashoona's Land'. Today, sometimes Namoonie still goes to Natsilik – but now he flies by plane.

Sometimes we went to the islands near Cape Dorset for seal and walrus. Spring and autumn are the best times for this kind of hunting.

Both in summer and winter we used to move a lot. In summer there were always very big mosquitoes. I have made many drawings of moving camp in summertime and I always put in the mosquitoes. I do not like insects.

Sometimes, when we camped in a place for the first time, we would put up an 'inukshuk'. My father and Ashoona

ᑕᐊ�” ᐱᐅᕐᐊᔨᔪᕐᓕᒥ ᐊᒥᕝᕋᐊᑕ ᖃᓕᓇ ᐱᐅᓂ ᑕᕐ ᐊᕐᕆ ᓴᓇᐊᓗ. ᑕᐃᑕᓇ ᐱᐅᓇᐸᕐᒥ ᐊᒥᕝᐅᑕ ᐊᒥᕐᐸ.ᐱᐅᓇᐸᒃ ᐊᒥᕐᐸ ᑕᐊᓕᐅᐅᕐᒥᐳᑕᐅᓯᓂᕐ ᐊᒥᕆᐊᑲᓂᐸ. ᐊᕐᓕᑐᐸᐅᑐᐊ ᐃᑲᓴᐊᑎᐊᑯᐊᑕ, ᐊᓗᑐ ᑕᐃᑕᓇ ᐊᕐᐸᓕᒥ ᐊᒪᕐᐊᑐᐃ ᓂᑲᐸᐅᑎᕐᓕᑕ. ᕐᐊᐳᑕᓇᑐᔪ ᖃᓴᐅᓇ ᑲᑎᑎᐊᑐᐱᓕᓴᔪ ᑕᑯᐊ ᐊᓯᑎᐊᓂ ᐊᖃᐊᐅᖅᑐ ᑕᐊᑐᓕᑲᑕᐊᑐᐱᓕᓴᑕᐅᐳ ᐊᓗᐅ ᐃᓂᑕ ᑕᐊᑐᐳᐁᓂᐅᑐᖅ ᐊᖃᕐᓂ ᓄᒪᓕ. ᓚᒪ ᐃᓯᐅᑕᕝ ᓇᐳᕐᓇᐃ ᕐᑕ ᐊᕐᓕᐊᔪᖅᑐᖅ ᐃᓯ ᓚᒪᕝ ᑲᓕᕐᐲᑐᐸ ᓂᒪᕝᑲᑐᖅ.

ᐃᓯᐅᑕᕝ ᖄᐁᐊᕝ ᖃᓴᓇ ᓄᐊᖅᐸᐅᑐᔪᕝ ᐊᓂᕐᕍᐅᑎᐊᕝᑕ, ᐊᐃᕐᐲᐅᑎᐊᕝᓕᕐᕐᑕᒍ. ᐅᐊᐳᕐᕝ ᐅᐱᐊᖃ ᕐᒍ ᐱᐅᓇᐸᔪᐊᓂ ᑕᓗᒍᒪ ᐊᖅᒪᕐᐊᓂ ᐊᒪᐊᕐᐊᓯᓂ.

ᑕᓚᐊᓂ ᐊᐳᖅᐸᕝ ᐅᐳᐊᑐᓗ ᐊᐳᓕᕐᐊᕐᐲᐅᐳᔪᕝ ᐊᒪᕐᐱᕐᐲᕝᑕ. ᐊᐳᖅᐸ ᑕᐊᒪᒪ ᐊᕐᕍᑐᓂ ᐱᓕᑐᐊᕝᐸᐅᐳ. ᓂᓂᑐᐲᕝᓕᕐᐊᒍ ᐊᐳᐊᑐᖅ ᓄᓇᐅᕝ ᐊᐳᖅᐸᑐᓗᒍ ᐊᓗ ᑕᓗᒪ ᐊᐃᕐᕍᕐᕝᒪ ᐱᓕᑐᐊᕐᖅ. ᐱᐅᖅᐲᑐᒪ ᑯᐱᓇᖅ.

ᐃᓯᐅᑐ ᑐᐱᕐᓕᕐᐊᕝ ᑐᐱᕐᓕᐊᑎᐊᓂ ᕐᐳᕐᒥ, ᐃᓕᕐᐱᕐᑕᐅᐱᕐᓕᕐᔪᕝ ᔪᕝ ᐃᓄᖅᓯᓂ. ᐊᑕᑕ ᐊᖅᕐᐊᓇ ᑕᓕᒥ ᐊᐱᕐᐊᕐᐊᑐᐱᕝ

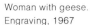

ᐊᕐᓇᖅ ᐊᒡᓗ ᓂᕐᑲᖅ
ᐅᒡᕈᓴᕐᒥ ᑎᑎᕋᒪ, 1967

both built them from time to time, and Kumwartok built
one a few weeks ago when he camped for the first time
at a new place near Akudluk Island. A few years ago
people from the Co-op built inukshuks above Cape Dorset,
and these reminded me of the ones we used to make and
I drew some for the prints.

In the old days we had different kinds of housing for the
different seasons. We had the igloo, the 'kaamuk', which
is a tent-hut, and the summer tents.

In winter I didn't mind whether we had an igloo or a kaamuk
so long as we had a shelter for our family.

To build an igloo you have to have the right snow, but what
kind of snow I don't know. Men built the igloos. I remember
when I was a little girl I once built an igloo myself, but it
was a funny-looking igloo – skinny and tall! Perhaps they
take an hour to build, but in those days we didn't have
watches. It is better to know the time. It used to be okay

ᑐᐱᖕᐊᐳᓂ ᐃᓂᕐᓭᐳᔪᑕᐅᑐ ᐊᒡᓗ ᖦᒡᕈᑐ ᐃᓂᕐᓭᐳᑕᐅᒥᑕ
ᐱᓂᕐᐊᐳᔪᖕ ᐊᒥᕐᕐᐅ ᖦᐱᒐᓂᓱᒥ ᑐᐱᖦᒐᒥᕐᕐᐊᑕᑎᓂ
ᓄᑕᒥ ᓄᒐᒥ ᐊᑕᖕᓐ ᖠᓴᐊᐱᓱ. ᐊᑕᒐᐃ ᐊᒥᕐᕐᐅ ᐊᓴᔪᕐ
ᒪᑎᓂᓱᒥ ᐃᓄᐃᑦ ᖦᑐᐊᕐᒥᑐᐦᑦ ᐃᓄᖅᕐᖦᐅᐳᕐᐱᒐᐦᐦ ᑭᓚᖅ
ᓄᓴᓂ ᐊᒡᓗ ᑕᖦᐊ ᐃᖦᐊᔪᑎᕐᖦᐅᐦᖠᖅ ᐃᓄᖅᕐᖦᐊᑎᕐᖦᐅᑕᓂ
ᑕᐊᒪ ᐃᓂᕐᓂᖦ ᑎᑎᑐᖦᐊᐳᑐᒪ ᐃᓂᓚᓂ ᐊᐳᖦᐊᕐᒪ.

ᐅᕐᖦᐊᑎᓂᖦᒍ ᐊᐱᕐᕐᔪᓂ ᐊᖦ ᖦᖦᖦᐳᑕᐅᑐᔪ ᐅᑭᐅ ᐅᐱᖦᐳ
ᐊᐳᖦᖦ. ᐊᐳᖦᑎᒥ ᐊᖦ ᖦᐊᓚᖦᒐᖦᑕ, ᖦᒍᒥ ᑐᐱᖦᓂᖦ ᖦᐊᒥ,
ᐊᒡᓗ ᐊᐳᖦᖦᒐ ᑐᐊᕐᖦᐅᔪᖦᖦ.

ᐅᑭᐅ ᖦᖦᐊᖦᖦᐳᑐᔪ ᕐᒥᕐ ᐊᐳᒥ ᐊᖦ ᖦᐊᓚᖦᖦᐳᐳᑕ
ᐅᖦᖦᖦᒥ ᖦᒍᒥᖦᖦᖦᖦ ᐊᖦᖦᐊᖦᖦ ᐅᖦᔪᖦᖦ ᖦᐳᓚᖦᓂᖦ.

ᐊᐳᖦᑎᒥ ᐊᖦ ᖦᐊᓚᖦᖦᐳᖦ ᖦᒪᖦᒥ ᐊᐳᖦᖦ ᐊᐳᖦᐊᖦᐳᖦ ᐊᖦ
ᖦᖦᐊᐳᒪᒪ ᐊᐳᖦ ᖦᐳᖦᒪᕐᖦᐳᖦ. ᐊᔪᖦ ᐊᖦ ᖦᐊᓚᖦᖦᐳᖦᒪᖦ.
ᐊᐳᖦᖦᖦ ᓂᖦᐊᐳᖦᐊᖦᖦᖦ ᐊᖦᖦᐊᓚᖦᖦᐳᑕᐅᐳᖦᒪᒪ ᐊᑐᖦᐊᖦᖦ
ᖦᖦᐊᖦᓂ ᐊᖦ ᖦᐊᓚᖦᖦᐳᖦᖦᖦᐳᑕᐅᐳᖦᖦᖦ -- ᐊᖦᑐᖦᒐᓂᖦ
ᑕᖦᖦᖦᐳᖦᖦᖦ! ᐊᖦᖦ ᐊᖦᐳᓂᖦᖦᒥ ᐊᖦ ᖦᐊᓚᖦᖦᐳᖦᒍᖦᐳᐳᖦ
ᐊᖦᖦ ᑕᐊᖦᖦᐊᓂᖦᒍ ᐅᐊᖦᖦᐊᖦᐳᖦᐊᖦ ᑕᖦᐊᖦᖦ. ᐱᐳᖦᐳ

without clocks, but it is okay with clocks, too. Now I am used to watching the time. The igloo would last all winter but often it would melt and drip inside from the heat of the kudlik. We used to dig a trench around the base to catch the water, and the women would scrape the soft snow from the walls inside with their 'ulus', the women's knives.

It was good to have a new snow house built because they were easy to clean – and very clean. But sometimes, if it was windy, the wind blew holes in the snow house, so perhaps the kaamuk was more comfortable.

To make the kaamuk, we would put up a tent and line the inside with wood. Between the tent and the wood we would put little bushes – sometimes blueberry bushes – to make it warm. I remember when Kumwartok, my son, got married. He and his wife were building the hut and she was carrying the bushes on her back. They were too heavy for her and she fell down, covered in bushes. They laughed. They were happy, building the hut together.

ᑎᔪ ᑲᖅᒍᒪᒪ ᑲᐅᕆᒥᒐᐊᔭ. ᑲᓴᐊᔅᑲᐅᑉᒥᕋ ᓯᑉᒍᔪᖃᒪᑕ ᐃᓇ ᑲᓂᐊᑉᒥᔤᑊ ᓯᑉᒍᔪᖃᓱᓂ. ᒪᓇ ᓯᑉᐅᔦᒪᑕᐅᒪᒪ ᑲᐅᕆᒥᕋᔭ ᑲᖅᒍᒪᒪ. ᐃᑊ ᔭᐊᒪ ᐅᑉᐅᑕᒥᖵ ᐊᑐᒐᐊᑕᐅᑐ ᐃᓂ ᑭᕐᐊᓂ ᐃᑊ ᔭᐊᒪ ᐊᑊᐊᑊᐅᑐ ᐊᕐᖵᔪᖔᓱᓂ ᐃᔪᐊᒍᔅ ᐊᑊᐅᑊ ᐅᑯᓱᓂᖅ. ᐳᐊᑎᖵᔅᐊᑐᑐᒍ ᐃᔪᐊᒪ ᑲᒥᒐᑲᐊᕐᑕ ᐃᒥᑎᑲᐊᒐᕐᒍ ᐊᒪᓗ ᐊᑊᖔᐊᑊ ᐱᔭᐊ᙭ᑐᑊ ᐊᐅᑎᖔᕐᑎ ᐊᑭᔭᒥ ᐊᑊᖔᒥ ᐃᑊ ᔭᐊᓯᐅᑊ ᐃᔪᖔᓂ ᐅᔪᒥᔤ. ᐱᐊ᙭ᑐᐊᔭ ᔭᑊᒥ ᐃᑊ ᔭᐊᒪᑲᖵᒍᒐᐊᔭ ᓱᓗᓯᕐᔭᒪ ᐊᑲᐅᐊ᙭ᑐᐊᕌᑕ, ᐊᒪᓗ ᓱᓕᕐᐊᔪᒥᖔᑊ. ᐃᓂᓱᐅᑕᑊ ᑭᕐᐊᓂ ᐊᔪᓴᓕᐊᒪᑊ ᕆᐳᐊᓯᑎ ᑭᓯ ᐊᐅᒥ ᐃᑊ ᔭᐊᒪᒥ ᑕᐊᒪ ᐊᒪᑊ ᑲᓇ ᑲᒍᑊ ᐊᕆᐊᓯᖄᐳᐃᓴᒥᑊ.

ᑲᒍᑐᐊᕐᑕ ᑐᐱᓴᐅᑲᐅᑐᒍ, ᐊᒪᓗ ᑐᑭᔪᐊᑐᓂᑊ ᐃᓂᐊᔪᓯ ᕆᐊᑕᐊᕆᒍ. ᐊᑐᓂᔪᐊᓂᑊ ᑐᐱᑊ ᕆᔪᓇ ᓄᐊᖃᐱᐊᑕᕆᒍ -- ᐃᓂᓱ ᐊᐳᐃᑯᐊᐱᓂ ᓄᐊᖃᑲᐊᕆᒍ ᐅᑯᔪᐱᐊᓕᒥᑊ. ᐊᐳᓕᕐᐊᔪ ᑕᐊᕆᓇᒥ ᐃᑊᐊᓇᒪ ᑯᒐᔭᐊᐊ, ᓄᐊᐊᑐᓕᒥ ᓄᐊᐊᓗ ᐃᑊ ᔪᑊᐳᐃᓴ ᐅᕆᓕᔪ ᑲᓯᒥ ᑕᐊᒪ ᓄᐊᐊᔪ ᐊᓂᓕᑕᐅᕆᓕᔪ ᓄᐊᖔᓂ. ᓄᐊᖔᓂ ᐊᓕᑊᖔᓂ ᐅᑯᓗᐊᖔᓱᐊᓕᒥ ᐊᓕᑊᖔᓂ ᐸᓴᑎᑐᑲᐅᔪᓕᔪ ᓗᐊᓗ ᓂ ᓄᐊᖔᓂᑊ. ᐃᓯᓕᐅᔪᓕᔪ ᐊᔪᓕᐅᔪᓕᔪ. ᑯᐱᐊᕐᐱᖃᐊᑐᑊ, ᐃᑊ ᔪᓕᐅᑐᑎ ᑲᒍᑊ ᑲᑐᕆᑎᓂᑊ.

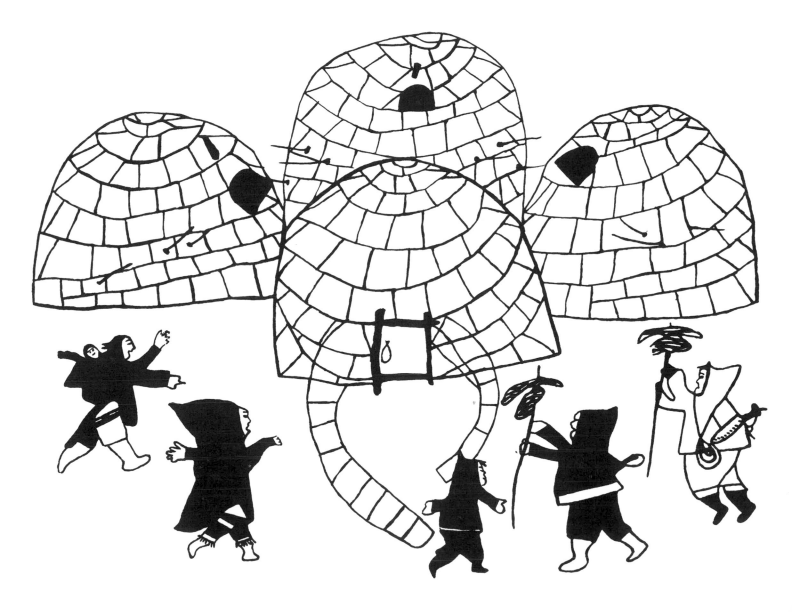

In summer I lived in a great big
sealskin tent (detail).
Felt pen, 1970

ᐊᐅᔭᒃ ᐅ�">< ᑭᓯᒪ ᑐᐱᕐᐸᓚᐅᑐᒪ
ᐃᓗᓯᓗ ᐊᓚᐅᓇᒍ ᓇᓇᑐᒪ ᓚᒥ, 1970

In the kaamuk we put a window. We made the window
from the intestine of the whale. We would clean it and blow
it up with air and hang it up to dry in long pieces. This
made a good window. It was also from the whale intestine
that we made sails for the sealskin boats.

In the summers before I was married I lived in a great
big sealskin tent made from the 'udjuk', the square-flipper
seal. These tents were so large they used to be used by
two families. Inside there was a great room and usually
the children slept on the 'kilu', the sleeping platform, at
the back of the tent and far away from the door. The
grown-ups slept just in front of the kilu on the 'ilukatigit',
which means 'both sides of the tent'. This was a sleeping
platform for two families or four grown-ups.

The sealskin tent was changed every summer because
it would dry out and then it was very hard to use. I used to
see my mother make these tents. She would scrape
the udjuk three times with the ulu and sew the skins on

ᑲᒥᒥ ᐃᑉ ᔪᓚᐅᕐᑕ ᐃᓗᓚᓚᐅᐸᓚᐅᑐᒍ. ᐃᓗᓚᓚᐅᕐᑕ ᐊᑐᕘᓚ
ᐅᑐᒍ ᑭᓕᓗᐃᐄ ᐊᑭᐊᒍᓚᓂ.ᓴᓗᓕᓴᐸᕐᒍ ᐊᓚᓗ ᓇᓗᑐᐸᕐᒍ
ᓯᓕᒥ ᑲᓚᑕᓚᕐᒍ ᐸᓂᕐᐊᑎᕐᒍ ᑕᐸᕈᐱᑎᓇᒍ. ᑲᓇ
ᐃᓚᓇᕐᐊᒍᐸᓚᐅᕐᑐᑉ. ᐊᓚᐅᑕᑉ ᑭᓚᐅᑉᕐ ᐊᐸᐊᓗᕐᑉ
(ᐃᑉᕐᓚᓂ) ᓂᑎᓴᐸᑕᐄᐅᐸᓚᐅᑐᒍ ᑭᓂ ᐅᒥᐊᓂ ᓂᑎᓴᐸᑕ
ᓚᐊᑎᕐᕐᑕ.

ᐊᐅᔭᒃ ᐅᐃᓚᓚᐅᑕᓇᒪ ᐊᓇᓴᑲᓚᐅᕐᐸᓚᐊᒍ ᐊᕐᐊᐊᒏᕐ ᑭᕐᕐ
ᐅᕘᑉ ᑭᓯᒪ. ᑲᑯᐊ ᑐᐱᐊᑭ ᐊᕐᐊᐊᓂᐊᑉᐸᓚᐅᑐ ᐊᑐᑕᐸᓚᐅᑐ
ᓚᒪᐊᕐᒃ ᑭᑐᓚᓂᐊ. ᐃᓂᐊᐅᕐ ᐊᕐᐊᐊᓂᕐ ᐃᓇᑲᓯᐊ ᐊᓚᐊ
ᐱᐊᓴᐃ ᑭᓂᕐᓂ ᕐᓯᐊᑲᓯᐊ ᑭᓂᓕᐅᑕᐅᐸᓚᐅᑐ. ᐃᓐ ᐃᓇᓂᑎ
ᕐᓯᐊᑲᐅᑐ ᑭᓂ ᓴᓚᓂ ᑭᕐᕐᓂᐊ. ᐃᑉ ᓚᑲᓂᕐᕐᑕ ᕐᓂᑲᓂᕐᐊ
ᐅᐊᑲᐅᑐ ᓚᒪᐊᓂ ᑭᑐᓚᓂᐊ ᐅᐊᓚᓂ ᕐᑲᓚᓂ ᐃᓂᓕᓂᐊ.

ᓇᕐᐅᕐ ᑭᕐᕐ ᑐᐱᑉ ᐊᐱᐊᓂᑲᑉᐸᓚᐅᑐ ᐊᐅᓯᑲᓕᕐ ᐸᓂᔪᐊᓯ
ᐊᕐᒪ ᐊᓚᓗ ᐊᑭᐅᓂᔪᓚᓂᐊᓴᓯᓂ ᐊᑐᓇᐊᒪ. ᑲᑕᓇᓂᐸᐅᑐᓕ
ᐊᓂᓂᑉ ᑲᐃᓚᐊᑐᒥ ᑐᐱᓯᐅᑐᒥ. ᐅᑉᕐᐅᐊᓯᐊᓂᕐ ᓴᑯᕐᓂᓇ

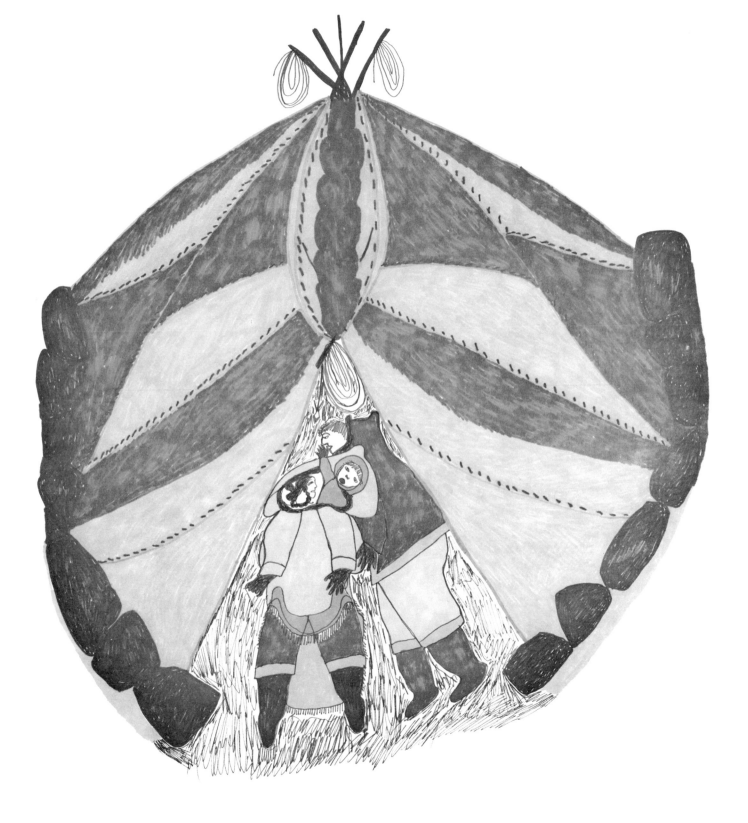

Talilayu who keeps the sea animals
away from the hunters.
Felt pen, ca. 1967

ᑕᓪᓕᐊᖅ ᐊᓘᐸ ᐅᒪᔪᓂᖅ ᐅᒪᔪᓇᐊ
ᑎᓄᖅ ᐃᖅᐅᒐᐊᑎᠭᠭᐅ ᐊᓪᒪᖕ ᐊᓕᐅᑎ
ᒧᖅ ᑎᑎᐅᒪ, 1967 ᐅᑎᠶᒧ

We used to hang up the intestine
of the whale in long strips to dry.
Felt pen, ca. 1967

ᑭᠶᓪᐊᖅ ᐊᐊᓯᐊᕐᖅ ᐸᖅᠶᐸᖅᐅᐅᒧ
ᐊᓪᒪᖕ ᐊᐸᐅᑎ ᑎᑎᐅᒪ,
1967 ᐅᑎᠶᒧ

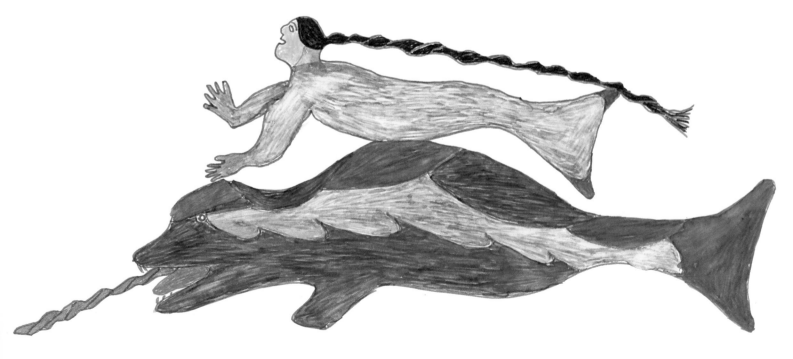

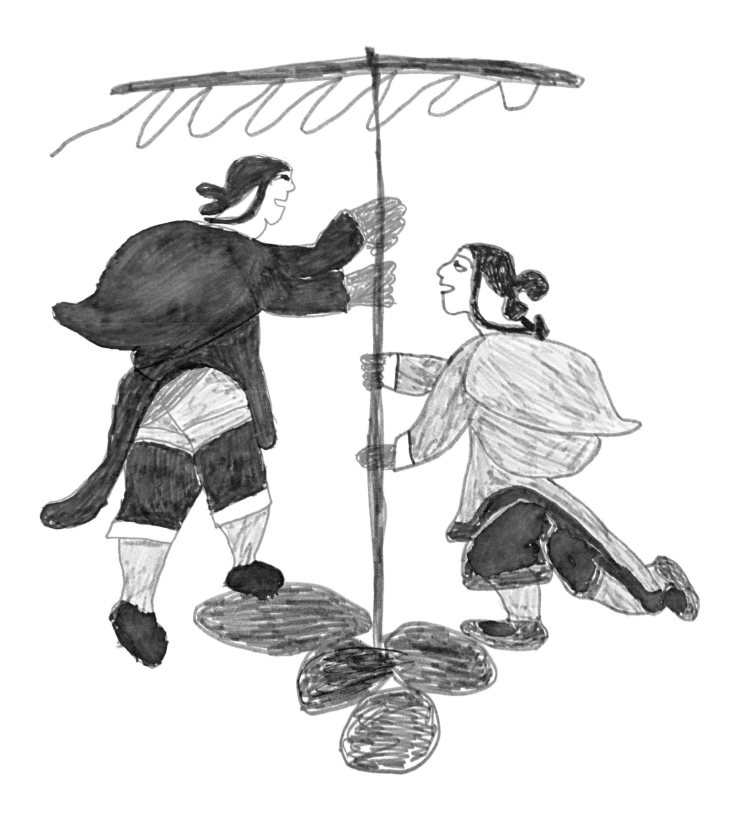

the ground. These skins could dry out very quickly, too, so damp moss would be brought from the tundra to cover them as she worked.

The first year I was married I made a sealskin tent just for our family. I made only this one because, at the time, my mother used to stay in turns in our camp and in the camps of her sons. She would help me with all the sewing. Every year she made us a tent. Then, when I had four children, they began to sell canvas at the Bay. Ashoona was always able to buy canvas and so, after this, I made canvas tents. The last tents I made were for Jim Houston when he was here. One summer a group of white people – I think they were the first tourists – came and spent all summer camping here outside Cape Dorset. Eskimo families went and lived with them. I made about six tents.

In the old way, of course, women also made the boats. I never sewed for a sealskin boat but I used to sew for the

ᐅᖃᖅᒥ ᐱᒪᕐᐱᕆ ᐅᔪᒥᓄᑦ ᒥᕐᑕᒪᕐᒡ ᑭᕆ. ᑕᒃᐊ ᐱᕆᑦ
ᐸᓱᖅᐅᑎᕐ ᐊᔮᒍᒪᕐᔕᑕᐅᑉ ᑕᐅᒪ ᑿᐅᕐᑐᑉ ᖃᐊᖅᓲᖅ ᐊᑉᒐᑎ
ᕐᔖᑐᔾ ᖃᐊᖅᓲᒥᑦ ᑎᕐᖏ ᒪᔾᕐᒍ ᑕᐊᒪ ᐱᐊᕐᕚᑲᐅᑉᒃ.

ᕐᔖᑦᕈᕐ ᐊᖠᒥ ᐅᐊᓄᒃᒥᕐᐅᕆ ᓇᕐᕚᒥ ᑭᕐᒥ ᑐᐊᑕᐅᑕᕐᕆ
ᒪᕐᒫ ᑭᒍᓝᒍᑦ ᑭᕐᐊᓂ ᑐᐊᖅᓄᓕ. ᑕᓇ ᖃᓇᑕᐅᕐᒪᖠᒪ
ᑭᕐᐊᓂ ᑕᐊᕐᒪᓚᐅᑎᓲᒍ ᐊᓇᐊᒪ ᑐᐱᓄᕐᑕ ᑲᓕᑐᕐᕪᒪ ᐊᒪᓚ
ᐊᕐᓂᕐᑕ ᑐᐱᕐᓇᕐᕚᕐᓇ. ᐊᑐᕐᒃ ᑲᑕᐅᕐᕪᒪᓕ ᐱᐊᕐᒪᓱᑲᓚᓂ.
ᐊᖠᒍᑕᑎᕐ ᑐᐱᕐᐅᒃ ᑲᑕᐅᕐᕪᓚ ᐅᕐᒍᓂ. ᑕᐊᒪ ᑕᐊᕐᓗᓇ
ᕐᑕᓚᓄᕐᒃ ᐱᐊᖅᓱᑲᓕᒍᓪ, ᑐᐊᕐᓱᒥᕐ ᓄᐅᐱᐊᕐᖃᕐᕪᑲᐅᕐᕪᕐᕚᕐᒃ
ᓄᐅᐱᐊᕐᒥ. ᐊᕐ ᕪᐊᕐᒃ ᑕᐊᒪᒪ ᓄᐅᐱᐱᐊᒪᖅᓱᑲᐅᑉᒃ ᐊᒪᓚ ᑕᐊᒪ
ᑐᐊᕐᓱᑲᓚᕐᒍᒪᒪ ᑐᐱᕐᐅᕐᕚᕐᓗᓚᑕᐅᑐᓚ. ᑭᔨᕐᒥ ᑐᐊᕐᖠᒪ ᖃᓚᑕᐅᕐ
ᕐᒪᓱᑲ ᓱᐅᕐᒍ ᓱᐊᕐᕪ ᐊᕐᕐᑲᖕ−ᒍ ᑕᑕᓇᕐᒍᒍ. ᐊᐅᕪᑕᐸ
ᖃᓄᒐᕐ ᐱᑲᓄᕐᕪᑎ ᓂᐱᕐᑲᐅᕐᕪᓚ ᑕᑕᐊᒪ ᕐᔖᑦᕈᐱᕐᑲᐅᕐᕪᑐᓚᑐ
ᓄᐅᕐᕪᑲᓕᕐᓄᕐᒃ−ᓂᐱᕐᒥ ᑕᑕᓇᕐᒍᒪᐱᕐᕪᓚ ᐊᐅᕪᒡᑎᕐᒪ ᑐᐊᕪᕐᑎᓇ
ᑕᑕᓇ ᐱᑕᐊᑦ ᕪᑲᓇ. ᐊᒪᓄᕐ ᑭᔪᑭᓇᓄ ᐊᐊᐱᑲᐅᕐᕪᓚᕪᑕ
ᑐᐊᕪᒪᑲᑎᕐᕪᐊᕐᕪ. ᐱᑕᐊᕐᓱᑲᐅᕐᕪᓚᓱᑲ ᐱᒪᕐᕐᑕᑲᑐᓄᕐᒃ.

ᐅᕪᕐᐊᑐᓄᕐᒃᓄ, ᕪᑲᐊᒪ, ᐊᕐᖃᐊᑲᐅᐱ ᒥᕐᑲᐅᑉᒪᕐᓪᑦ.
ᒥᕐᑲᐅᕐᕪᓚᓱᑐᓚᑕ ᖃᕆᐱᑦ ᑭᕪᓄᕐᒪ ᐅᒥᐊᕐᒥ ᖃᐊᕐᒥ ᑭᕐᐊᓂ

We would sew covers for kayaks with sinew from the caribou leg muscle.
Coloured pencil and felt pen, ca. 1967

ᑲᕐᑲᐅᑕᐅᑕᑦ ᑐᑐᑦ ᓗᕆᓯᓂᑦ ᐃᕿᖕᑲᑦ
ᓚᐅᑐᔾᑦ ᑦᑦᓯᓚᓂ ᐊᕐᐅᐱᓄᑦ ᐊᒪ
ᐊᒪᓚᒍ ᑎᑎᐅᒪ, I967 ᐅᑦᒍ

kayaks. In the old days, usually the women would row the sealskin boat and the men would go in the kayaks. In one drawing, I have shown the women's boat towing a kayak. If it became rough they would take the kayak-man aboard. In this print, all around the boats are little pests. What are they doing there? It is their business to be there. Did Eskimos believe in spirits and pests and monsters? Maybe they did. In the old days there was much to fear.

In the old days I was never done with the sewing. There were the tents and the kayaks, and there were all the clothes which were made from the different skins – seal, caribou and walrus. From skins we also made cups for drinking and buckets for carrying water. And when we caught geese we used to make brooms for cleaning from the wings which we bound together. If we had enough brooms we would throw the wings away.

As soon as I was finished sewing one thing, I was always sewing another. Sometimes, when I was very busy with

ᒥᕐᓴᑲᐅᑐᒪ. ᐅᕐᕆᐊᑎᓄᒍ ᐊᖃᓇᐃᑦ ᐸᕿᑲᐅᑐ ᓇᕐᐅᑦ
ᕿᕐᓂᑦ ᐅᒥᐊᕆ ᐊᒪ ᐊᒍᑎᑦ ᑲᓴᑐᑎᓂᕐᑦ. ᐊᑕᐅᕐᒥᑦ
ᑎᑎᖃᕐᒪᓚᕆ ᐅᖓᓱᕆᒪᓚᕆ ᑎᑎᖃᕐᒥ ᓴᓄᕐᓚᕐᑲ ᑕᖅᖅ
ᑎᕐᕐᒪ ᐊᖃᓇᐃᑦ ᐅᒥᐊᒪ ᐅᓇᑐᖃ ᑲᕐᒐᕐ. ᐊᑯᓇᑐᐊᒪᑦ
ᐊᖃᓇᐃᑦ ᐊᕿᑎᕐᐵᐅᑐᑦ ᑲᕐᑐᑐᖃ. ᑕᕆᒪ ᑎᑎᖃᕐᒥ,
ᐃᓄᒍ ᐅᒥᐊᕆᑦ ᒥᕿᑦᐊᒍᕐ ᐅᒪᕐᑕᖃᓂ. ᕐᓇᕐᐊᐃᑦ
ᑕᐃᑲᓂ? ᐃᖃᓇᐃᕐᓄᓕᕐᒪᑦ ᑕᐃᑲᓂ. ᐃᐊᐃᑦ ᐅᐱᓐᑲᑦ
ᐊᑦᑐ ᐅᒪᕐᒍ ᐃᓄᖓᖓ? ᐊᒪᑲ ᐅᐱᑐᐊᓂ. ᐅᕐᕆᐊᑎ
ᓂᒍ ᐊᕿᓇᑐᐊᑐᑲᕐᑲᐅᒪ. ᐅᕐᕆᐊᑎᓄᒍ ᒥᕐᕆᒍᑦᕿᑲᐅᑐᒍ.
ᑐᐱᑲᕐᑲᐅᑐᒍ ᑲᕐᓇᓂ ᐊᒪ ᐃᐊᒥ ᐊᖃᓇ ᓴᕐᕿᑐ
ᐊᕿᕐᕆᑐᑦ ᕿᕐᓇᐊᓇᓂ, ᑐᑦᓂ, ᐊᐅᓯᓂ. ᕿᕿᐊᓂᑦ
ᓴᐊᕿᐅᕐᕿᒍᑦ ᐊᕿᑐᑎᕿᐅᕐᑦ ᐊᕿᑕᐅᑎᕿᐅᕐᑕ. ᐊᒪ
ᑲᒍᑕᑦ ᓴᓇᐅᑎᕿᐅᕿᑲᐅᕿᒍᑦ ᐃᕿᕐᕿᓂ ᑲᑎᕐᑦ ᓴᓇᐅᑐ
ᕿᑲᐅᑐ. ᓴᓇᐅᑎᓂ ᓇᓗᑐᑲᑐᐊᑦ ᐃᕿᕿ ᐊᕆᕿᑲᐅᑕᑕ.

ᐊᑕᐅᕿᒥ ᒥᕿᑎᑐᐊᒪᒪ, ᐊᕿᐊᓇ ᒥᕿᑎᐊᕿᕿᑲᐅᑐᒪ ᑕᐊᒪ.
ᐃᓇᓇᒍ ᐊᕿᕿᐊᓗ ᒥᕿᓗᐊᕿᒪᒪ ᐅᐊᓂᑦ ᐊᕿᕿᑐᐊᕿᑲᐅᑐᒪ.
ᐊᑎᕿᐅᑎᓄᒪ ᐃᕿᕿᐊᕿᑲᐅᑕᒪ.

Happy girls.
Felt pen, ca. 1967

A bird from my mind.
Felt pen, 1968

ᓂᐱᐊᕈᔭᖅ ᕿᐱᐊᕈᒃᑐᖅ
ᐃᒪᓕᒐ ᐊᓕᐅᑎᒍᑕ ᑎᑎᕋᒐ,
Ⅰ967 ᐅᑎᒍ

ᐃᓯᒪᒪᓂ ᕿᑉᓄᐊᖅ
ᐊᓕᐅᑎᒍ ᐃᒪᓕᒐ ᑎᑎᕋᒐ, Ⅰ968

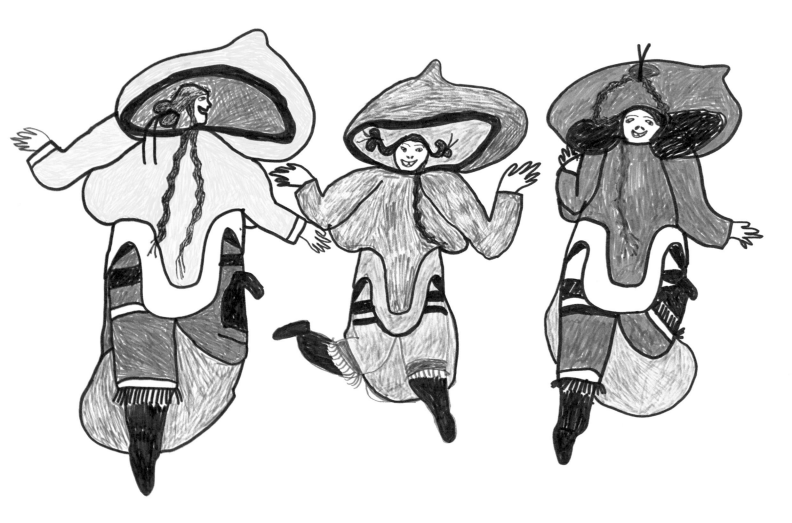

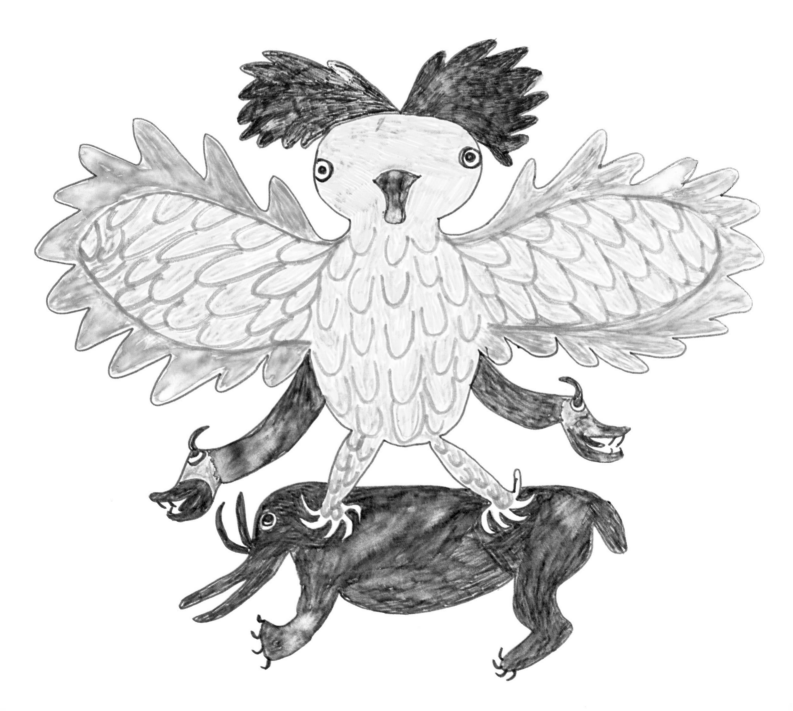

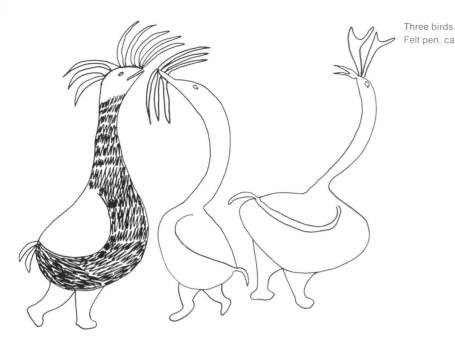

Three birds.
Felt pen, ca. 1967

ᑯᐸᓄᐊᶜ ᐱᒦᶜ
ᐊᒪᒐᒍ ᐊᓴᐅᑎ ᑎᑎᒪ,
1967 ᐅᓈᒍ

the sewing, my husband would help me. He used to help me with the parkas.

This is how we used to make our clothing. The men would take the skins from the animals and the women would scrape them with the ulus. When I was a young girl and had just married, I did my first sealskin, which was a young, square-flipper seal. I was scraping this seal very quickly and, when it was finished and I stretched it for drying, I saw hundreds of holes! The skin had not been done properly. But I did not do that twice. I tried hard to learn how to sew because I envied the women who could sew nicely. We bought needles from the Bay but we made thread from the whale muscle which was soaked in sea-water and we also used strips of the caribou skin. The clothes could be made out of any kind of skin – caribou, seal or walrus – but I liked the lovely caribou best.

We also had duffel. I do not remember exactly when the duffel came, but I remember having a duffel parka as a

ᑖᐃᓇᑕᒪ ᐊᓐᒐᓇ ᓴᓇᶜᐊᐅᒍ ᒍᶜ. ᐊᒍᓐᶜ ᐱᓯᶜᐊᐅᒍᶜ
ᐅᒪᐊᓲᵇ ᐊᒦᓲᵇ ᐱᓯᓄᵇ ᐊᒪ ᐊᵇ ᐊᐃᶜ ᑭᓯᓐᶜᐊᐅᑎ
ᐅᵇ ᔪᒍ. ᑖᐊᓚᓲ ᓄ ᐊᓴᔪ ᐊᒍᓲ ᐅᐊ ᑭᒥᐅᐊᒥᓲ ᔪᑉᶜᐊᒦ
ᓇᓯᐅᶜ ᑭᒦᓴᓄ ᓇᓲ ᐊᵇ ᑭᓯᓐᶜ ᐊᐅᒪᓲ ᑖᒥᒪ ᑭᓯᒥᵇ
ᐊᵇ ᓲᓗ ᓲᵇᓴᒪ ᑖᒪᓚ ᐱᓯᓐ ᔪᒍᐊ ᐊᓄ ᑭᓯ ᐅᒪᓲᓴᵇ ᐸᓄᐊ ᓂᔪ
ᓲ ᒍ, ᑖᑖ ᑭᓯᐅᒦᓲ ᑭ ᑭ ᓯᐊᓯ ᐊᒦ ᔪᓓ ᔪ ᓄᵇ! ᑕᓇ ᑭᓯᵇ
ᐱᓴᓲᓂ ᑖᓲ. ᐊᓄ ᑖᒪᐊᓂ ᓯᐊᑎᔪᓲ ᒍ ᐳᒍ ᓚᒦ. ᐊᓄ ᔪ
ᐊᒍᓲᔪᓲᓐ ᓴᓲᐊᒍ ᐱᒦᒪ ᐱ ᓓᒪᒪ ᔪᵇ ᓄᵇ ᒣᔪᓲᔪ ᓲ ᐅᔪᵇ.
ᓄᐅᓄᓲᓲᶜ ᒣᔪᓄᵇ ᓄᐅᓄᓂ ᑭᓲᓄ ᓯ ᐊᓕᓲᐅᓲᓲᐅᒍ ᔪᶜ
ᑭᓴᓲᐅᶜ ᓇᑭᓄ ᑭᓇᓲᓐᓴᒍ ᑖᓐᒍ ᐊᒪᒍ ᐊᒪᓲᑖᵇ
ᔪᒍᓴᐅᒦᓴᒍ ᒍᒍᶜ ᐊᓲᓄᓄ. ᐊᔪᓲᐅᓲᓴᐅᒍᒍ ᓇᓄᐊᓄ
ᑭᓲᓄᵇ -- ᒍᒍᓲᓄ ᓂᓯᓄ ᔪᐊᓄᓂᒦᓄ ᐊᓄ ᒍᒍᓲᵇ
ᐱᐅᓲᓄᓲᐅᑖᐊᐅᒦᓴᒍ.

ᐊᒍᑭᓲᓲᵇᓴᐊᐅᒦᓴᒍᑖᵇ. ᐊᒍᓚᓲᓐᒍᒪ ᵇᒪ ᐊᒍᑭᓲᵇ
ᓂᑭᓲᒪᒪ, ᐊᓄ ᐊᒍᓚᓲᒪ ᐊᒍᑭᵇᓲᒦ ᐊᒍᑭᓲᓲᒣ ᓄ ᐊᓴᔪᐊ

Overleaf: ᒪᐱᑕᖁ ᑐᒡᓕᐊ

This is how we played tennis. ᐃᒪ ᐸᑦᑲᓗᑐᑐᒡ
Felt pen, 1970 ᐃᒪᓂᒧᐊ ᐊᓄᐳᕐᒍᑦ ᓐᑐᒪ, 1970

In summer there were always ᐊᐳᖕᒥ ᐊᒐᗼᓴᓂ ᑭᑐᓐᐊᖴᖃᐳᑕ
very big mosquitoes. ᐃᒪᓂᒧᐊ ᐊᓄᐳᓐᒍ ᓐᑐᒪ, 1970
Felt pen, 1970

little girl. Probably, when the Hudson's Bay post came
here, the duffel came along with the company. The duffel
was used for the inner parka and for the duffel socks.

Each person wore two parkas. Before the duffel came, the
first parka, the one nearest the skin, had the fur touching
the skin, while the outer parka had the caribou hair outside.
When the duffel came, we used it inside. We didn't
have money often – we bought the duffel with fox skins.

When I made a parka I used to try to make it the way I
wanted it to look. I would try to make it look very good. It
was not easy and I used to sew on a parka for many days.
We always used the finest skin of the young caribou for
the head of the parka and, on top, we would put little ears
from the baby caribou. It looked very nice. I would also
make patterns and designs with different-coloured skins.

Before we started living in one place, as we do now, we
used to walk very long distances and the boots would wear

ᓀᓱᕐᒪ. ᐃᒪᖅ ᓐᑭᑐᕼᑐᔾᐊᓂ ᓂᑐᐱᓐᑯ ᓐᑭᓐᓱᕐ ᑕᒪᐱᒪ,
ᐊᓐᕐᕼᗼ ᓐᑭᖅᑕᐳᑯᑐᐃᓂ ᓂᑐᐱᓐᑯᓱ. ᐊᓐᕐᕼᗼ ᐊᓐᕐᐳᕫ
ᐃᓴᐊᓂᓱᒍ ᐊᑐᑕᐳᕫᑐᐳ ᐊᒪᓱ ᐊᓭᓐᓭᐊᓐᕓᒍ.

ᐊᑕᐳᕫ ᐃᓄᕫ ᐊᓐᕸᓂᕫ ᒪᓱᕫ ᐊᑐᕫᓱᐳᕫ. ᐊᓐᕐᕼᕸ
ᓐᑭᓱᐳᓐᓱᒍ, ᕫᐳᓂᕫ ᐊᓐᕸ, ᐳᐊᓂᒍ ᖃᓂᓂᕫ ᒥᒍᖃᓐᓱᒍ,
ᒥᒍᓂ ᐳᐊᓂᒍ ᐊᑐᐊᓐᓱᒍ, ᕫᓂᕫᒪ ᐊᓐᕫᐳ ᑐᑐᕼᐳᕫ ᒥᒍᕫ
ᕫᓂᕫᐊᓂᕫᕫᕫ. ᐊᓐᕐᕼᗼ ᓐᑭᒪ ᐊᑐᕫᓂᐳᕽᕫ ᐃᓴᐊᓐᕓᒍ.
ᕍᓂᐳᕼᓂᐳᕼᐊᕫ ᓂᐳᐊᕫᐳᕫᒍ ᐊᓐᕐᕼᗼᕼ ᓐᓐᓂᓂᐊᕼᓂᕫ.

ᐊᓐᕐᕸᐳᕫᐊᒪᒪ ᐊᕫᕼᐊᓯᕫᐊᕫᐳᕫᒪ ᖃᓂᐊᕫᑯᕫᓂ. ᐊᕫᕼᐊ
ᓂᕫᐊᕫᐳᕫᒪ ᐊᕫᕫᕼᕫᓱ ᐱᐳᕫᕫᐊᓐᓂᕫᒍ. ᐱᕫᐊᓯᓐᕫᐳᐳ
ᕫᓂᕫᕫ ᐊᒪᓱ ᕍᕫᕫᐳᕫᒪ ᐊᓐᕸᕫ ᐳᕫᓱᕫ ᐊᕫᕫᕫᕫ.
ᑕᐊᒪᒪᒪᓱ ᐊᑐᕫᕫᐳᕫᒍᕫ ᐱᐳᕫᕫᕫ ᑐᕫᐊᒪᕫ ᐊᕫᕼᕫᐊᓐᕓᒍ
ᐊᓐᕐᒍᕫ ᐊᒪᓱ ᕫᒪᕫᕼᕫᒪ ᑐᕫᖃᐳᕫ ᕫᕫᐳᕫᕫᓂᕫᕫ.
ᐱᐳᗼᕫᓱᕫᐳᕫᕫ. ᐳᕫ ᑐᕫᑐᐳᕫᐳᕫᕼᕫᒍᕫ ᐊᕫᕫᕼᒪᕫᓂᕫᓱ
ᐊᕫᕫᕫᓱ ᑕᕫᕫᕫᓐᓱᕫ ᑐᕫᕫᐊᕫ.

ᐊᑐᐳᕫᕼᐊᒪᕫᕫᐊᕫᕫ ᓄᒪᕫ ᑕᐊᒪᓂᐊᕫᒪᕫ ᒪᓱ ᐱᕫᕇᐳᕫᒍ
ᐳᕫᕫᐊᒍᕫ ᕫᕫᓱᓱ ᕫᕫᕼᐳᓐᕫ ᐊᐱᕫᕫᓐ. ᐱᕼᓐᕫᐳᕫᕫᕫᐳ

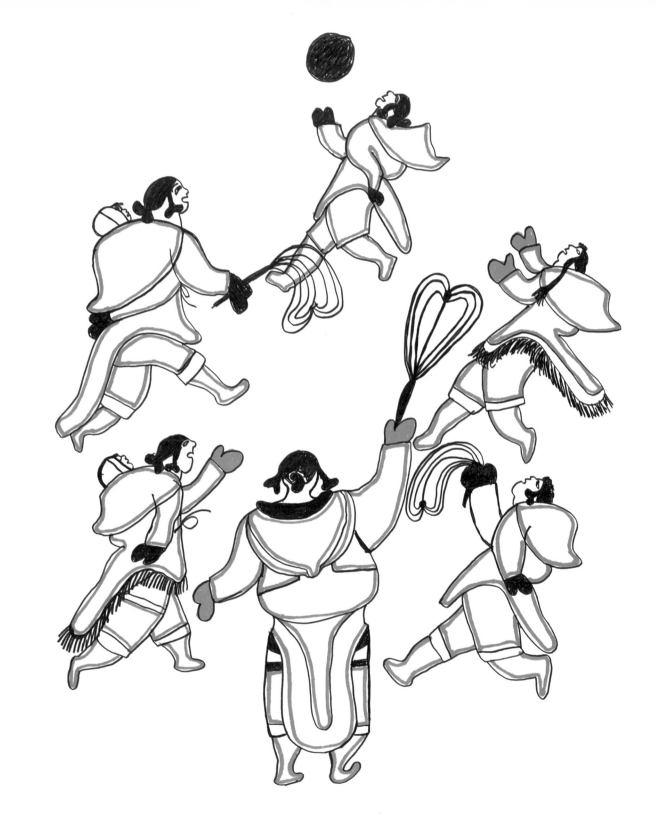

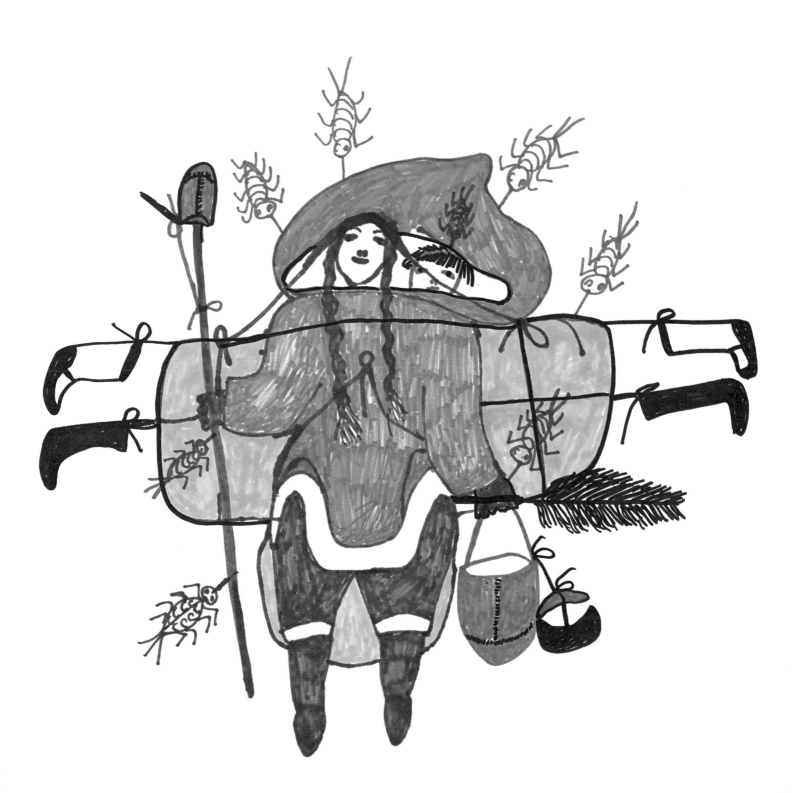

On top of the parka we put
little ears from the baby caribou.
Felt pen, 1970

Engraving, 1962

�ᐅᐳᐱᐅᐸᑦ ᒥᐅᐱᑎᒥᖕ ᐊᑎᑕᐱᑦ ᓇᒥᓓᖃ
ᓯᐸᑕᐅᐱᒐᑦ ᐃᓃᕝᒐᖕ ᐊᖃᐱᑕᖕ
ᑎᑎᐱᒪ, 1970

ᐅᔨᖕᑕᖕᒥ ᓇᕆᐊᒪᐅ, 1962

out quickly. I was never finished with making mukluks.
I also would make new soles and sew them on the worn
boots. For boots we used only sealskin and, once the skin
was cleaned, we would chew it so that the mukluks would
be soft. It was hard to do but it worked well.

I also made 'qutugut', which were worn above the boots
and covered the legs. This is how it used to be with
qutugut – there was string with a knot on the end, which
went up and hooked over the pants above.

When James Houston, whom we call Sowmik – the left-
handed one – came to Cape Dorset and told me to draw
the old ways, I began to put the old costumes into the
drawings and prints. Some days I am really tired of the
old ways – so much drawing. But many liked my parkas –
many people really used to like my clothes.

I am too old now to make any more and my eyes are not
good. But every year I still make sealskin pants for Kaka.

ᐊᖕᑐᒪ ᑲᒥᑕᐅᕐᒪ. ᓄᓕᓂ ᐊᑭᓄᕐᑕ ᑲᕝᖕ ᐊᑭᓂᓗᓂ
ᒥᕐᐸᑭ. ᑲᕝᖃᐸᑕᐅᔪ ᓇᓯᐃᓄᖕ ᖃᐸᓂ ᑕᐊᒪ ᖃᓂᖃ
ᓴᓗᓴᑎᕐᐊᑐᓂ ᖃᓄᕝᖃᐱᑕᑭᖕ ᑲᕝᖕ ᖃᑐᓂᐊᒪᑦ.
ᐊᕿᐊᑎᑕᐅᔾᖃᐱᑕᕝᕝ ᐃᓕ ᐱᔨᕿᐊᖃᐱᑕᕝᕝ.

ᑯᑐᔾᓕᐸᑕᐅᐸᑕᒥᕐᕝᐸᐃ ᑲᕝᖕ ᖃᓕᓂᑎᖕ ᐊᑐᖃᐱᑕᖕᑎᖕ
ᓄᐅᕆᓇᑦ ᖃᓄᖕ. ᑕᐊᒪᓇᑕᖕ ᑕᐊᒪᐊᑐᐸᑕᐅᕝᕝ ᑯᑐᔾᓂᐃ
ᐊᖕ ᕿᓇᖃᑐ ᖃᓗᕝᓗᖕ ᐊᕆᒥᑦ, ᑲᐸᑐᓇᕿ ᖃᓗᕝᓗ
ᓂ ᖃᑦ ᖃᓕᒥᑦ.

ᑕᐊᕝᓂ ᕿᐸᕿ ᐊᕆᖕ ᓴᐱᕆᓄᕿᐊᕝᕕ, ᑭᒪᑭ ᑕᐊᒪ
ᐅᖃᐱᓂᑭᐸᕿᒪᕝᖕᕝ ᑎᑎᐱᕿᑕᓄᖕ ᐅᕿᕿᐊᓂᕿᖃ ᐃᕿᕿᓕᓇᐱ
ᑐᖕ ᑎᑎᐱᕿᐱᖕ ᐃᐱᕿᔪᖃᐃᓇᓂ ᑎᑎᐱᕿᐸᕝᓕᕿᕿᕆ ᐊᕝᓗ
ᐊᐸᕿᐱᕿᕿᕝ. ᐃᓕᓂ ᖃᕆᕿ ᑕᖃᕿᕝᕿᖕᒪᕿ ᐅᕿᕿᐊᓂᕿᖃ
ᖃᕿᕿ ᑎᑎᐱᖃᐸᕿ. ᐃᓕ ᐊᕿᕿᓂ ᐃᐱᕿᖃᖕ ᐊᑎᕿᖕ
ᐊᕿᕿᓂ ᐃᓇᓂᑦ ᖃᕿᕿ ᐃᐱᕿᖃᐱᑕᐅᕝᕝ ᐊᓇᖃᖕ.

ᓚᓇᑦ ᓂᕿᐱᔪᒪ ᓇᖃᐱᕿᒪᔪᖕᑎᒪ ᐃᐸᖃ ᐃᐱᕿᐊᔪᖃᕝᕝ.
ᐃᓕ ᕿᑦ ᐊᕿᒍᖃᑕ ᖃᕿᕿᑐᕿᖕᑎᒪ ᐊᕿᕝᓄ ᖃᖃᐱᑦ ᖃᑭᕿᕿ.
ᐊᑦᑦᕆᓇᑦᖕ, ᖃᖃ ᓄᖃᖃᖃᔪᕿᕆᕿᔪᑦ ᐃᐱᖕᑎᕿᓇᖕ ᐊᕝᓗ.

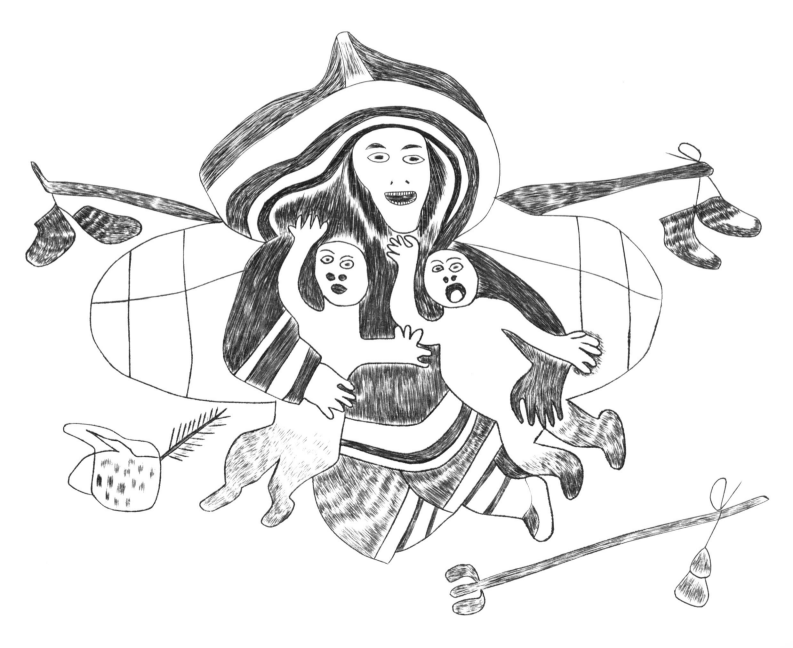

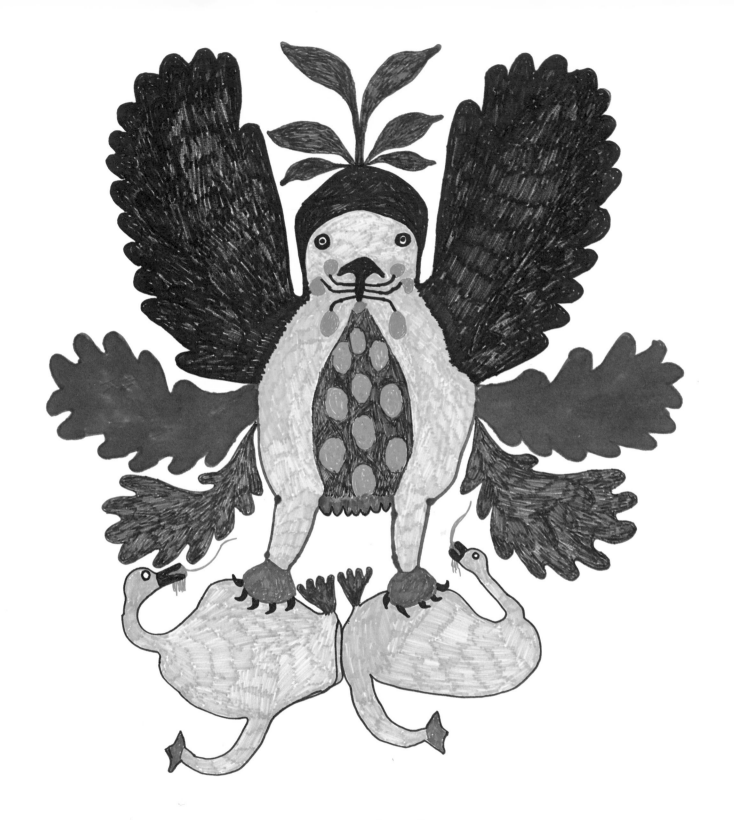

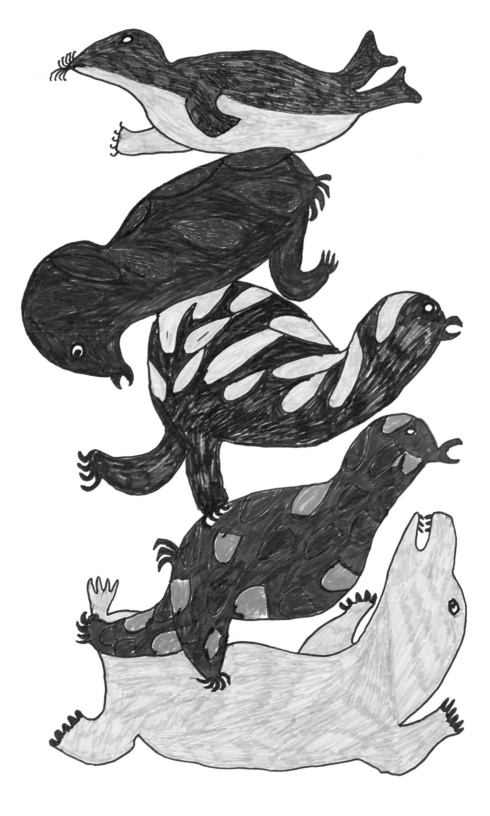

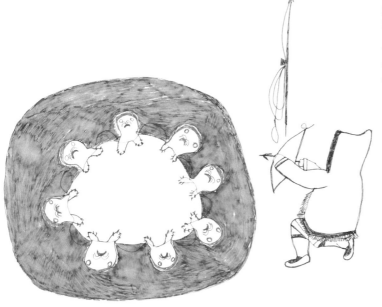

Bearded seals around ice.
Felt pen, ca. 1967

Travelling by dog team (detail).
Coloured pencil and felt pen,
ca. 1967

ᐅᐸᐃᕐ ᕐᒧᒻᒍᕐ
ᐊᒪᓪᒎ ᐊᑕᐅᓐᒍ ᑎᑎᐅᒪ,
I967 ᐅᓄᒍ

ᕐᒍᕐᕈᕐ (ᐃᒪᐃᓇᓪᒍᒪ)
(ᕐᑹᑲᓐᒧ ᐊᑕᐅᑎᓇ ᐊᒪᓘ ᐊᒪᓪᒎᕐ
ᑎᑎᐅᒪ, I967 ᐅᓄᒍ

Like his father, Kaka does not want to live with other people and he stays in camp. Like his father, Kaka is a very good hunter and every year he gets the most beautiful skins from a special seal – the 'kasigiak'. The skins are lovely and dark, and he brings them to me and I must make these pants.

I liked the old clothes but I like the new clothes, too.

In the old days men were very good hunters. They had to keep busy to feed the dogs and the family. We depended on the dogs and Ashoona always had a very good team. Dogs would have puppies and there were always from five to ten. They never had to be trained, they knew by instinct. They were clever and dangerous, too, but when they were full and happy, they went fast. Sometimes in the camps in a bad winter, the dogs used to starve, but Ashoona always brought lots of food. Some days he would bring ten seals from one day's hunting. He would cut meat for the dogs even in winter.

ᐃᕐ ᓄᕐᑐᒻᕐᕐᑐᕐ. ᐊᕐᕐᒥᑎ ᕐᕐ ᐊᒍᓇᕐᐊᑎᕐᒍ ᐊᒪᓘ
ᐊᕐᒍᒐᒐ ᐱᐅᕐᕐᓴᒍ ᓇᕐᕐᑐ ᒥᕐᕐᐊᑊᑐᕐᕐᓴᒍ ᓇᓇ − −
ᕐᕐᑎᐊᓴ. ᑕᐊᐊ ᒥᕐᕐ ᐱᐅᕐᕐᐊᓘ ᕐᓇᓗᑎ ᐊᒪᓘ ᕐᐊ
ᒐᕐᓴᓇ ᕐᒥᓇᕐ ᕐᑕᒐᐊᕐᕐᕐᓇᕐ.

ᐱᐅᕐᕐᑕᐊᐅᑐᒪ ᐅᕐᒐᐊᒍᕐᓇ ᐊᕐᓇᓴ, ᐃᕐ ᐊᐅᕐᒥᕐᕐᑕᐅᑊ
ᓇᒐ ᐊᕐᓇᓴ. ᐅᕐᒐᐊᑌ ᐊᒍᓐᕐ ᐊᒍᐊᕐᐊᕐᓇᐅᕐᕐᐊᑎᐅᕐᕐ.
ᓇᕐᕐᑕᐅᐱᕐᒥᕐᕐᐊᑎᕐ ᓇᓐᕐᐊᕐᕐᑎᕐ ᕐᒥᓇ ᐃᕐᒥᓇᓴ. ᕐᒥᓇᕐ
ᐃᕐᕐᑎᕐᕐᕐᑕᐅᑐ ᐊᒪᓘ ᐊᕐᕐᕐᐊ ᐅᒪᒪᓴ ᐱᐅᕐᐊᓇ ᕐᒥᕐᕐᑕᓴᓇ.
ᕐᒥᕐᕐ ᕐᒥᕐᐊᕐᕐᕐᑊᓐ ᐊᒪᓘ ᑕᐊᒪᒪ ᕐᒥᕐ 5−ᒍᓴᓐ I0−ᒍᓴ
ᓐᕐᓇ. ᐃᕐᕐᑲᐊᑲᕐᕐᑕᐅᕐᕐᑐ, ᕐᑕᐅᑊᒪᕐᐊ ᐊᑐᕐᓇᓴᐃᐊᒍ.
ᐊᕐᑐᕐᕐᓇᒥᕐ ᒍᐊᐊᕐᕐᓇᒥᕐᓴ ᕐᕐᑲᐊᕐᕐᕐᑕᐅᑐ. ᐃᕐᓇᓇ ᓇᓇᓴᕐᓇ
ᕐᕐᐊ ᐱᐅᓇᓇᒍ ᕐᒥᕐ ᕐᕐᕐᕐᑕᐅᑐ ᐃᕐ ᐊᕐᕐᕐᐊ ᑕᐊᒪᒪ ᓐᕐᐅᕐᕐᕐ
ᕐᑕᐅᑐ ᓇᕐᕐᐊᒐᓇ − − ᐃᕐᓇ I0−ᓇ ᓇᓇᓴ ᐊᓇᕐᐅᕐᕐᕐᕐᑕᐅᑐᕐᕐ
ᐅᕐ ᒍᒥ ᐊᕐᑐᐅᕐᒥ ᐊᒍᓇᕐᐊᕐᓇ. ᓇᓇᓴ ᐱᕐᕐᕐᕐᑕᐅᑐ ᕐᒥᓇᓴᓐ
ᒥᓇᕐ ᐅᕐᕐᐅᒪᓴᒥᕐ.

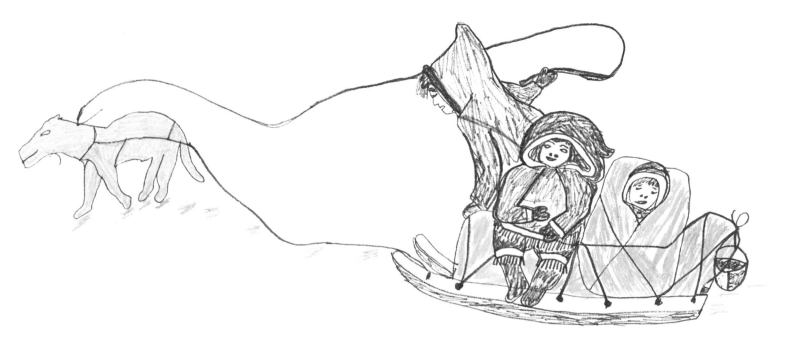

There seemed to be more animals in the old days. There were more whales and more seals and, just quite recently, there were lots of narwhales around Cape Dorset. But today the animals don't seem to come into the settlements much. Now they have all these motors and the animals hear them and run away. Now there are motors everywhere, but dogs were safer than skidoos. Skidoos can break down out there, far from Cape Dorset; and dogs will bark when they see a polar bear.

In the old days, when men left the camp, they would always give the women something that killed – a gun. But I used to be very poor at shooting and I remember one day, although we had lots of food, I wasted a whole box of ammunition trying to kill a little seal. I knew it would get away. But though I have never shot a caribou, there are very few birds that I have not caught.

When I was a little girl my father and mother taught me how to catch a goose. Four people would corner a goose

ᐅᐸᓯᐊᑎᓄᒍ ᐅᒪᕐᖃᓴᖅᐅᕐᗨᐸᑕᐅᑐᖅᒃ. ᖃᓚᑲᖃᖅᐅᕐᓂ ᐊᒪᓗ ᓇᕐᑲᓴᖅᐅᕐᓂ ᒪᓇᖕᑕ ᑭᕐᐊᓂ ᐊᖕ ᓄᑕᖃᑲᖕᒥ ᐊᒥᕐᓂ ᑭᐅᐊ ᓴᓇᐊᓂ. ᐊᐃ ᒪᓇ ᐅᒪᕐᐄᐊ ᑎᑭᕐᐊᑲᐅᕐᒪᕐᔾᒍᓇᐅᐃ ᓄᓂᖃᓄ. ᒪᓇᐃ ᐊᒪᕐᓂ ᐊᐅᑲᐅᑎᖃᑲᓕᑕ ᐅᒪᕐᖃ ᑐᖏᖅᐸᖃᑕ ᓕᑕ ᑭᓕᕐᖃᑲᕐᑎᓄᒍᓕᑕ. ᒪᓇ ᐊᐅᑲᐅᑎᖃᑲᓕᑕ ᓇᕐᒪᓕᖕᖃᑉ, ᐊᐃ ᑭᒥ ᐊᑕᖃᐊᓄᖅᐊ ᕐᕐᑉᓄᖅ. ᕐᕐᑉ ᑲᒍᓄᐅᕐᐊ ᕐᒍᔭᖃᐃ ᓇᒥᑐᐊᖕᖕᒃ, ᑭᒪᐄᕐᒃ ᐅᒪᕐᕐᖃᒍᓕᓄᖃ, ᐊᒪᓗ ᑭᒥᕐᖕᕐᒃ ᔾᔾᐸᓄᖕᖃ ᑕᑯᓕᐊᒪᕐᒥ ᐊᓄᕐᒃ.

ᐅᐸᓯᐊᑎᓄᒍ ᑕᐊᕐᒪᓄ ᐊᔾᓄᖕᕐᒃ ᑭᒪᐊᒥᕐ ᐊᖃᕐᒥᓄ ᑕᐊᒪᒪ ᐊᑲᖕᖃᐊᖕᕐᒃ ᔾᐅᕐᔾᒍᓄᕐᖃᓄ ᔾᐅᕐᗨᕐᖃᐅᔾ ᙹᙹ ᒍᕐᐅᐅᒪᕐ. ᐊᐃ ᕐᕐᐊᔾᓄᖕᕐᐊᑲᐅᕐᔾᒍᒪ ᐊᒪᓗ ᐊᐅᖃᕐᔾᒪᕐᒪ ᐊᖃᐅᕐᔾᐊᕐᒪᕐᒪ, ᓄᑭᖃᐊ ᓄᒪᓇᔾᐊᑕ, ᐊᔾᑭᖃᐅᕐᔾᒪᕐᒪᕐᒪ ᐄᓄᐊᑎᖕᕐᒃ ᐊᕐᐊᒪᕐ ᖄᔾᓄᐊᕐ ᖃᕐᔾᓄᕐᒃ ᔾᐅᕐᕐᔾᒪᕐᔾᒪᕐᒪ. ᑲᐅᕐᒪᕐᒍᒪᕐ ᕐᒪᓕᕐᕐᕐᔾᒪᕐ. ᐊᐃ ᕐᕐᐊᒪᕐᒍᒪᕐ ᑲᒍᐊᔾᒪᕐ ᔾᔾᒪᕐᕐᒃ, ᐊᕐᔾᒍᒍᒪᕐᒃᔾᒪᕐᒃ ᔾᐊᕐᓇᐊᒍᕐᒃ ᔾᐊᕐᓇᐊᑲᐅᕐᒪᕐ ᑕᖕᕐᒃ ᐊᓄᓄᑲᓕᓄᖃ.

ᑕᐊᕐᒪᓄ ᓄᐊᔾᓄᕐᐊᔾᒍᓇᐅᒪ ᐊᑕᑲᓄ ᔾᐊᓇᐊᓄ ᐊᑕᕐᖃᑕᐅᑲᐅᕐ ᒪᕐᔾ ᑲᓄ ᑎᔾᓄᕐᔾᒍᓕᓕᑕ ᓄᓄᒪ. ᕐᕐᒪᓕ ᐄᓄᐄ ᕐᓄᔾᕐᕐᑎ

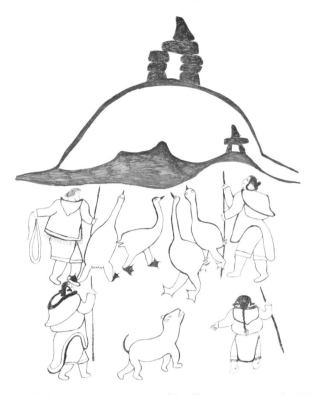

and then my parents would tell me to run up behind it,
hooting and shouting, and put my foot on its neck. I'd run
and I'd catch the goose and I'd stand there waving my
arms like a bird. Sometimes we'd all have headaches
from shouting and yelling.

In 'isha', the season when the geese lose their feathers,
they are very easy to catch. They can't fly then and you
can catch them easily on the grass. Just before I was born
they used to drive the moulting geese into stone pens,
but we didn't bother with pens. Geese are best found in
mossy areas. Their feet are very sensitive and they
won't go on the rocks. They always go where it's mossy
or where there's grass.

Sometimes an Eskimo man will take a long rope with a
loop on the end and place the loop on the ground. Then
the Eskimo man will hide behind a rock and, when
a goose passes over the loop, he'll pull the rope and
he catches the goose.

ᓄᓕᒪᒃ<ᐊᑕᐅᑐ ᑕᐅᒪ ᐊᑕᑲᑐᓄ ᐅᑲᐅᓄᔭᐊᑲᐅᑐᒪ ᐅᑲᔭᑐ
ᒃᒪ ᐅᒪᑕᓴ, ᓄᐱᐊᑐᓗ ᑲᐊᒪᓕᓄᔭᓗᓄ ᑐᓴᒪ ᑯᓯᒪᒍᒃ
ᐅᓕ<ᐊᑐᒪ ᓄᓕᑉ ᓐᒍᒃᓕᓕ ᐊᓕᒪᓄᓂ ᓄᑐᐊᓕ<ᓕ
ᓴᐊᓕ. ᐊᓕ ᓄᓕᓕᐅᓴᒪᐊᓕ. ᐊᓄᑯᑦ ᓄᐊᒍᓄ<ᓕᐅᑐᒪ
ᓄᐱᐊᑐᐊᓄᐅᒍ ᑲᐅᒪᓕᓕᐅᓄᐅᒍᓗ.

ᐊᓴᐅᓐᓄᒥ ᓄᑦ ᐊᓴᐱᐊᓴᓕᒪᓄᓂ, ᓐᒍᓴᐅᓐᒍᒍᐅᐊᑲᑉ.
ᓐᒥᓄᐅᓴᒪᓕᑦ ᑕᐅᒪ ᓐᒍᓄᐅᓴᐅᓐᒥᓄ ᓄᑲᓴᑮᒥ. ᐅᓗᑉᒥ
ᓗᐊᓴᐱᓄᔭᒍ ᐊᓄᐅᑦ ᐊᓴᓗ ᐅᓴᐅᐱ ᐊᓗᐊᓗᓄᑯᑐᐅᓄ ᐊᓕ
ᑲᒪᓕᐊᑐᓴᓐᑐᒪ ᐊᓗᐊᓄᐊᓄᑉ. ᓄᑐᓄ ᑯᑐᓴᐅᓐᒍᓴᐊᓄᑉᑦ
ᓄᐊᓴᑦᒥ. ᐊᓕᒪᒥ ᑕᐱᔭᐊᑐᒃᓗᐊ ᐊᒪᓗ ᐅᓕᐅᓴᑯᓄᐅᓕᓐ.
ᑕᐅᒪ ᓄᐊᓕᓴᑯᑦ ᐅᒃᓗᓄ ᓄᐊᑐᐊᓕᑐ.

ᐊᓄᑯᑦ ᐊᓄᑉ ᐊᒍᓐᑉ ᐊᑉᓕᒥ ᓐᒍᑉᐊᑐᒃ ᑕᑭᑦᓄᓗ
ᐊᑉᓕᓄ ᑭᓴᑲᓐᓗᒍ ᑕᐅᒪ ᓕᓗ ᓄᐊᔭᑦᒍ. ᑕᐅᒪ ᑕᓄᓕᒪ
ᒪᑭᓄ ᐅᓴᐅᐱᑦ ᐊᒪᓕ ᑕᐅᒪ ᓄᑉ ᑭᐊᓗᑦ ᓄᓕᓄᒃᓕᓴᓄᑉᒃ
ᐊᑉᓕᒥ ᓄᑲᐊᓕᑦᓄ ᑕᐅᒪᑉ ᓄᑉᓕᑉᐊᑐᒪᑉ.

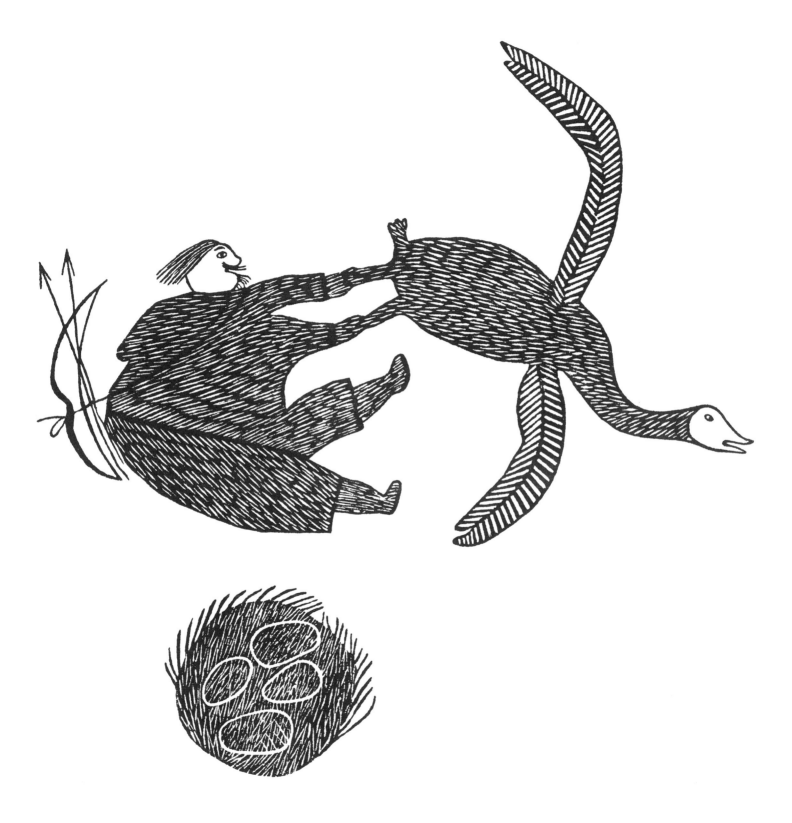

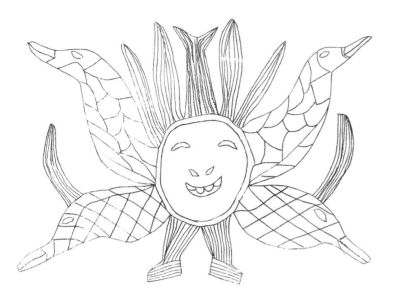

Flower spirit.
Engraving, 1968

ᐱᔪᕐᖓ��b
ᐅᒡᕈ�*ᖕᒥ ᓐᓄᒪ, 1968

It's fun to chase a goose and it's always fun to be around animals – they are meat.

I can't remember the first time I tasted the white man's food, but I do remember one incident. At the time, they were building the Hudson's Bay post's big warehouse and I was just a little girl. I remember watching people unload the supply boat, and I was crying very hard. They gave me a pilot biscuit and I really liked it.

I like the white man's food but I think the old food was better for Eskimos. In the old days we had more food from animals and we didn't get sick so much. We ate the food raw. We used to eat seal, whale, caribou, ducks and ptarmigan all raw, though we used to cook the goose, and goose cooked is very good. We also used to cook the polar bear, though some people ate it raw.

We had fruit in the summer. We used to pick the berries on the tundra, and something else we ate was dulse. We

ᒡᓴᐊᖕᑐ ᐅᑕb ᑕᓇᐅᖅ ᓂᒡᒥᖕᖅ ᐊᒪᖪ ᑕᒪᒪ ᒡᓴᐊᖕᒪᓴᓂ
ᐅᒪᐊᕕᒥᕐᐊᒥ -- ᐅᒪᐊᐃᖕ ᓂᖅᐅᒪᕐᖕᖕ.

ᐊᐅᑕᐅᕐᑐᒪ bᒪ ᖅᐅᑕᐊᕐᒥ bᔪᐊ ᓂᖅᒪᓂ ᐅᐅᓂᒪᒪᒪᒪ ᐊᐃ
ᐊᐅᑕᐅᖕᒪᒪ ᐊᑕᐅᕐᒥ ᐅᐅᖕᒪᒪᒪ. ᑕᐊᕐᒪᓴᐅᐅᕐᖕᒧᒡᐊᖕ ᐊᖕ ᖕᕈᐅᐅᐅ
ᖅᒪᖕᖕ ᓂᐅᐊᐅᖅ ᖅᖅᒪᐃᖕᐊᖅᐅᐅᖕᒡᓂᖕ ᐊᒪᖪ ᑕᐊᕐᒪᐅᐅ ᓂᐊᐃ
ᖅᒡᖕᖪᒪᒪ ᐅ ᐃᐊᖅᐅᐅᖕᒪᒪᒪᖕᒪᒪᐅᒪ. ᐊᐅᑕᐅᖕᒪᒪᖕᒪ ᑕᖕᖕᐅᐅᕐᒪᐅᖕᒪᒡᖕ ᐃᖕᐊᖕᖅ
ᐅᔪᖕᒪᖕᔪᖕᓂ ᐅᒪᒪᐊᖕ ᐅᔪᖕᖕᓂ ᐊᒪᖪ ᖅᐅᑕᐅᖕᒪᒪᖕᒪ ᐊᖕᖅᖕᖪ.
ᐊᐊᑐ ᑕᐅᑕᐅᖕᒪᒪᒪᖕᒪ ᖪᖕᑕᐅᖕᒥ (bᒡᖪᖕᒥ) ᖅᖕᖅᖕᖕ ᐱᐅᖕᑕᐅ
ᖪᖪᖪ ᐊᖕᖅᖕᖪᖕ.

bᐊᖕᖕ ᓂᖅᖕᖕ ᐱᐅᖕᖪᒪᒪ ᐊᐃ ᐅᖕᖅᖪᐊᖕᓂᑕᖕ ᓂᖅᖕ
ᐱᐅᓂᖕᐅᖕᑕᐅᖕᑕᖕᖪᒪᒪᒪ ᐊᖕᐅᖕ. ᐅᖕᖅᖪᐊᑕᐅᒡᖕ ᓂᖕbᖕᐊᖕᖕᐅᖕ
ᐅᑕᐅᖕᐅᖕᖪ ᐅᒪᖕᖪᐊᖕᓂᖕ, bᖕᐅᒪᖪᐊᑕᐅᖕᒪᖪᒪᒪᖪᑕᑕ. ᓂᖕᖪᐊᑕᐅᖕᐅᖕᖪᒪᒡᖕ
bᑕᒪᖕᖕᒥ ᓂᖅᒥ.ᓂᖕᖪᐊᑕᐅᖕᐅᖕᖪᒪᖪ ᐊᖕᖕᖕ ᖕᑕᖪᖕᖕᖕ, ᐅᐅᐊᖕᖕᒥ,
ᖕᖕᖪᐊᖕ ᐊᖕᖕᖪᖕᖪ ᐃᖪᐊᖕ bᑕᖕᖪᒪᖪᐊᖕ ᐊᒪᖪᐊᑕᐅᖕᖪᒪᐊᖪᐅᖪᐊᒡᖪ
ᓂᑕᖕᒥ, ᐊᒪᖪ ᓂᑕ ᐊᒪᖪᖪᒪᖪᐊᖕ ᐱᐅᖕᖪᖪ. ᐊᒪᖪᐊᑕᐅᖕᖪᐊᒡᖕ
ᖕᐊᖪᖕᖪᖕᖕ, ᐊᐅᐊᖕ ᐊᖕᖕᖪ ᖕᐱᖪᐊᑕᐅᖪᐅᐊᖕᖪᖪ.

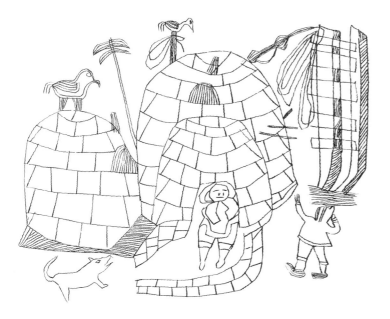

Eskimo camp scene.
Engraving, 1967

ᑐᐱᖃᐱ
ᐅᑯᕐᓴᕐᒥ ᑎᑎᒍᒪ, 1967

used to hunt for dulse around the beaches. Sometimes, when the men went hunting, they would bring back dulse for the women. Eskimo people believe that it has some medicine in it; when they are sick they feel better if they have some.

Sometimes in the winter it was boring in the igloo but we never stayed inside much. We had warmer clothes in those days and it used to be fun when It was windy. The fathers would make toy sleds for their sons and daughters to slide on and, when the children had their sleds and their toy whips, they would play outside most of the day. Now they are in school all day and they have the habit of staying indoors.

Very often in those days when we felt happy in camp, Ashoona and I would play the accordion. My favourite brother once gave me an accordion and we both could play. The little children would come and dance. Kaka used to dance a lot.

ᐊᐅᑕᖃᐸᑲᐅᑐᕐᔪ ᐊᐅᖕᒃ. ᐊᐅᑕᑦᑲᑲᐅᐸᔪᔪ ᓄᐊᒥ, ᐊᒪᓗ ᐊᕐᒪᓂ ᓂᑎᐸᑲᐅᑐᕐᔪᒃ ᑭᐅᕐᓂ. ᑭᐅᐊᕈᐅᐸᑲᐅᑐᒍ ᕐᓱᒥ. ᐃᓂᓂ, ᐊᒍᑎᒃ ᐊᒍᓇᕐᐊᑐᐱᓂ ᐊᓇᖅᐅᕐᑲᐅᑐᕐᔪ ᑭᐅᐊᓄᖃ ᐊᖃᓂᐊ ᓂᓇᐅᕐᒥᓂ. ᐃᓇᐃ ᐊᓂᐊᕐᐅᓂᑦᖃᐅᓂᕐᓕᒥ ᑭᐅᐊᒥ; ᑲᓇᓚᑐᐊᒪᒥ ᐊᕐᑲᐅᑐᕐᔪ ᓂᓂᐊᒪᒥ ᑭᐅᐊᒥ.

ᐃᓂᓂ ᐅᑭᐅᒥ ᐃᑭᐊᓇᐸᑲᐅᑐ ᐃᖃ ᓯᐅᒥ ᐃᓇ ᐃᓇᐊᓂᓇᐸᑲ ᐅᖕᑐᔪᑦ. ᐅᑯᓄᖃᑐᖃ ᐊᓇᖅᑲᐸᑲᐅᑐᑲ ᑕᐊᕐᓂᓇ ᐊᒪᓗ ᑯᐊᐊᓇᐸᑲᐅᑐ ᐊᓇᓇᑐᓇᐅ. ᐊᑦᑲᖅᐊᑕ ᐱᒍᐊᕐᐸᑲᐅᑐᕐᔪ ᑲᔪᐊᕐᐊᑐᕐᑎ ᐊᖃᓂᒥᓇ ᐸᓇᒥᓇᖃ ᕐᐊᑐᖃᐱᓯᓂ ᐱᐊᖃᐃᑦ ᑲᔪᐊᑲᑲᓂᑭᖃ ᐃᓇᖃᐅᑐᔪᐊᓇᓄᖃ, ᐱᒍᐊᖃᐸᑲᐅᑐᕐᔪᐊᑦ ᕐᓴᒥ ᐅᖃᐊᓚᑲᖃ. ᓚᓇᖃ ᐃᓇᓂᐊᑕᓯᒥ ᐊᖃ ᓄᐊᒍᓚᑐ ᐊᐊᕐᒍᑐᐅᑦ.

ᑯᐊᐊᑲᑐᓇᕐᑲ ᓄᐊᓂᓇ ᐊᖃᕐᓂᖃ ᓄᕐᑎᓂᕐᐸᑲᐅᑐᕐᔪ ᑕᕐᔪᐊᒥ. ᐊᓇᐊᕐᑐᐅᑦ ᐊᐊᑐᑕᐅᑯᐅᑐᕐᐸᓕᐊᒥ ᑕᕐᔪᐊᒥ ᓄᕐᑐᓂᒥ ᑕᓚᓇᖃ ᓄᕐᑐᔪᐊᕐᑎᓄᖃ. ᐱᐊᖃᑯᓄᐊᑦ ᑲᐊᕐᖃᐸᑲᐅᑐᕐᔪ ᑕᓇᕐᑎᐊᑐᕐᑎᐱᓂᖃᐱ, ᑲᖃ ᑕᓇᕐᕐᓱᓂᐱᐊᓇᖃᐅᑐᕐᔪᐊᖃ.

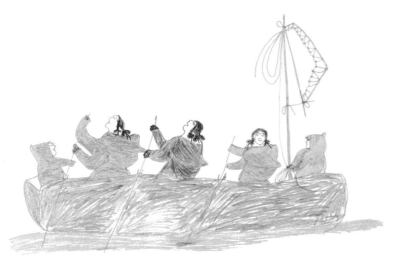

Women would row the sealskin
boats; men would go in the kayaks.
Coloured pencil and felt pen,
ca. 1967

ᐊ�B ᓇ ᐃᑦ ᑭᓯᒥ ᐅᒦᐊᑐᐸᑕᐅᑕᐅᑦ; ᐊᒍᑎᑎ
ᑲᖕᑐᑎᖕᒥ ᑉᖕᓴᓇ ᐊᑕᐅᑎᓂᑦ ᐊᒪᓗ
ᐊᓚᒐᔾ ᑎᑎᑐᒪ, 1967 ᐅᑎᓗᔾ

Sometimes, just for two seconds,
I could keep three stones up.
Felt pen, 1970

ᐃᓚᓂᒥ ᑭᑯᐊᓗ ᐊᑯᓂᐅᑎᑐᑉ ᐅᖕᖓᓇᑉ
ᐱᒪᕐᓂ ᐃᓴᑭᒐᒪ ᑲᑕᑎᒍᓇᐸᑕᐅᑦ
ᒪ ᐊᓚᒐᔾ ᐊᑕᐅᑎᔾ ᑎᑎᑐᒪ, 1970

Ashoona used to like to juggle. He could keep three
small stones in the air and sometimes, just for two seconds,
I could keep three stones up there, too.

We played lots of games. One game was 'illupik' – jumping
over the 'avatuk', the sealskin float that hunters used to
tie to the harpoons so the seals would stay on the water
after they were killed. I hear young people in Cape Dorset
still try to jump the avatuk at the youth club meetings.

Another game was the Eskimo tennis! This is how we
played this game – we threw a ball underhand and tried to
catch it in a sealskin racket. The racket was called an
'autuk'. We made the ball from caribou skin and stuffed it
with something. We used to play this game a lot, even
in winter. It was a good game, but they don't play it now;
they are following the world.

It was always most joyful when people came together
in Cape Dorset. Every year we would make three trips to

ᐊᖕ ᓯ ᐊᖕ ᔪᑭᑎᐊᕐ ᐱᐅᖕᕐᑲᐅᑦᑦ. ᐱᒪᕐᓂᑦ ᐅᖕᕐᐱᓂ
ᑲᑕᑎᒍᓇᐸᑕᐅᑐᑦ ᐃᓂᓗ ᒪᕐᐱᑲᑦᐱᕐᒥ ᐱᒪᕐᓇᐅᑦ
ᐊᖕ ᔪᑭᑐᓇᒥᕐᕐᓚ.

ᐊᒦᕐᐊᔪᓂ ᐱᔪᐊᕐᕐᑲᐸ. ᐊᑕᐅᕐ ᐱᔪᐊᕐᕐ ᐃᓗᐱ – –
ᐊᕐᑲᐅᑦ ᑲᓗᕐᑦ ᒦᕐᑲᕐᓂ, ᐊᕐᑲᒦᕐ ᐊᔪᓇᕐᐊᑎ ᐳᐊᕐᐱᑲ
ᐅᔾᔾ ᑭᑦᑲᓗᕐᒍ ᐳᐊᒍᑦ ᑕᐊᒪ ᓇᕐᑉ ᑭᐊᓂᐊᕐᒪ ᓗᑐᐳᐊᕐ
ᓚᑦᓗᓂ. ᑐᕐᑲᐳᑎᒪ ᐅᐊᑲᐃᑦ ᑭᓗᓂ ᕐᒥ ᒦᕐᑲᕐᑎᓂᕐᒥ
ᐊᕐᑲᑦᒍᑦ ᐅᐊᑲ ᑲᑎᓇᑎᓂᕐᒥ. ᐊᕐᑲᑕᕐ ᐱᔪᐊᕐᕐ ᐃᓇᕐᑦ
ᐊᖕ ᓯᒪ: ᐊᓗᓇᑕᒪ ᐱᔪᐊᕐᐱᑕᐅᑐᔾ ᑕᕐᒦᒪ ᐱᔪᐊᕐᕐᒦ – –
ᐊᕐᑉᑲᕐᔾ ᐊᑦᕐ ᐊᑐᐳᑦ ᐊᑐᔾ ᐊᑯᓇᕐᑉᑲᕐᔾ ᓇᕐᐳᑦ
ᑭᕐᓚ ᐊᑦᕐᕐ. ᑕᓇ ᐊᑦᕐᕐ ᑲᐅᕐᐳᐊᑲᐅᑐᑦ ᐊᐳᑕᕐᒦ. ᐊᑦᕐᓚᐳ
ᐸᐸᐅᑐᔾᑦ ᐊᕐᑲᕐᐳᐊᑲᐅᑐᔾ ᑐᑦ ᑭᕐᓚᓂ ᐊᔪᐊᑐᓗ ᓇᑭᔾ
ᐳᕐᔾ ᑭᑐᓇᒦᕐᑉ. ᑕᓇ ᐱᔪᐊᕐᓇᐸᑕᐅᑐᑦᑦᔾ ᑕᐊᓗᓗᑦ,
ᐅᕐᐳᓗᑕᕐᒦ ᐱᔪᐊᔪᑉᑲᐅᑐᑦᕐ ᐊᑦ ᓚ ᐱᔪᐊᑎᑉᑐᓇᐊᑕᓗ,
ᓗᑦᓚᑕᕐᕐ ᕐᑦᕐᐊᒦᕐᕐ.

ᑕᐊᓗᓗᑦᓚ ᑯᐊᕐᐊᓇᐸᑕᐅᑦᕐᕐ ᐃᓇᐃᑦ ᑎᑭᐸᑲᓚᑦ ᑭᓗᓂᕐᑦ.
ᐊᕐᔾᔾᑕᒪ ᐱᔪᐊᑕᕐᕐᑦ ᐊᐳᑲᐸᑕᐅᑐᔾ ᑭᓚᑲᐊᕐᑦ ᑭᔾᕐᑐᕐᕐ.

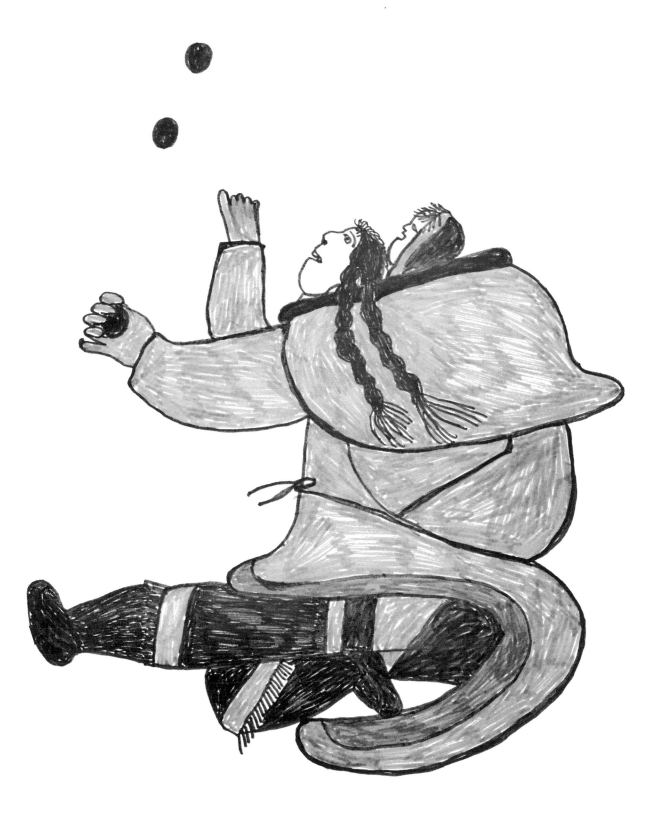

ᐱᒍᐊᐸᑕᐅᑦᑕ ᐃᓚᒻ ᐃᓗᐱᒃ ᒥᓯᒃᑕᕐ
ᑕ ᐊᓱᑕᒍ ᐊᓚᓗᒻ ᐊᖃᐅᑎᒍ ᏁᏉᒪ
I 970

Cape Dorset with the dog team. When the nights were
light we would travel after midnight and build an igloo
when we stopped. It used to be cold when it was windy!
We would go to Dorset to sell the fox skins to the Bay and
get supplies. We got good prices for the fox then; fox
used to be worth a lot. We would buy in exchange what
we call the grub – the white man's food – tea, flour, salt,
baking powder and shortening.

We always made one trip in summer to see the Nascopie.
This ship used to bring all the supplies for the year
to the Bay. We were always happy to see the Nascopie.
One year the Nascopie went on some rocks coming
into Dorset and was wrecked. Many people got things
from the wreckage. I remember my son, Kiawat, got
a primus stove and some blankets. He saw other people
getting things and decided he should have something, too.

In those days, a lot of people and families would spend a
long summer in Cape Dorset and then, before the weather

ᐅᓄᐊᒥ ᑕᑐᒐᓇᐊᑦᐊᒪᑦ ᐊᐅᓚᐸᑕᐅᑐᒍ ᏇᏁᏒᒥᐃᓚᏁᑐᒍ
ᐅᓄᐊᓗ ᐊᓱᐱᓚᐅᐸᒃᑦᑲ ᐅᖃᐸ. ᐸᐅᐸᐸᑕᐅᕝᕝ ᐊᓗᏁᓚᒪ!
ᐱᓚᓂᐊᐸᑕᐅᑐᒍ ᓂᐅᑐᏁᒃᒥᐊᑐᏒᐸ ᏁᏁᓗᓇᐊᕐᓗᓇ ᓂᐅᐱᏁᑎᓱᐊᑦ
ᓂᐅᐱᏁᐊᑐᏒᐸ ᓂᐅᐱᐊᕐᓚᕐᒃ. ᐊᐸᒃᐊᕕᑦᏁᐅᐸᑕᐅᐸᏒᑕ
ᏁᏁᓗᓇᐊᕐᓇᒃ ᑕᐊᒻᓚᓂ, ᏁᏁᓗᓇᐊᕝᒃ ᐊᐸᑐᐊᓚᑐᒃᐸᑕᐅᕐᓚ.
ᓂᐅᐱᐊᑐᒍ ᓂᐅᐱᐊᐅᏁᐱᑦ ᑕᐊᓗᐅᓇᏒᏁᓂ -- ᐳᓇᐅᑦ
ᓂᐸᓚ Ꮑᒥ, ᐸᐊᐅᒥᒥ, ᑕᏁᐅᒥ, ᐳᐸᏒᐅᏁᒥ ᐳᓇᒥᓗ.

ᐊᐅᏒᐊᑐᒍ ᐊᑕᐅᕝᐊᐸᑦ ᐊᐅᕝᑐᏒ ᑕᑐᕝᑐᐸᑦ ᐊᐸᑦᐊᒥ.
ᑕᐊ ᐅᒥᐊᐸᒃ ᓂᐅᐱᐊᕐᓇᓚᓇᒃ Ꮑᐸᐅᐸᑕᐅᕐᒪᑦ ᐊᒍᒪᑦ
ᐊᒪᑐᏒᓇ ᓂᐅᐱᐊᐊᒍ. ᑐᏁᐊᕐᐸᑕᐅᑐᒍ ᑕᑐᏒᐊᏒ ᐊᐸᑦᐊᒥ.
ᐊᑕᐅᏒᒥ ᐊᒍᒥ ᐊᐸᑦᐊ ᐅᕝᑐᑐᐸᐅᐱᒻᒪ ᐳᐊᒪᏒᏒᓂ Ꮑᐸᓇ
ᑕᐊᒪ ᏒᏒᏒᐅᐱᒻᒪ. ᐊᒻᏒ ᐃᓇᐃ ᐱᑕᐅᐱᏒᏒ ᐸᏒᐅᐃᓇᓂ
ᏒᏒᓇᐊᓇᓇᒃ ᐊᐱᏁᐊᐃᓇᏁᏁ. ᐊᐸᑦᐊᏒᏒ ᐊᐱᓗᏁ ᐸᐅᐸᏒ,
ᏒᐳᏒᏁᓱᒍ ᐸᏁᏒᓗ. ᑕᑐᏁᒥ ᐃᐅᑕᏁᒥ ᐸᏒᐊᐃᓇᑕᏁᒥ
ᑕᐊᒪ ᐊᐸᓚᏒᏒᏁᓇ ᐱᒥᐊᒥᏒᒥᏁᑕᐅᕝᒃ.

ᑕᐊᒪᓇᐅᑐᒍ ᐊᒻᏒᏒᐊᓇᐃ ᐃᓇᐊᑦ ᐸᏒᓚᏁᓗ ᐊᐅᏒᐸᏁᒪ
ᐸᓚᓂᐸᑕᐅᐸᑦᐅᑦ ᐊᒪᓗ ᑕᐊᒪ ᏒᏁᓂ ᐸᐸᓇᒥᏁᓂᏁᒥᓇ, ᓇᏒᏁᒃ
ᑐᐸᏒᏒᐅᐱᐊᑐᐸᑦᐅᑦ ᓇᒪᒥ. ᑐᐊᐊᕐᐸᑕᐅᑐᒍ ᐸᏁᓚᏒᏁᐊᓚᑦᏁ.

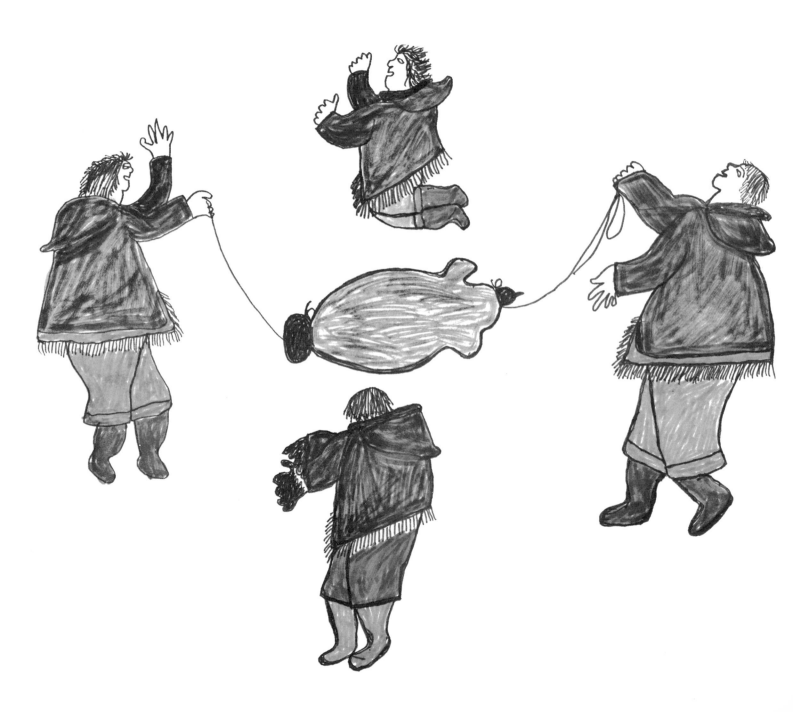

In the old days there were good
dancers.
Felt pen, 1970

ᐅᕙᓯᐊᑎᒍ ᑕᓂᕐᔭᐊᑲᐅᑐᑦ
ᐊᒪᓱ ᐊᓴᐅᓄᒡ ᓇᑎᒪ, 1970

got cold, they would look for new camps inland. We used
to be happy to be together. There would be dances at
the Bay residence and at the warehouse. I only danced
when I moved into the settlement after my husband died,
but there were many people in Cape Dorset then who
were good dancers. I don't remember the drum dances;
I only remember the accordion dance. They danced
Eskimo dances that went on for a long time – there were
no drunks in the dances then!

This was the old Eskimo way of life; you couldn't give up
because it was the only way. Today I like living in a house
that is always warm but, sometimes, I want to move and
go to the camps where I have been. The old life was a
hard life but it was good. It was happy.

My husband died at Natsilik. That year I hadn't wanted to
go to Natsilik and neither had Namoonie. But Ashoona
begged us to go and so we did. The week my husband
became sick we heard that his brother had died in Cape

ᑕᓂᕐᕚᑲᐅᑐᑦ ᓂᐅᐱᐅᑯ ᐊᑉ ᓗᓂ ᐊᒪᓗ ᑭᕐᒍᐃᓇᑯᒥ
ᑕᓂᕐᕚᑎ. ᑕᓂᕐᕐᒪᕚᑯ ᑭᕐᐊᓂ ᓂᕐᒪᓕᖕᒐᒪ ᐊᑉ ᓗᑉᓗᒃ
ᐅᐊᒪ ᑐᑯᓗᓕᑎᓗᒡ, ᐊᓂ ᐊᒥᕐᓂ ᐊᓂᓂ ᑭᓂ ᑕᓂᕐᕐᑎᑲᕚ
ᓚᐅᑐᒃ. ᐊᐅᓚᕚᔭᑎᒍ ᐊᓇᐅᓚᒡ ᑕᓂᑐᓂ ᒍᒪᑐᒃ;
ᐊᐅᓚᕚᕚ ᑭᕐᐊᓂ ᑕᕐᔭᐊᒍ ᑕᓂᑐᓂ. ᑕᓂᕐᕚᑲᐅ ᐊᓂᐊ
ᑕᓂᕐᑉᕐᓂ ᐊᑯᓂ ᓄᑲᒍ�لᑎ -- ᐊᒥᐊᓗᕐᒪᑲᕐᓇᒍ
ᒍᒪᑐᒃ ᑕᐊᕐᓚᓂ!

ᑲᓇ ᐊᓂᐊ ᐅᕙᕐᐊᐳ ᐊᐳᕐᓂᕚᑲᐅᑕᒪ �hᐱᓇᕐᑎ ᑕᐊᒪᓇ
ᑭᕐᐊᓂᐅᕚᑲᐅᑐᑤ. ᒪᓇᒃ ᐊᐳ�hᑐᒪ ᐊᑉ ᓗᒥᒥᐊᔦ ᑕᐊᒪᒪᑤ
ᐅᑯᐊᑐᐊᓂᐅᒪ ᐊᓂ, ᐊᓂᓄᑯ ᓄᒍᒪᕚᑐᒪ ᑐᐱᒪᒥᕚᐊᓚᑐᒪ
ᓄᓇᕐᕚᑲᐅᑎᓂᓂ. ᐊᓂᕐᑐᒃ ᐊᑉᐅᕚᑲᐅᕐᑐ ᐊᓂ ᐊᐳᕚᑲᐅᑐᒃ.
ᒍᐱᔭᓇᕚᑲᐅᒥᕐ.

ᐅᐊᒪ ᓇᕐᓯᒥ ᑐᑯᑕᐅᕐᒥᒪᒪ. ᑲᓇ ᑐᑯᐊᒪ ᐊᕐᒍᑎᓂᒍ ᓇᕐᓂ
ᒍᒍᒪᑕᐅᕐᒪᕚᑐᒪ ᐊᒪᓗ ᑲᓇ ᐊᓇᐊ ᑕᐅᒪᒍᒪᑕᐅᕐᒪᕐᒪᕚᑤ.
ᐊᓂ ᐊᑉᕚᓇᕐ ᑕᐅᒪᑯᑕᐅᕐᒪᒪᒪᑎᒍᑤ, ᑕᐅᑕᐅᕐᒪᕐᔭᑤ.
ᑕᕚᓂᔑᐊᓇ ᐅᐊᒪ ᑲᓂᓚᕐᓯᑕᐅᑕᐅᕐᑕᓗᓂ ᐱᓂᕐᔭᐳᕐᒥ ᑐᔥᑕᐅᕐᒥ

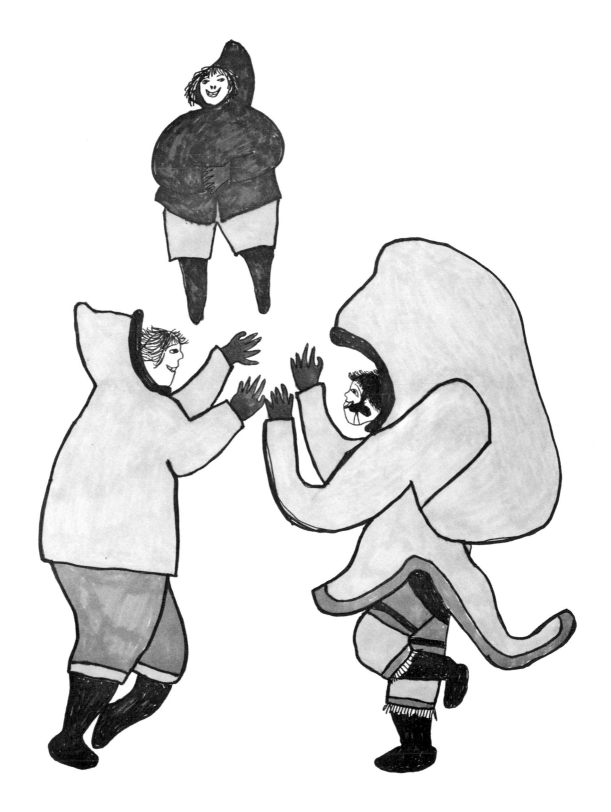

Packing a sleigh (detail).
Coloured pencil and felt pen,
ca. 1967

ᑲᒍᓂᒐ ᐅᖕᐸᒍᐋᕈ (ᐃᒪᐃᓕᖓᒪᒪ)
ᑖᖅᓯᓐᓄ ᐊᒉᐅᖏᓄ ᐊᒡᓗ ᐃᒪᒉᒍ
ᓐᓄᑐᒪ, I967 ᐅᓐᔾ

Dorset, but we didn't tell Ashoona because we were
afraid it would make him even sadder. He died of a very
bad sickness. Many people died at that time in the camps
and in Cape Dorset. There was no doctor then and
nobody knew what the sickness was.

For a long time after Ashoona died we were very sad.
Sometimes I thought I would lose my mind. Whenever a
dog team came to the camp, Ottochie would go and look
for his father. He thought he would find him.

In the spring after Ashoona died, we came out of Natsilik
on a dog team. We came here to Cape Dorset just for
a little while. But my relatives were no longer here. My
eldest brother had died on the water; he was on a kayak
and didn't return. My other brothers, with my mother who
lived for a long time, had gone to Resolute Bay – some
of them died around there just last year, I hear. Now I am
the only one left and I often think that I will not live much
longer, now that my relatives are all dead.

ᕈᒍᑦ ᓄᑲᓪ ᓱᒉᕐᐊᒪ ᕹᖓ. ᐃᐨ ᐅᑳᕌᑎᒉᕐᒪᒉᓐᒉᐨ
ᐊᑫᕋᓄ ᑯᐊᕌᑫᒐᐅᒉᓄ ᐃᐤᓇ ᕌᒍᕐᒍ. ᓄᑫᑕᕲᒪᕗᒃ ᕌᑫ
ᕐᕌᓄ ᑲᓄᒪᕍᓇ. ᕌᒉᕐᒉ ᐃᓄᐃ ᓄᑫᑕᕲᒪᕋ ᑕᕌᕐᒪᓇ
ᓇᒐᓇ ᕌᒡᓄ ᕹᒪᓇ. ᓄᑳᖅᓇᒍ ᕌᒡᓄ ᑲᐅᕲᒪᕲᖅᓇᒍ
ᑲᓄᕌᓄᒪᒪᒻᒉ ᑲᓄᒪᕆᕐ.

ᕌᒍᓄᕌᓄ ᕌᕐᕋᕐ ᓄᒡᒉᓐᒍ ᒐᕌᕌᕐᓄᕋᓄᑫᑕᕲᕋᕌᓪ.
ᐃᒉᒪᒐ ᐃᕲᓕᐅᕕᒍᕵᓄᕋᒉᐅᓪ. ᓐᕋᒍᑲᒪᒪᒉ ᕯᒍᕐᓄ ᓇᒪᓄ
ᐅᕐᓄᕆ, ᓄᕐᕵᕋᒍᓐᒪᒪ ᕵᓄᕵᕋᕲᓄᕐ ᕌᑕᕌᕐᓄᕐ. ᓇᕐᕋᕌ
ᓄᕌᕐᓄ ᕌᑕᕌᕐᓄᕐ.

ᕌᕐᕋᕌ ᓄᒡᒉᓐᒍ ᐅᕐᐃᕵᒍ ᕌᕗᒋᕌᕲᒪᕋᕲᒍ ᕌᕐᒉᕐᒪᕲᕵ
ᕵᒍᕵᕍ. ᕵᕋᕖ ᕌᒪᕲᒪᕋ ᐃᕲᒪᕌᑕᕲᒪᕋᕲᒍ ᕹᒪᓇ. ᐃᐨ ᐃᓇᕖ
ᕌᒪᕌᒪᕍᒍᕌᐃᕲᕲᒪᕋᕲ. ᕌᕋᒪ ᕌᒉᕌᕵᕓ ᓄᒉᕲᒪᕋᕲ ᐃᕲᓄᕖ;
ᕵᕋᕖᕌᓄ ᕲᕐᕹᕍᕲᒪᕋᕲᕓᕵ. ᕌᕐᕖᓄ ᕌᕲᕵ, ᕌᓇᓇᒍ
ᐃᓇᕐᕍᕋᕌᕵ ᕌᒍᓄᕲᒍ, ᕵᑕᕲᕌᕲᒍᕍᕋᕖ ᕷᕲᕲᕓᒍ ᐃᑫᕵᕵ
ᓄᒍᕲᕵᒍ ᑕᕌᕵᓄ ᕌᕵᒍᕲᐃᕍᕵ, ᓄᕹᕵᕲᒪᕋ. ᒪᕲᕵ ᕌᕍᕌ
ᕍᕵᕵᒪ ᐃᕲᕍᕵᕲᒪ ᐃᕲᕲᕵᕵᕵᕵᕌᕲᕵᕵ, ᒪᕲ ᐃᕵᕵ
ᐃᕲᕌᕵ ᕌᕍᕵᕍᕋ.

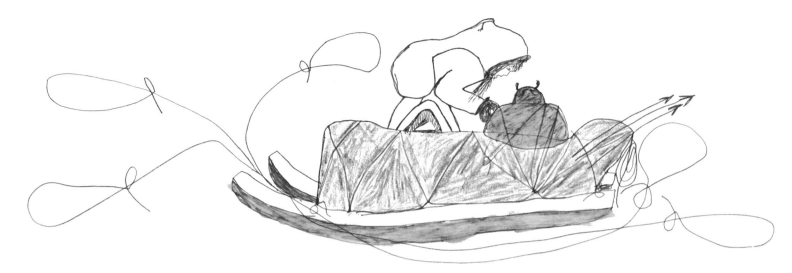

After Ashoona died we were very poor and sometimes we would be out of oil for the kudlik. Things were given to us by other people; we used to get oil from Oshaweetok. We lived in camps near Cape Dorset and my eldest son, Namoonie, did the hunting and sometimes Kaka helped. But for a long time, we were very poor and often we were hungry. We were poor until Sowmik and the government houses came.

Before Jim Houston came to Cape Dorset we had the people at the Bay who were here for the furs, and we were grateful to have them and very pleased to be able to get tea, sugar and flour. But I think Sowmik was the first man to help the Eskimos. Ever since he came, the Eskimo people have been able to find work. Here in Cape Dorset they call him 'The Man'.

When Sowmik came to Cape Dorset we had moved into the settlement and were living here in a snowhouse. This is how we first met him. A boat was coming in from Lake

ᐊ�b ᕐᓄb ᑐᑯᒪᒥᓂᒍ ᐊb ᕐᐸᔅb ᕐᑯᒐᐅᑐᒍ ᐃᓗᓂ
ᐅb ᕐᐸᔪᐸᔅᑯ ᑯᓗ ᐅb ᕐᔑᕐ. ᐊᐸᑕᐅᐸᔅᑯ ᐃᐅbᑎᑎᓄ;
ᐅb ᕐᐸᑕᐊᐸᑐᒍ ᐅᕐᐃᐅᒥ. ᐊb ᓄbᕐᒥᓄᑯ ᑭᐅ ᓴᐅᓄ,
ᐊᒪᓗ ᐊᒪᕐᐸᔪᐸ ᐊbᓄᒪ ᐊᓗᐊ ᐊᒍᐊᕐᐸᓄ bbᐃ ᐃᓄ
ᐃbᕐᑯᓄᓴ. ᐃᓐ ᐅᕐᐸᕐᐊᐸᓄᐊᔅb, ᕐᑯᒪᑎᐊᓄᐸᑐᒍ
ᕐᐸᐊᓴ ᓴᐅᒥ bᕑᒪᑯᓄ ᐊb ᓴᒥ ᑎᕐᒪᓗ ᕐᑯᒪᓄᐊᐃᐸᑐᒍ.

ᓴᐅᒥb ᑎᕐᑯᐅᑎᓄᒍ ᕐᒪᐅᓴ ᓄᐅᐸᑎbᕐᐸᑐᒍ (ᒪᓗᓄᐸᐅᓄ
ᕐᐸᓄᓴ ᑎᑎᓗᐊᔅᐅᓄ ᐊᒪᓗ ᑯᕑᕑᐸᓄᕐᐸᑐᐅ (ᒪᓗᒪᑎ
ᓄᑯᓐᕑᐸᓄᕐᐸᑐᐅ ᑎᑯᔪᐸᐅᑐᓴᐃ, ᕐbᕐ ᕑᐸᐅᒥᕐᓄ. ᐃᓐ
ᓴᐅᕐ ᕑᐸᕐᑯᐊᐅᑯᐸᕐᒪᑯᑐ ᐊbᕑᑎᐊᒥᕐᓄ ᐃᓄᓄ. ᑕᐊᒪᓄ
ᓴᐅᕐb ᑎᕐᑯᐅᕑᒪᒪᓴ, ᐃᓄᐊᐃ ᐸᕑᕑᑯᒪᕑᕑᒪᑯᐊ. ᒪᓄ
ᕑᒪᕐᐅᓄᐊᐃ ᐃᓄᓄᐊᐃ ᐊᒍᑎᐅᓄᕐᑯᐅᕑb.

ᑕᐊᕑᒪᓄ ᓴᐅᕐ ᕑᒪᓄᓄᒍ ᓄᓄᐅᕑᑯᕑᐊᒍ ᐊbᓄbᓄᒍᐊ ᐊᒪᓗ
ᐃb ᓄᐊᒪᕑᑎᐅᓄᑯᐅᕑᑯᕑᐊᒍ. ᑕᐊᒪᓄᒪᒪ bᑎᕐᐊᒪᓗᑯᓄᕑᐸᕑᕑᒪᑯᐊᔅb
ᓴᐅᕐᓄ. ᑕᐊᕑᒪᓄ ᐅᕐᐊ ᑎᕐᑯᐅᕑᕑᒪᕐ ᕐᒥᐅᕐ ᐃᕑᓄ ᑕᐊᒪ
ᓄᐅᐸᐅᑯᕑᑯᕑᐊᒍ ᐃᒪᐅᕑ ᓴᓄᐊᓄ ᑕᑯᐊᐊᕐᕑᑯ ᕐᓄᑯᒪᒪᓄᑯ.

Bringing a gift.
Felt pen, ca. 1967

ᐊᐊᒍᏆᑭᕝ ᐊᑊᕐᑋᔭᕝ
ᐃᒪᓗᒍ ᐊᓂᐳᓪ ᏆᏁᎴ,
1967 ᐅᏁᒍ

Harbour and we went over near the Bay to see who was on it. That was the first time I saw Sowmik. We didn't know he was coming in and we had never heard of him before but, immediately, he began to ask for carvings and sewing. After this visit he came often to Cape Dorset, and then he built his house and the government office.

At first, after Sowmik came, I did lots of sewing. I made parkas and duffel socks with designs. Lots of women began to work – any kind of women so long as they could sew. I used to embroider animals and all kinds of living things. But it was always $12 for a parka – even though it was hard to do.

Two winters – two years – after Jim came to live in Cape Dorset, he began to ask for drawings. Many people had been doing the drawings before I started. It was only just before Jim went away that I heard people were drawing to make money. I heard that Kiakshuk was drawing, and he was my very close relative – my mother's sister's son.

ᑖᐱᒪᓂ ᑕᑯᕆᐊᒧᑯᐳᕐᒪᕿ ᑲᐳᕐᓄ. ᒥᐳᕆᒧᐳᕐᒪᕿᏆᒪ
ᑲᐃᓇᐊᒪᒪ Ꮪᓯᑫᐳᕐᒪᓄᒍ ᐃᓯ, ᐊᎴᏁᑲᐊᏁᕆ ᐊᑫᏁᑫᐳᕐᒪᕝ
ᓇᒍᐊᒪᓂ ᒥᕈᕐᒪᕝᔭᓄᒍ. ᓯᐅᎴᕆᕐᒪᓕᒪᕆ ᏁᕿᒍᕿᏁᐳᕐᒪᕝ
ᕿᒪᒪᐤ ᐊᒪᒍ ᑕᐊᒪ ᐃᑊ ᓄᏁᑫᐳᑫᐳᕐᒪᕝ ᐃᑊ ᒍᕋᒪᓂ ᐊᒪᒍ
ᑲᕝᒪᒍᑊ ᏁᏁᓭᒪᓄᑊ.

ᕐᔭᓕᕝᒥ, ᑲᐳᒥ Ꮑᕿᑲᒫᐅᓄᒍ, ᐊᒪᕆᕝᔭᓄᑊ ᒥᕆᏁᐳᕐᒪᕝ
ᒪ. ᐊᏁᕆᏁᐳᕐᒪᒪ ᐊᒪᒍ ᐊᏁᏆᒪᓂ ᐊᏁᏁᏆᏆᒪ ᑕᑊᓯᏁᏁ
ᕿᑊ. ᐊᒪᒍ ᐊᑊᐊᏆᑊ ᐊᒥᕐᑊ ᒥᑊᕆᑲᒥᏁᒍᕆ -- ᕿᓇᏆᐃ
ᐊᒍᑊ ᒥᑊᕆᕐᔭᓇᒍᐊᕐᒥ. ᒥᑊᕆᏆᓄᑊ ᑕᑊᏚᑫᏁᕝᑫᐳᑫᐳᒪ
ᑲᒪᐊᒍᒍᐊᓇᓄᑊ ᐅᒪᕝᒍᔭᓄᑊ. ᑕᐊᒪᒪᓕᑲᒪᑊ ᐊᏁᕿᑊ ᒥᕈᓄᕿ
$12-ᑕᓕᓄ ᐊᑊᑊᕝᑫᐳᑊᑊ -- ᐱᓯᏁᐊᒍᓕᓄᐊᕐᒥ.

ᐅᕿᐅᓂ ᒪᕋᓄᑊ ᑲᐳᒥ ᕿᓄᕆᓕᓂ ᐊᎴᏁᕆᑫᐳᕐᒪᕝ ᐱᕝᏆᓄᓂ
ᏁᏁᑊᕐᒪᕝᔭᓄᑊ. ᐊᒥᕆᐊᔭᑊ ᐃᐊᐃ ᏁᏁᑊᕐᑲᑕᓕᑫᐳᕐᒪᕝᑊ
ᐱᒥᐊᏁᐳᏁᒪᒪ. ᑲᐳᒥ ᐊᐳᓕᒥᓇᐊᒃᐊᏁᒍᒍ ᒍᕐᑫᐳᕐᒪᕝᕝ
ᐃᐅᐊᑊ ᏁᏁᑊᕐᒥᐊᕿ ᕿᓇᐳᕐᑫᐳᒍᏁᒥᕈ. ᒍᕐᑫᐳᕐᒪᕝᕝ
ᕿᐊᕐᒥ ᏁᏁᑊᕐᒍᒥ ᐊᒪᒍ ᕿᐊᕐ ᐃᑲᒍᒍᕐᑫᐳᕐᒪᕐᒪ ᐊᐊᒪᒪ
ᓄᑊᓕᑕ ᐃᑊᓄᒥᕐᒪᕝ.

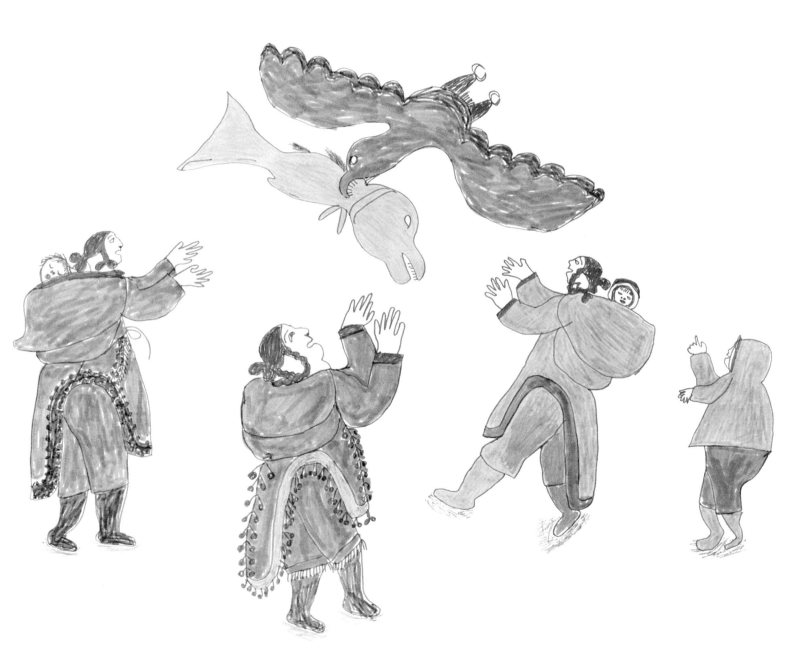

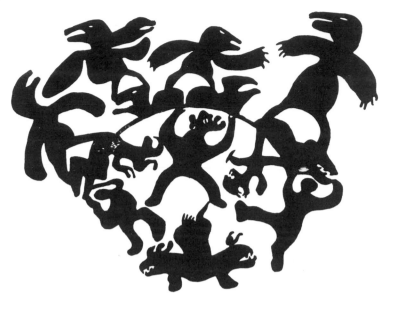

Kiakshuk was drawing a lot and I wanted to do drawings, too, to make some money. I bought some paper myself and I think I made four small drawings. I think I drew little monsters. I meant the drawings to be animals but they turned out to be funny-looking because I had never done drawings before. I took these drawings to Jim's office. I was scared to go there at first but he gave me money – I think it was $20.

I began to think, maybe someday I can be like Kiakshuk. Maybe I will. Kiakshuk was working really hard on the prints when he died. He worked right up to the time he died. I am still doing the drawings and perhaps I will die like Kiakshuk, doing the drawings right up to the end.

Because Kiakshuk was a very old man, he did real Eskimo drawings. He did it because he grew up that way, and I really liked the way he put the old Eskimo life on paper. I used to see Kiakshuk putting the shamans and spirits into his work on paper. Were the shamans useful in

ᑭᐊᕐ ᑎᑎᒍᖦᔪᑦᐸᖕᓴᕐᓴᐅᕐᒪᖕ ᑕᒪ ᑎᑎᒍᖦᔪᒪᖦᓴᕐᑐᑕᑕᖕ ᖃᓄᐅᖕᕐᑕᐅᑐᒥ. ᓂᐅᐱᐊᕐᑕᐅᕐᒪᒥ ᐸᐃᐳᒥ ᑕᒪ ᕐᐸᑭᑎᐊᑐᓂ ᒥᑭᕐᓂ ᑎᑎᒍᖦᕐᑕᐅᕐᒪᒥ. ᑎᑎᒍᖦᕐᑕᐅᕐᒪᒥ ᑐᒍᐊᑯᓄ. ᑎᑎᒍᖦᕐᑕ ᐅᖦᕐᑕᐊᕐᒪᕐᓂᓴᕐᕐᐸᕐᒪ ᑕᓚ ᐱᐅᕐᒐᐊᒍᕐᑕᐅ ᕐᖦᕐᑕ ᑎᑎᒍᖦᕐᑕᐅᕐᒪᕐᓂᒪᖕ. ᑕᔪᐊ ᑎᑎᒍᖦᕐᑕᖕ ᓴᕐᒥᐃᕐᓴ ᑎᑎᕐᓱᒪᖕᓂᐃᐃᐅᕐᒪᖕᕐᖕ ᐴᐃᕐᑕᐅᕐᒪᕐᒪ ᐆᑎᕐᓴᕐ ᕐᕐᓴᖕᕐᒪ ᑕᒪ $20-ᑕᖦᒥ ᖕᐊᕐᓱᕐᑕᐅᕐᒪᕐᖕ.

ᐃᕐᓴᖕᕐᑕᐅᕐᒪᕐᒪ, ᐃᒪᖕ ᖕᓚᐃᐊ ᑭᐊᖕᕐᑎᒍᒪᓴᖕᖕᒪ. ᐃᒪᖕ ᖕᕐᑕᒪᓚ. ᑭᐊᕐᖕ ᐊᕐᕐᐊᓴ ᐱᓱᕐᐊᓚᕐᑕᕐᓂᕐ ᑎᑎᒍᖦᕐᒪ ᑐᕐᖦᕐᑕᐅᕐᒪᕐ. ᐱᐊᕐᖦᕐᑕᐅᕐᒪᕐ ᓂᕐᖕᖕᑕᐅᕐᒪᕐᒪᓂ ᑐᕐᒥᕐᑕᕐᒪᕐ. ᕐᓂ ᑎᑎᒍᖦᕐᑕᐅᖦᖕᑐᑕᒪ ᐃᒪᖕᑕᐅ ᑐᕐᓚᕐᒥᕐᒪᖕᕐ ᑭᐊᕐᑎᖕᕐ, ᑎᑎᒍᖦᕐᑕᐅᓴᖕᓂ ᓱᒐᐊᓂ ᓂᑭᓴᖕᓂ.

ᑭᐊᕐᖕ ᐊᑐᐊᒍᖕᕐᑕᐅᕐᒪᒪᕐ, ᐃᓄᑎᑎᒍᖦᕐᓂ ᑎᑎᒍᖦᕐᕐᑕᐅᖦᖕᕐᖕ. ᑕᒪᓚᐊᐅᖕᕐᕐᑕᐅᖦᖕᕐᖕ ᑕᒪᓚ ᐃᓄᓂᖦᒥᕐᒪ, ᐊᕐᖕ ᐱᐅᕐᖕᕐᐊᕐᕐ ᕐᖕᑕᖕᕐ ᐃᓄᐊᕐ ᐃᓄᕐᔭᖕᕐᓂᕐ ᐸᐊᕐᔪᖕᓴᕐᒪ. ᑕᔪᕐᑕᐅᖕᕐᕐ ᑭᐊᕐᖕ ᐃᑎᕐᖕᓴᖦᒍ ᐊᒪᖕᓂ ᑐᒪᓴᖕ ᐱᓴᕐᖕᒥᕐᓂ ᐸᐊᕐᔪᖕᕐ.

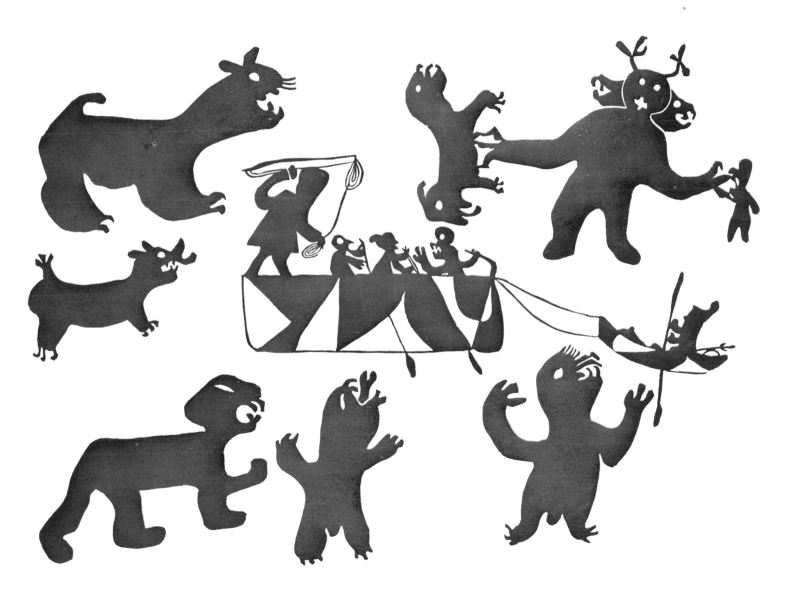

any way? I don't know much about shamans because
I don't like to think about them. Did the Anglican clergy-
men tell people not to be shamans? I have never heard
of a single minister telling an Eskimo not to be a shaman.
People just didn't like to give instructions to these
powerful people.

Jim Houston told me to draw the old ways, and I've been
drawing the old ways and the monsters ever since. We
heard that Sowmik told the people to draw anything, in
any shape, and to put a head and a face on it. He told
the people that this drawing was very good. Some people
saw the monsters, somewhere, some place, but I have
never seen the monsters I draw. But I keep on drawing
these things and, sometimes, when I take Terry a monster
drawing, I say, ''Perhaps when I die I'll see these
monsters.''

Terry Ryan came to Cape Dorset just before Jim went
away. Terry, whom we call 'The Printer', came to run the

ᐊᒪᑯᐊᖕ ᐊᑐᑐᐸᓗᕐ ᖃᓄᐊᖄᖃ? ᖃᐅᕿᒪᒍᑎᒪ ᐊᒪᑯᐊᖕ ᒥᔅ
ᓄᕐ ᐊᒋᒪᕆᒎᓕᕿᕋᖃᕿ. ᐊᕿᕿᐅᐊᐱ ᐅᖃᐅᑎᓇᐅᕿᕿ ᐊᓗᖕ
ᒪ ᐃᓄ ᐊᒪᑯᑯᐱᓗᖕ. ᐃᓄ ᒪᓕᖃᐅᑯᐊᕆᑎ ᐃᓇᓕᐅᕿᒪᕿᖃ
ᑕᒃᑯᒪᒪ ᕆᒍᕿᐅ ᐃᓗᖃᖃᖃᖃ.

ᕿᐅᒪᐱ ᐅᖃᐅᑎᓇᐅᕿᖃᒪ ᑎᑎᖃᑯᔭᖃᒎᒪ ᐅᕿᕿᐊᐸᖃᕿᓂᖄ,
ᑕᒪᒪ ᑎᑎᖃᕿᕿᒪᕿᕿ ᐅᕿᕿᐊᐸᖃᕿ ᐊᒪᓗᖁ ᐊᒪᒋ ᑐᒪᖃ ᑕᒪᒪᒎᖄᕿ.
ᑐᕿᖃᐅᑐᒪ ᕿᐅᒪ ᐅᖃᐅᑎᖃᖃᓄᖃᖃ ᐃᓄᖃ ᑎᑎᖃᒎᒪᕿᕿᒎ
ᖃᓄᐊᑐᑐᐊᓄᖃ, ᖃᓄᐊᖕ ᐊᕿᕿᒪᖃᕿᒪᒎ, ᐊᒪᒎ ᖃᐊᒎᒪ
ᐃᓇᒎᔪ ᕿᐊᖃᑎᒎᒎᒎ. ᐅᖃᐅᑎᖃᐅ ᐃᓄᖃᖃ ᑕᐊ ᖃᐊᒎᖃᒎᖃᖃ
ᕿᐊᖃᕿᖃᒎ ᑎᑎᖃᕿ ᐊᕿᕿᕿᒎ ᐱᐅᕿᑯᒎᖃᐅᕿ. ᐃᓄᐊᖕ ᐃᐊᒋ
ᑕᒃᑯᖃᐅ ᑐᑎᖃ, ᐊᒋᑕᐊᖄ, ᓄᐊᒋ ᐃᖄ ᑕᒃᑯᖃᐅᕿᒪᒎᕆᑕᐊᖃᖕ
ᑐᑎᖃ ᑎᑎᖃᕿᖃᕿᒪᒎᒪ. ᐃᖄ ᑎᑎᖃᕿᖃᓇᖃᑯᑐᒪ ᑕᒃᑯᒪᒎ ᐊᒪᒎ
ᐃᒎᒎᖃ ᑎᑎᑎᒎᒎᖃᒪᒪ ᑐᑎᖃ ᑎᑎᖃᕿᕿᒪᕿᖄᒎ ᐅᖃᒎᒪ "ᐃᒪᖃ
ᑐᒎᔪᒪ ᑕᒃᑯᖃᖃᖃ ᑕᒎᐊ ᑐᑐᐊᖕ". ᑎᑎᕿ ᕸᐊᕿᖄᐊ ᕿᒪᒎᖃᐅ

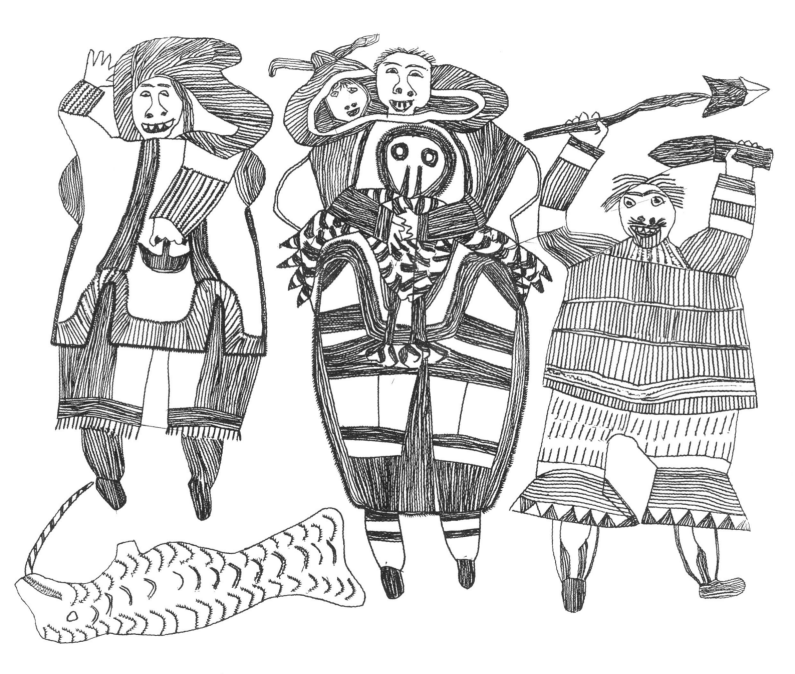

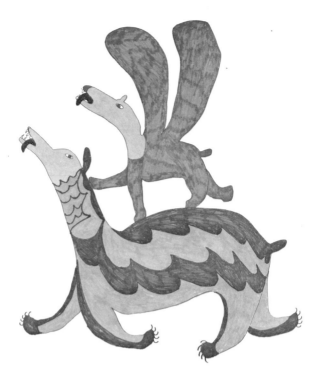

Some people saw the monsters, somewhere, some place.
Felt pen, 1970

ᐃᓄᐃᑦ ᐃᓕᒋᓐᕿ ᑕᑯᕈᓛᕈᓐ ᑐᓗᓐᓇᒃ
ᓇᓄᑐᐃᓇ ᐊᓴᐅᑎᓐᕿ ᐃᓕᓇᒍᓐ ᑎᑎᑕᒪ
I 970

Bird spirit and fish.
Stone cut, 1968

ᕿᐸᓇᐊᔭᑦ ᐊᓪᓗ ᐃᑲᓗᑦ
ᐅᕸᒋᒪ ᑎᑎᑕᒪ, I 968

Co-op. The Co-op sends the carvings and prints to the south, and it is owned by Eskimos. I don't know exactly how it works but there is a board of directors who are Eskimo. Terry gives out the pens and the papers for drawing, and later when we bring him our work, he pays for the drawings and carvings. I don't do drawings when Terry has gone somewhere; when Terry's away I get tired of waiting for him. A lot of people miss him when he's away.

Since the Co-op began I have earned a lot of money with my drawing. I get clothes from the drawings, and I earn a living from paper. Because Ashoona, my husband is dead I have to look after myself, and I am very grateful for these papers – papers we tear so easily. Whenever I am out of everything, I do some drawings and I take them to Terry at the Co-op and he gives me money with which I can buy clothes and tea and food for the family. He is paying well. I am happy to have the money and I am glad we have a Co-op.

ᕿᓚᐊ ᓴᐅᒥ ᐊᐅᓚᕐᔪᐊᑎᓴᐱᓐᓇᒍ. ᑎᐅᑎ ᑕᐊ ᐊᕐᓱᑕᐅ
ᑎᑎᑐᓚ ᓂᕿᓚᐅᕿᓚᐊ ᑯᐅᐊᑕᒥ ᑲᓚᕐᐊᑐᕐᓂᐊ. ᑕᐊ ᑯᐅᐊᑦ
ᐊᐅᑎᓐᕿᑲᑐ ᓴᐅᐱᓚᕿ ᑎᑎᑐᓚᕿ ᑲᓇᑦ ᓄᐊᓚᕿ, ᐊᓪᓗ
ᓇᒥᓂᕼᐅᕿᒍ ᐃᓄᕿ. ᑲᐅᕼᓚᒥᓚ ᑲᕿᕐᐊ ᐱᕐᔪᓚ ᐃᓕ
ᐊᓚᐊᑲᑐ ᐃᓄᕿ. ᑎᐅᑎ ᑐᓯᕐᑲᑐ ᑎᑎᔅᐱᓐᒃ ᐸᐊᓴᕿ
ᑎᑎᑐᓚᕼᐊᓱᕿ ᐊᓪᓗ ᐊᑯᑲᑦᕿᓚ ᑎᑎᑐᓚᕿ ᓇᔪᐊᓚᕿ.
ᑎᑎᑐᓚᑲᑐᕼᕐᑐᓚ ᑎᐅᑎ ᐊᐅᕿᕐᓚᓚᐊᓚ ᓇᔾᑐᐃᓇ; ᑎᐅᑎ
ᐊᐅᕿᕐᓚᓚᕿᐊᓚᕿ ᐅᑕᕿᒍᕼᕿᕼ. ᐃᓄᕿᑦ ᐊᕐᕿᓚ ᐱᕿᓚᐊᕼᐅᐸ
ᕿᓚᑲᑐᕿ ᐊᐅᕿᕐᓚᓚᕿᐊᓚᕿ.

ᑕᐊᓪᓗᓇ ᑯᐅᐊᕿᕐᕿ ᐱᕿᐊᕐᓚᐅᕿᒪᓚᕿ ᕿᓇᐅᕼᓚᑐᕼᔪᓚᒃ
ᑎᑎᑐᕼᑲᓚᕿ. ᐊᓚᕼᑲᕿᓚ ᑎᑎᑐᕼᑲᓚᕿ, ᐊᓪᓗ ᕿᓇᐅᕼᓚᐊᓇ
ᐃᓄᓚ ᐸᐊᕿᓇ. ᐅᐊᒪ ᑐᑯᕿᓚ ᐃᕐᓇ ᑲᓚᕿᐊᑲᓚᓚ ᐊᓪᓗ
ᓇᑦᕼᑐᓚ ᑕᑐᓇ ᐸᐊᕼᓇ ᐊᐅᕼᐊᑕᐱᕼᓚᕼᐅᓇ. ᑲᓚᑐᐊᐊᓇᓚ
ᓄᔾᕼᓚᓚ ᕿᐊᑐᐃᓇᓚ, ᑎᑎᑐᕼᕿᐊᑐᓚ ᑕᐊᓚ ᑎᐅᑎᓚᑲᓚᕼᕐᕿᕼ
ᑯᐅᐊᕼᓚᕿ ᕿᓇᐅᕼᓚᓇ ᑲᐊᕼᕿᑐ ᐊᓚᕼᓇ ᓂᐅᐊᐅᑎᕼᕿᑲᓇ ᑎᕐᒥ
ᐃᓚᓇ ᓂᑎᕼᔅᕼᒥ. ᑎᐅᑎ ᐊᕿᓚᕼᐊᑐᑲᕼᐅᕼᕐᑐᕿᕼ. ᑯᐊᕐᑐᓚ
ᕿᓇᐅᕼᓚᑲᕿᐊᕼ ᐊᓪᓗ ᓇᑦᕼᑐᓚ ᑯᐅᐊᕼᑲᓚᕼ.

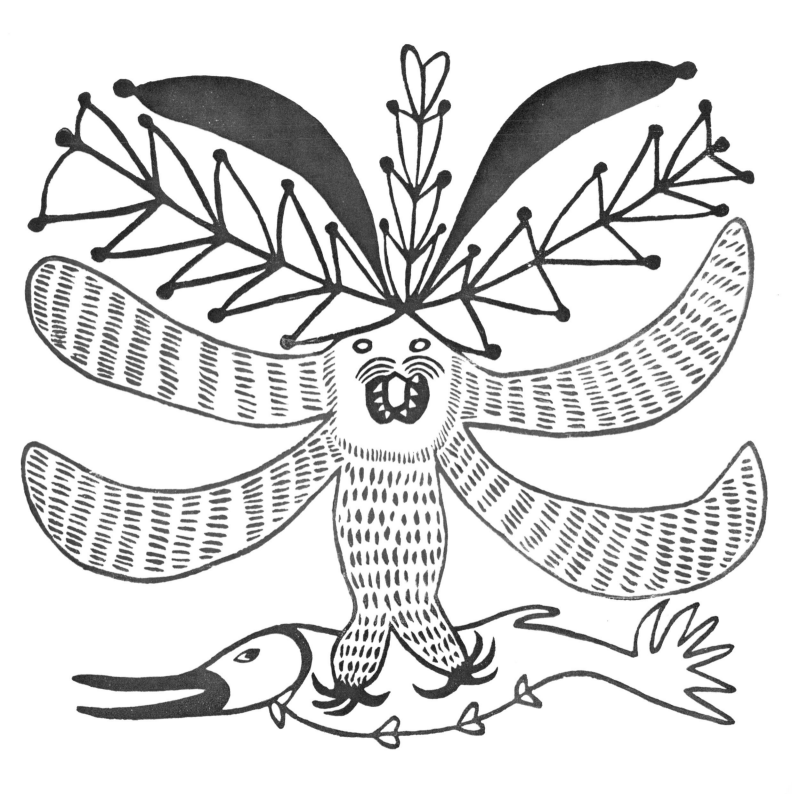

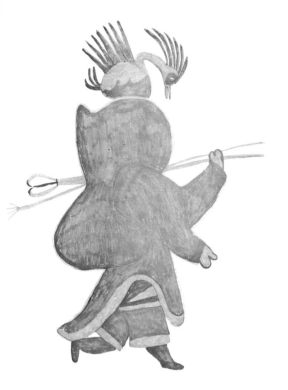

The woman with the blue fish spear.
Felt pen, 1970

Pitseolaks.
Felt pen, 1970

ᐊᐧᖃᓇ�ᐧᒃ ᑐᒍᐊᕐᑎᖅ ᑲᑭᕐᓇᖀ
ᐊᓕᓇᒍ ᐊᒐᐅᑎᒍ ᑎᑎᒪ, 1970

ᐱᕐᐅᓚᕙ
ᐊᓕᓇᒍ ᐊᒐᐅᑎᒍ ᑎᑎᒪ, 1970

Does it take much planning to draw? Ahalona! It takes much thinking, and I think it is hard to think. It is hard like housework.

The other day I drew an Eskimo woman with a blue fish spear. I did not want to leave the fish spear alone; that is why I put the bird on her head. There's a baby hidden inside the parka, too – you can tell by the shape of the parka!

When I first started doing the drawings I did all the work in black and brown, and I still like these two colours, although now we are using many coloured pens. Jim said to draw the old ways in bright colours.

After Terry gets the drawings, some are put on the ·stone and made into prints. The drawings are carved into stone by Nawpachee's husband, Eegyvudluk, and by Iyola, Lukta and Ottochie. After they are put on the stone, they are always better. Sometimes we make prints, too, with

ᑎᑎᒍᕐᑕᒪᕐᖁᒥ ᐱᕐᑎᐊᒍᐧᒃ! ᐊᑉᓇᓇ! ᒪᑎᐊᒍᕐ ᐊᑉᕐᐊᒍ.
ᐊᕐᒪᕐ ᐊᑉᕐᓚ ᐅᑉᒪ ᐊᕐᒪᕐ ᐊᑉᕐᓚᖁᕐᕆᓚ. ᐱᕐᑎᐊᒍᕐᓚ
ᐊᑉ ᓚᓂᑉᑎ ᐊᕐᑎᒍᑉ.

ᐅᓚᐊ ᐊᓚᒍᓂ ᑎᑎᒍᕐᒋᐅᒪᓚᒐᖅ ᐊᓂᒥ ᐊᑉᓇᒥ ᑐᒍᕐᒋᐅᑎᒍ
ᐊᑉᓚᒥ ᑲᑭᕐᓚᒋᒥ. ᐊᒐᕐᐱᐅᑎᕐᑉᐅᓇᐊ ᐊᑉᓚᒥ ᑲᑭᕐᐅᑎ,
ᑕᐊᒪᐊᒪᕐ ᓂᐊᑉᓚ ᓂᕐᑉᑎᐅᑉᒪ ᑉᕐᓚᐊᕐᑉ. ᐱᐊᕐᑉᐅᒥᕐᑉ
ᐊᐅᕐᒪᕐᑉᑐᑉᑉ ᐊᑎᕐᐅᕐ ᐊᒍᐊᓂ, ᑕᑉᑕᐅᕐ ᐊᕐᐱᕐᒪᓚᒥ
ᐊᑎᕐᐅᕐ!

ᕐᐅᑉᐊᕐ, ᑎᑎᒍᑉᑕᑎᑕᐊᒍᕐᓚ ᑎᑎᑉᑐᕐᑕ ᐊᓚᓂᑉ
ᓂᓂᑕᐅᕐᐊᑉᑐᑉ ᑉᕐᓚᑎᓚ ᐊᒪᓚ ᕐᓂ ᑕᐊ ᒪᕐ ᒥᒍᐊᑉᑎᕐ
ᐱᐊᑎᓂᕐᑉ, ᒪ ᐊᕐᕐᓂ ᐊᑐᑎᐊᑉᑎᒪ ᑉᕐᓂᓚᓂᕐ ᑎᑎᒍᕐ
ᐅᑎᓂᕐ.

ᑎᑉᑎ ᐱᕐᐱᒪᑉᑕᒪ ᑎᑎᒍᕐᐱᒪᕐᓂ ᐊᓚ ᐅᕐᑕᒍᑕᑉᕐᓚᓂ
ᐊᒪᓚ ᑎᑎᒍᕐᑕᐊᑉᕐᑉᑉᓂ. ᑕᑉᐊ ᑎᑎᒍᕐᐱᒪᕐᑕ ᓂᑲᑉᑕᐱᒪᕐᑕ
ᐅᕐᑕᒍ ᓂᐊᕐᐱᑉᑕ ᐅᐊᓚᓂ, ᐊᑐᕐᓚᒍ, ᐊᒪᓚ ᐊᐊᑉᓚᑎᑉ,
ᓚᑉᑕ ᐅᑐᕐᒍᓚᒍ. ᑕᑉᐊ ᑎᑎᒍᕐᐱᒪᕐᑕᐊᑉᑎᒥᕐ ᑉᕐᓚᐊᑉᑎᑎ
ᑉᑕᑎᓚᒍ ᐅᕐᑕᒍᑕᑉᑉᑕᑉᒪᕐ, ᑕᐊᒪᓚᑎᓚᒪᕐ ᐱᐅᓂᐊᑉᑉᑐᑎᑉ.

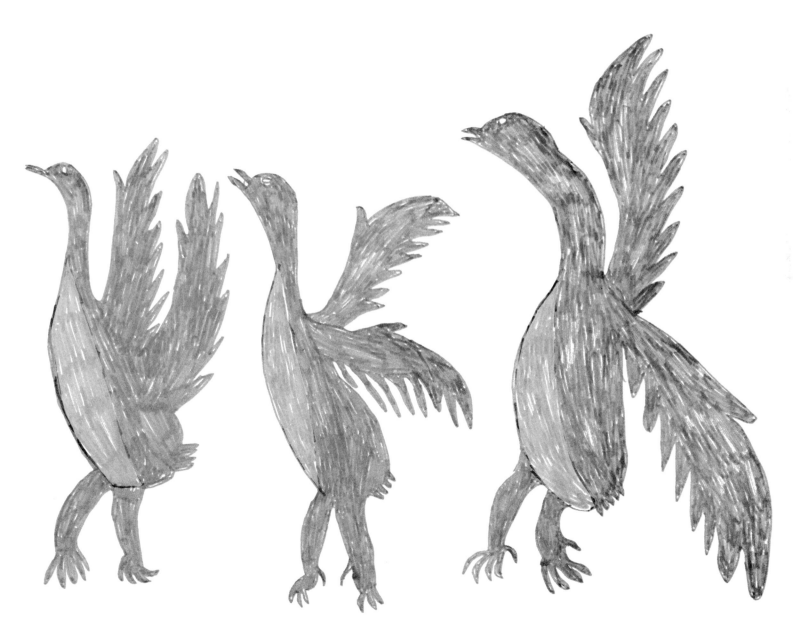

stencils and with copper plates. Now some of the drawings are also arranged on material and, when it is carefully done, it looks very well.

Sometimes, when I see pictures in books of my drawings and prints, I laugh. I laugh to think they have become something. But even when they are waiting for papers from the south, Terry Ryan is giving artist's papers to me. Sometimes, when I am the only one who is given papers to draw on, I am scared that the other women will become jealous of me. Sometimes I feel sorry when other people don't have papers – papers which I can get.

But many Cape Dorset people have done well with the prints. I don't know who did the first print, but Kiakshuk, Niviaksiak, Oshaweetok and Tudlik were all drawing at the beginning. I liked the first prints – I liked them because they were truly Eskimo. Others have worked well, too. Parr was an old man when he began to draw, and he died last year, but I really loved the way he drew. Kenojuak

ᒪᓇ ᑎᑎᑐᓭᒪᓭᐊ ᐊᓪᒥ ᐊᕿᑕᐅᓭᒥᕋᓭᑕ ᑯᓄᑕᒍ ᐊᒡᓗ
ᐱᓭᐊᕈᐅᓪᐅ ᐊᒡᒥ, ᐱᓭᐊᕈᐅᓭᐸᓄᒃᑐᖃ.

ᐃᓚᓂ, ᑕᑐᒪᒪ ᐊᐸᒍᓄ ᐅᒃᑲᓪᓚᒥᑐᓄ ᑎᑎᓭᑕᐤᓯᓄᕋᒪ
ᑎᑎᓭᒍᓭᒪᓭᕍᓪ, ᐃᕍᑐᒪ. ᐃᕍᑐᒪ ᐊᕐᒪᕐᒪ ᑕᑮᐊ
ᕍᓄᐃᐊᒍᕐᐊᕐ. ᐃᓪ ᐅᑎᒃᒐᓪᐊᒪᒡ ᐸᐃᕍᓄ ᑯᓄ ᓄᐊᓚᓄ
ᐱᕍᓄ, ᑎᐅᑎᐅᕐ ᐊᐊᑐᕍᒪᒪ ᑎᑎᓭᐅᑎᕐ ᐸᐃᕍᓄᐊ. ᐃᓪᓄ
ᐅᕍᒪ ᒍᕍᓄ ᕸᐃᕍᒥᕐ ᐊᐊᑐᑕᐅᓯᕛᐊᒪᒪ ᑎᑎᓭᕸᓯᕍᕐᒃ
ᒃᐊᐱᕐᕍᓄᒪ ᕍᕐᕐ ᕍᓄᐊ ᕈᕍᓄᕈᓄᕍᒡᒪ ᐅᕍᓄ. ᐃᓪᓄ
ᒥᕍᕍᓄᒪ ᕍᕐᕐ ᐃᓄᐊᕛ ᕸᐃᕍᕐᒍᓄᐊᒍᕍᒡᒪ ᕸᐃᕍᕐ ᐅᕍᒪ
ᐱᕍᓄᑕᕐᓄ.

ᐃᓪ ᐊᒥᕐ ᕮᕐᕈᐅ ᐃᓄᐊᕛ ᐱᕍᕍᓄᕍᓄ ᑎᑎᓭᕸᑕᐅᕍᓭᕐᕛ.
ᒃᑕᕐᕮᕐᑐᒪ ᕮᓄ ᕐᕛᕛᕍᐅᕐᒍᓄ ᑎᑎᓭᑐᕍᒪᓭᕍᒪᐅᒪᓪᓪ, ᐃᓪ
ᕮᕍᕐ ᕮᐊᕍᕐᐊᕛ, ᐅᕍᐊᕐ ᑐᕛᓄ ᐃᓄᐊᓄᕛ ᑎᑎᓭᕸᕍᓭᕛᒪ
ᕛᕍᕮᕐ ᕛᕐᐊᕮᕍᕐᓂ. ᐊᐅᕛᑐᒪ ᕛᕍᕮᕐ ᑎᑎᓭᕸᑐᕍᕛᒪᓪᒪᕛᓄᒍ
ᐊᐅᕮᕛᕐᒃ ᐃᓄᐊᑎᐅᕛᒃᑕᐅᕛᒪᓪᕛ. ᐊᕛᕐ ᕮᕛᕍᕍᑕᐅᕮᕛᐊᕛᕐᒃ.
ᕍ ᐊᕐᕍᓄᕍᐅᕐ ᑎᑎᓭᕸᕍᕐᓄ ᐊᒡᓗ ᕐᑐᕍᐅᕐ ᐊᕛᓄ, ᐃᓪ
ᐊᐅᕮᕛᕍᓄᕮᓄᕍᐅᕐᒃᕐ ᑎᑎᓭᕮᕛᕍᕛᕍᓭᕛᐅᕛᒪ. ᐊᒡᓗ ᕮᓄᐊᕛᕛ
ᐅᕛ ᕍᓄᕍᒪ ᑐᕐᓄᕍᐅᕐᒪ ᕛᓄᕮᓄᕸᐅᕛᕍᕛᓄᒥ ᕮᓄ ᓄᐊᓄᒥ.

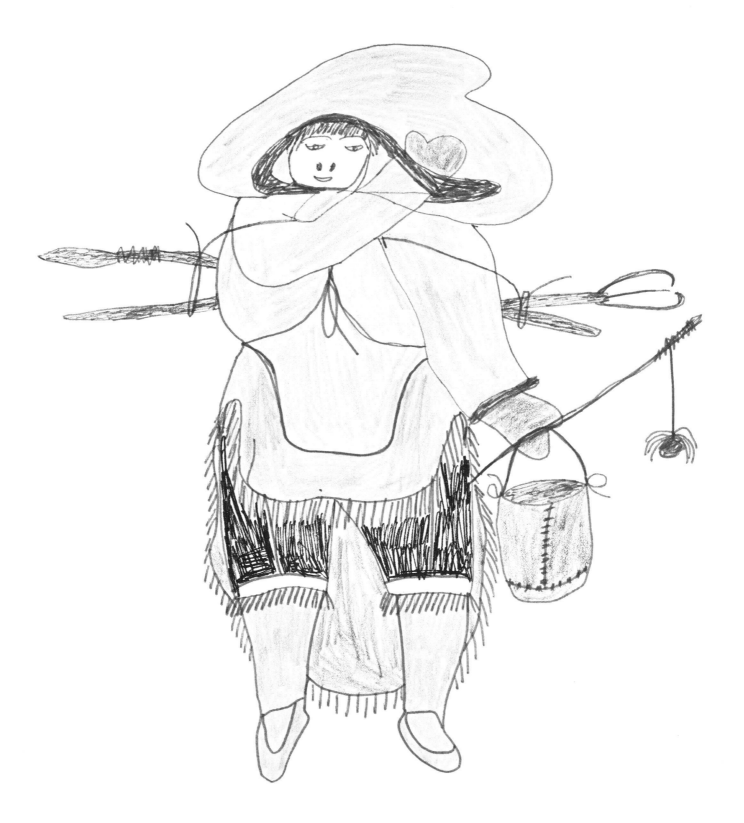

Woman hiding from spirit.
Stone cut, 1968

ᐊ�? ᑐᒐᑦ ᐊᐸᖕᓚᖅ
ᐅᖕᒐᒥ ᑎᑎᑐᒪ, 1968

made the owl which, I hear, became famous in the south.
Lucy is good sometimes and I have seen something
of Pudlo's which I like.

ᓗᖕᐸᑦ ᑎᑎᑐᖕᓗᒥᑦ ᐱᐅᕐᒐ, ᑕᑯᖕᒪᖅᐊᒥ ᑭᕐᑐᐃᓂᖕ
ᐸᓇ ᑎᑎᑐᖕᑕᐃᓂᕐᓂᖕ ᐊᐱᕐᓇᐅᖕᓇᖕ, ᐊᒪ ᐱᐅᖕᑐᒪ
ᖁᐊᓇᖓ ᑎᑎᑐᖕᓗᓇ ᓴᖕᑐᑦ ᑎᑎᑐᖕᑕᐃᓂᕐᓂᖕ.

My children are working for the Co-op, too. Kaka and
Kiawat are carving. Kiawat has also done prints – he once
drew a muskox with big horns – but he has been carving
since he was a young boy and is good at the carving.
Kaka also makes good money carving. Nawpachee does
sewing, drawing and carving, and Kumwartok and
Ottochie and Namoonie carve sometimes. But Kaka and
Kiawat are best. Once, Kiawat and Nawpachee's husband,
Eegyvudluk, went to Ottawa to do some carving and meet
the Queen. Jim Houston arranged it. But they didn't go
to Frobisher Bay to see her there when she came this year.
They had seen her already.

ᑭᐅᖕᑲ ᐃᖃᓇᐃᖕᒐ ᖁᐅᐊᖕᒥ. ᑲᑲ, ᑭᐅᖕᒐᓗ ᓴᐅᐅᑐ.
ᑭᐅᖕᑦ ᑎᑎᑐᖕᓚᐅᒐᑐᖕ ᐊᕐᒐᒥᖅ ᐊᑕᐅᖕᐊᓇ ᑎᑎᑐ
ᖕᓚᖅ ᐅᒐᓗᖕᖕ ᐊᖕᖕᓗᒐ ᓇᖕᑎᓇᒍ – – ᐃᓇ
ᖓᒍᐊᖕᓚᑐ ᑕᐊᓪᓂᓇ ᕐᖕᖕᐅᕐᐱᖕᓪᒐ ᐊᒪ ᐱᖕᐊᖅᖕᖅ
ᖓᒍᐊᕐᒥᓂ. ᑲᑲᓗᑐ ᑭᓇᐅᖕᐸᐅᕐᐊᖕᑕᕐᖅ ᖓᒍᐊᒪᓇ.
ᓇᖕ ᒥᕐᖕᑐᖅ ᑎᑎᑐᖕᖅᒥ ᖓᐅᒐᓂ ᐊᒪ ᒍᒐᖅ
ᑐᑭᖓ ᓇᒥᓇᐃ ᖓᖕᕐᐊᖕ ᐃᓇᖅ. ᐃᓇ ᑲᑲ ᑭᐅᖕᒐᓗ
ᐱᕐᖕᒍᓇ. ᐊᑕᐅᖕᐊᑎ, ᑭᐅᖕᑦ ᓇᖕᖕᐸᓇ ᐅᐊᒥ,
ᐃᐸᖕᒐ, ᒍᑐᖕᓇᐊᑐᖕᓚᖅ ᖓᒍᐊᖕᐊᒐᑎ ᑕᒍᖕᐊᒐᑎ
ᖁᐃᖕᒥᖕ ᐊᖕᓇᖅᒥ. ᓲᒥ ᖕᐊᖅᑐᑦ ᑕᐊᒪᐊᖕᑐᐅᖕᓚᕐᑦ.
ᐃᓇ ᐃᑭᖓᖓᐅᖕᖕᑐᑦ ᑕᖕᖕᖅᖕᒍ ᑕᐊᒪ ᑎᑭᖕᖕᒍ ᒪᓇ
ᐅᑭᐅᖕ ᑕᑯᖕᖕᒪᓇᖕᒐᐅᖕ.

I know I have had an unusual life, being born in a skin tent
and living to hear on the radio that two men have landed
on the moon. I think the new times started for Eskimos

ᑲᐅᖕᒐᒪ ᐊᖕᐸᖕᑐᖕᒥ ᐃᓇᖕᑲᑎᐊᖕᖅ, ᐃᓇᑐᐊᓂᐅᖕᒪ
ᑭᖕᒥ ᑐᐊᒥ ᐊᒪ ᐃᓇᖕᒪ ᑐᖕᑲᖕᓇᒥ ᓇᖕᐅᑐᒍ ᒪᐅ ᐊᒍᖕ
ᓇᖕᖕᑐᐊᒥ ᑕᑭᒍ. ᓇᒥ ᐱᕐᐊᖕᓚᖅᐊᖕᖕᐅᖕᒪ ᐃᓄ ᑲᓇ

Caribou and birds.
Stone cut, 1963

ᑐᑐᖅ ᐊᒐᓗ ᑯᐸᓪᐊᖅ
ᐅᖕᑲᒥ ᑎᑎᑐᒪ, I963

The knives, the drying rack,
the things we made to use.
Felt pen, 1970

ᓴᐱᒃ, ᐸᓯᐱᑲᖅ, ᓴᐃᐳᑕᑐᖕᑦ ᐊᑐ
ᓂᐊᓗᒥ ᐃᒪᒐ ᐊᒐᐳᑎ ᑎᑎᑐᒪ,
I970

after the white people's war, when the white men began to
make many houses in the Arctic. Eskimos began to move
into the settements and then the white people started
helping us to get these houses. That's why life changed.
I don't think everybody was too fond of moving from
the camps, but they still came anyway. Now they just
stay here in Cape Dorset. They are working for the white
man now.

Kaka didn't want to move away from his camp so now his
camp has a real house. He had it moved down the shore.

In some ways I like living in a warm house, but in the old
days, before all these things happened, we were always
healthy. I was never sick, not even with all the children
I had. In these late years I have been sick most of the
time and I have felt each year harder to bear. Now that we
all live in one place we get sick a lot. My worry now
is over one of my sons who was very sick in the spring. He
is down south now and I do not know how he is doing.

ᐅᓇᑕᕐᒪᑎᓄᒥ, ᑲᓄ ᐊᒥᕐᓂ ᐊᑭ ᓄᑎᐅᐊᕐᑕᐅᕐᒪᔭᕐ
ᐃᓄᐃᑦ ᓄᐊᓄ. ᐃᓄᐃᑦ ᓄᓪᑲᑎᐊᕐᑕᐅᕐᒪᔭ ᐊᑭ ᓄᑲᐅᔪᑦ
ᐊᒪᓄ ᑕᐃᒪ ᑲᓄᐊᑦ ᐊᑭᓴᑎᐊᕐᑕᐅᕐᒪᔭᕐ ᐅᐸᓂ ᑕᑯᓂ
ᐊᑭ ᓄᑲᐃᓄᖕᑦ. ᑕᐃᒪᐃᒪ ᐃᓄᒪ ᐊᑐᐸᕐᑕᐅᑐᖅ. ᐃᓄᒪᓗᑦ
ᓇᑕᓴᐊᑐᐳᑎᑎ ᓄᒪᐊᓴ ᓄᐊᒥᓂ, ᐃᓚ ᑎᑭᓲᓄᓄᐅᐅᐊᑦ.
ᓚᓄᐢ ᑕᓄᓴᐃᓄᓄ ᑭᓄᒪ. ᐃᑭᓇᐃᔾᔨᔭᓲᑐ ᑲᓄᓂ ᓄᒪ.

ᑲᑲ ᓄᒪᓄᓄᐳᑎᔾ ᓄᓂᒥ ᑕᐃᒪ ᓚᓄ ᓄᓇᒪ ᐃᓴᓴᑐᑲᓄᑦ.
ᑲᑲᐳᕐ ᓄᑕᐳᐊᓄᓄᐳᑕᓄᐢᖅ ᓯᐳᒐᔾᕐᖅ.

ᐃᓄᑲᔾᐊᖕᑦ ᐱᐳᕐᑲᓄ ᐅᑯᓴᑦᒐᒐᖅ ᐊᑭ ᓄᒐ ᐃᓚ ᐅᖕᐳᐊᐳ
ᑕᑲᔾᐊᓄᒪ ᐊᓄᑲᐅᑎᓄᒥ, ᑕᐃᒪᒪᓄ ᑲᓄᐊᐸᑲᐳᐳᒐᓴᑕᐳ.
ᑲᓄᒪᐁᓴᓄᐳᕐᑐᒪ, ᑕᓄᓄᓄᒪᐃᓴᓄᓄᒪ ᑭᐳᑎᑲᐳᒪᓄ. ᐊᕐᔾᑲᑲ
ᐅᑐ ᑲᓄᓚᐃᓄᓄᑲᐅᑎ ᐊᒪᓄ ᐊᕐᔾᒐᑕᓄ ᑲᓄᓚᑎᐳᑎᑯᐳᐸᑐᒪᓄᓄᓗ.
ᓚᓄ ᐃᓴᓄᐢ ᐊᑲᐳᐸᓚᓄᓚᑦ ᑲᓄᓚᓴᑲᓂᒥ. ᐊᑎᒪᓴᐸᑲᑦ
ᓚᓄ ᐊᒐᔾᐳᐸᓄᒪᖅ ᐊᑭᓄᒪ ᐃᓚᑦ ᑲᓄᒐᕐᑲᓄᒋᓴᓄᑕ ᐳᐃᒪ
ᓴᖅ. ᑲᓄ ᓄᓄᓄᒐ ᓚᓄ ᑲᐳᐳᒪᓄᑎᒥᒐ ᑲᓄᐃᓴᒪᒪᐃᓴᐢ.

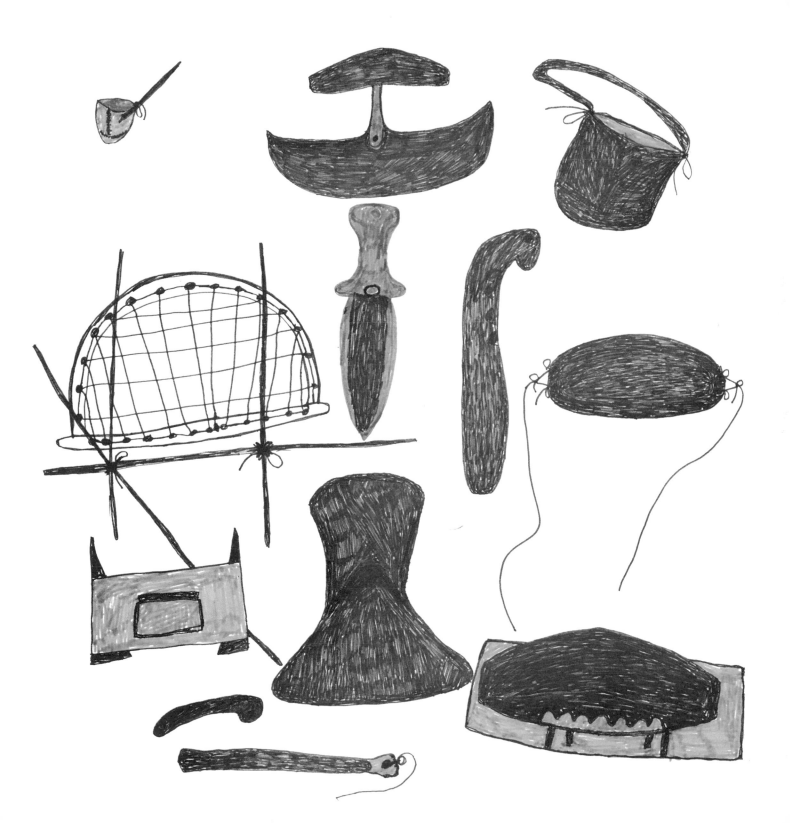

The little owl.
Stone cut, 1968

Fishing in front of the snow shelter.
Felt pen, ca. 1967

ᐅ�ᐃᐴᑊ

ᐅᕐᑕᒥ ᑎᑎᑐL, 1968

ᕐᑯᒥ ⊲ᐅᑕ⊾ᑐᑊ ⊲ᐳᑎᒉᑊ ⊅ᑯ⊲ᑊᓂᕊ
ᐃᒪᒎ ⊲ᒋᐅᑐᒎ ᑎᑎᑐL,
1967 ⊅ᑎᓄᒎ

A few years ago, too, there was a great loss in our family. Nawpachee and her husband, Eegyvudluk, were at church and they left their young children at home. The house caught fire and they died.

But I think the new ways would be better than the old, except that nowadays the young people make so much trouble. A long time ago when I was bringing up my children they would do what you told them to do. If you gave them something to eat they were grateful and happy about it. Ottochie, especially, was always thankful for everything. If he asked to do something and I said yes, he'd be really pleased; if I said no, he wouldn't do it. Now, all that has changed. They don't listen at all. People get worse when they all live in one place. The young people are always in trouble; if they were out of trouble, it would be much better the new way.

I have heard there is someone – not a human being but a spirit – in the moon. When I heard that the two men had

⊲ᒪᒎᑕᐅ ᐅᑭᐅᑯᕝ ⊲ᒥᑉᑎᐧᐧᑐ ⊲ᓂᒍᑊᒪᒉᐧᑐ ᐃᒉᐊᐳ⊲ᒉᒐᐅᑐᒍᕝ
ᓂᐸᕊ ᐅᐋᒎᒎ, ᐃᕊᒎ⊲ᕐᑐ ⊅ᕊᐊᒉ⊲ᑎ ᐱᐧᐧᕕᔭᒥ ᕿᒪᐧᐧᕝ
ᓂᕝ ᑉᑉ⊅ᒎ ᐸᓂᒉᓂ, ᑕᒎᒉᒃᐅᕝᒉ⊲ᕝ ᐃᒐᕐᕊᓂ ᕿᒉᓂ,
⊲ᓂᕲᓂ. ᐃᑊ ᒎ ⊲ᑯ⊲ᒉᒉᒪ ᑕᐃᒉ ᑕᑯ⊲ ⊅ᑯᒉᐅᕝᕟᕝ

ᐃᒉ ᓂᑎᑐᕝ ᐱᐳᕐᑐᐅᕝᑎᕊᒉᒪ ⊅ᕊᕊ⊲ᒎᕝᑎᒥᑊ, ᑭᕊᓂ
ᒪᓄ⊅ᑐ ⊅ᐃᑉᐋᕝ ⊲ᑊᕐ⊲ᒎ ᐱᒉᑉᑕᕝᑐ. ⊅ᕊᕊ⊲ᒉ⊲ᕐᑊ
ᐱᐧᐧᕕᑊ ᐱᐧᐧᕕᐅᑎᒎᕐ ⊲ᒉᕊ⊲ᕝᒉ⊅ᑐ ⊅ᑉⅅᑎᒉᕿ. ⊲⊲ᒍᑭᕝ
ᕊᓂ⊅ᐃᓂᕐ ᓂᑎᒉᕐ ᓂᑯᕝᑕᕝ⊅ᑐ ᑯ⊲⊲ᕊᕊᕊᒎ. ⊅ᑉ⊅ᑭ,
ᐱᒎ⊲ᑎᓄᒎ. ᑕⅅᒪᒪ ᕊᑎᐧᐧ ᕊᓂᐃᒉᓂ. ᕊᓂ⊅ᐃᓂᑎᒍᒪᕊᓂ
⊲ᐱᑎᒎ⊲ᒪᑊ ᑕⅅᒪ, ⊲ᕊᒪᑯ, ⊲ᑉᕊ⊲ᒎᑊ ᑯ⊲⊲ᕊᕝᑊ⊲ᕝᑐᑊ;
⊲ᕊᕊᑐ⊲ᒪᒪ, ᑉᒪᓂ⊅ᕊᒉᓂ. ᒪᒎᑊ ᐃᒎᓂᑎ ᑕⅅᒪⅅᒍᓂⅅ.
ᓂᑉᕊᕊ⊲ᒉᑐ. ᐃᓄᐃ ᐱⅅᒉᕊ⊲ᑐᐃᒎ ᐃᒎᓂᑎ ⊲ᑕⅅᒎᕊⅅᓂᕐ
ᓂᓂᑉᒉᑐ⊲ᒪᕐ. ⊅ᑉ⊅ᐃ ᑕⅅᒪᒪᒉᒪ ᐱᒉᒉ⊲ ᐱᒉᑉᑕᕊᕐⅅ⊲
ᐱᐳᕐᑊ⊲ᒎᒉᑊᕐⅅ ᓂᑕᒎᑐ ᐃᐳᕊᕝ.

⊅ᕊᕊᒪᒉᒪ ᕿᓂ⊲ᐃᑉ⊅ᕐ ᐃᓂᕐⅅ ᐃᒉ ⊅ᒪ -- ᑕᕿᕟᑊ.
⊅ᕊᕐᒪ ⊲ᒍᑎᑊ ᒪⅅ ᓂᓂ⊅ᐃᓂᕐⅅᕝ⊲ᕐ ᑕᕿᒎ. ⊲ᕊᒪ⊲ᕊ⊲ᒪ

In summer we hunted dulse
on the beach.
Felt pen, ca. 1967

ᐊᐅᔭᒥ ᑭᑯᐊᔪᐸᐸᑐᑐᒍ ᓲᔭᒥ
ᐊᓚᓚ ᐊᓚᐅᑎᒍ ᑎᑎᓘ,
I 967 ᐅᒎᒍ

Fishing through the ice.
Coloured pencil and felt pen,
ca. 1967

ᓲᒌᒥ ᐊᐅᓚᓲᖅ
ᑿᓴᓇ ᐊᓚᐅᑎᓇ ᐊᓛ ᐊᓚᒍᔅ
ᑎᑎᓘ, I 967 ᐅᒎᒍ

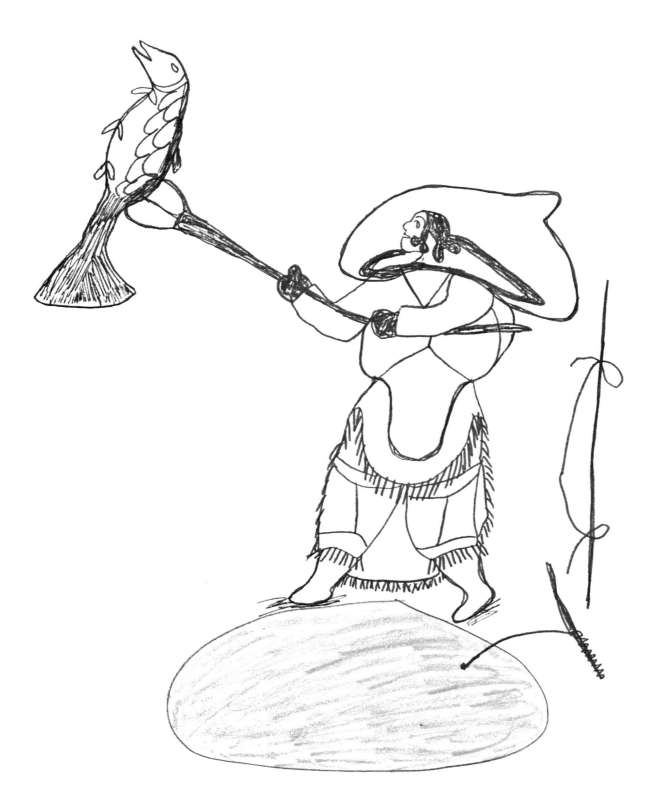

landed on the moon I wondered what the spirit thought
of these two men landing on his land.

We have an Anglican church here in Cape Dorset and
every Sunday I go there. The missionaries came to the
Arctic a long time ago and I was married by the Anglican
clergyman, Inutaquuq. But for a long time we had no
church in Cape Dorset. Then Pootagook, the father of
Eegyvudluk, Nawpachee's husband, told the missionaries
that they should bring a church to Cape Dorset. He said
the Eskimos would give fox skins to pay for materials.

The missionaries brought it and Pootagook had them put
it over at the end of the bay where the children wouldn't
get at it. He told them to put it there. Pootagook and other
Eskimos led the services but, later, a clergyman came
and lived here for a time. The women in Cape Dorset
sewed sealskin cushions and we also embroidered
hangings for the altar. Many women embroidered birds
and seals and other animals in bright colours on small

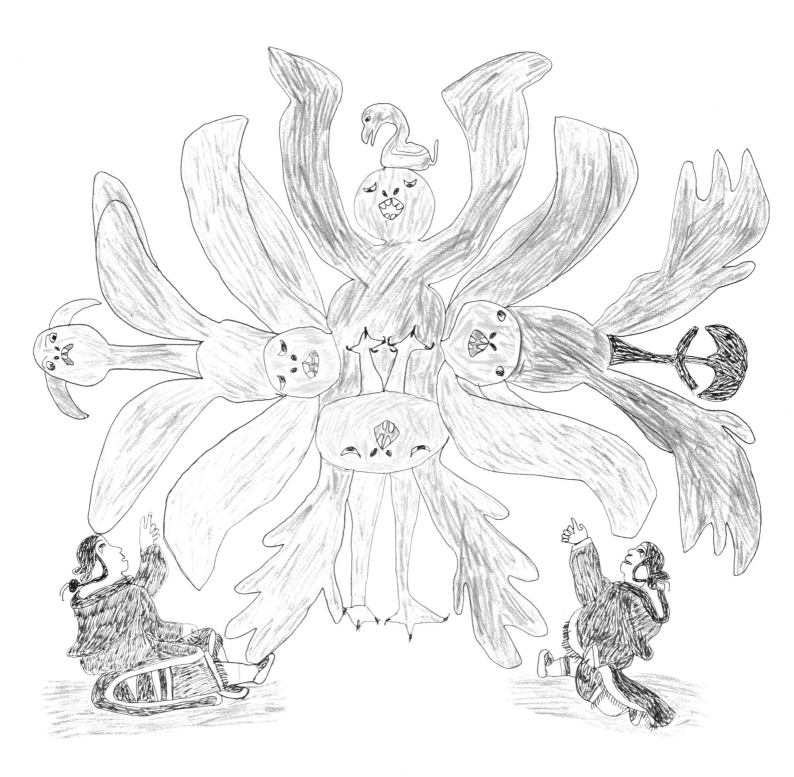

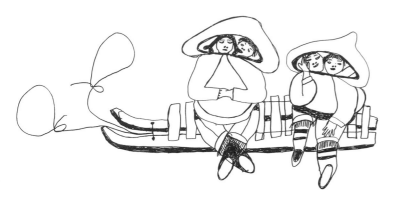

Waiting.
Felt pen, 1970

ᐅᑕᕿᔭᒃ
ᐃᒪᓗᒍ ᐊᖂᐅᑎᒍᑦ ᑎᑎᕐᑕᒪ, I970

The old life was hard – but it was happy.
Felt pen, ca. 1967

ᐃᓄᕐᑐᖃ ᐊᒡᕿᐊᖓᖄᐊᕐᓂ ᑯᐱᖃᐸᑲᐅ
ᑐᖃ ᐃᒪᓗᒍᑦ ᑎᑎᕐᒪ,
I967 ᐅᓂᒍ

squares of cloth. But we did much more embroidery than is there in the church today. What happened to it? Well, we think one of the missionaries' wives stole some of it. When all the squares were sewn together they looked very nice.

I have heard that they like my drawings in the south and I am grateful and happy about it. Nowadays, when very special people arrive on the plane to visit the Co-op, I am always invited. I am usually very shy but often they shake hands. Last week a very important minister was here from Ottawa and they gave him the stone which was made from one of my drawings. It was a sealskin boat I did last winter.

To make prints is not easy. You must think first and this is hard to do. But I am happy doing the prints. After my husband died I felt very alone and unwanted; making prints is what has made me happiest since he died. I am going to keep on doing them until they tell me to stop. If no

ᑕᑳᕐᒥ ᒥᕿᐊᓂ ᕿᓄᑐᔪᕐᑎ ᑲᓄᑕᓂ. ᐃᓇ ᐊᒡᕿᑲᓄᖃᑖᖅᑐᐃᓯᐅᕐᒥᓇᑐ ᐱᑕᖅᐊᖕᓇᐊᐃ ᑐᕐᐊᒥ ᓇᖕ. ᑲᓄᐃ ᓇᓐᖅᑭ ᐅᑐᑖ ᐊᖓᓕᓄ ᓂᓚᖕᖚᐅᕐᖕᕝᓯᕐ ᐃᓇᕐᖃ. ᐃᓄᓇᐅ ᕿᓄᑐ ᒥᕐᕈᓕᑐᐊᓕᕐᒥᑦ ᑲᑎᓕᕝᓂᑦ ᐱᐅᕐᕗᓄᖅᐅᐱᕐᒪᕿᑦ.

ᑐᖅᑲᐅᑐᒪ ᑎᑎᕐᖕᓄᑲᑦ ᐱᐅᒥᖕᐅᒥᕝᐊᒥᑦ ᑲᓄᓇ ᓄᐊᒥᓂ, ᓇᕿᓯᑐᒪ ᕿᖕᐊᔟᖕᒥᖚ ᑕᕿ ᒥᓚᓇᓂ. ᒪᖃᑐᔨ, ᐊᒡᕿᑲᓂᑦ ᑎᕿᒪᑕ ᑲᒥᑭᖚᐳ ᓯᐅᖕᔟᖕ ᕿᖃᐊᓈᒍᑦ, ᑲᖕᕿᐅᖕᕇᐊᕝᔟᔟᕝᑐᑦ ᐊᑭᖚᕝᖚ ᑲᔟᕇᔟᕝᕇᖚ ᐃᓇ ᖃᓲᖃᔟᑐᒍᑦ. ᐱᕿᕿᐅᖃᑭᐳᐃᕝᓯᐅᖂᑐᒥ ᐊᒡᖃᑲᓂᑦ ᑕᒪᑎᖕᐅᐅᓕᖃᕝ ᐊᒡᕿᑕᐊᖕᓂᖕᒥ ᑎᑎᕐᖕᓄᒪ ᐃᓇᓂᓂ. ᓇᕿᐅᖃ ᕿᕿᕿᐅᑕᒪ ᐅᕿᐊ ᑎᑎᕐᖕᖚᖃᐅᑕᒪ ᐊᒍᓂ.

ᑎᑎᕐᖕᖚᑎᖃᕝᖃ ᐱᖂᐃᖃᐅᕝᑐᖕ. ᐊᕿᒪᕿᕐᐊᑲᓇᑐ ᐊᑕᖚ ᑕᖃ ᑕᕝ ᐱᖕᖚᐊᑐᕝᕿᖚ. ᐃᓇ ᕿᖕᐊᔟᑐᒪ ᑎᑎᕐᖕᖚᕿᐅᑎᐊᖕᕕ. ᐅᕙᒥ ᑐᒡᓕᖃᐅᒍ ᐊᐃᕿᐊᑐᕓᓵᐅᕕᒥ ᐃᓇᖃᐊᒍᕿᖚᖕ, ᑎᑎᕐᖕᓵᕿᖃᐃ ᒪ ᕿᖕᖃᕐᖕᖃᑕᐅᓂᕓᐅᕇᔟᕓᒥ ᑕᐊᒥᖚᓂ ᐅᐊᒥ ᑐᕿᖃᐅᕕᒪᒥ.

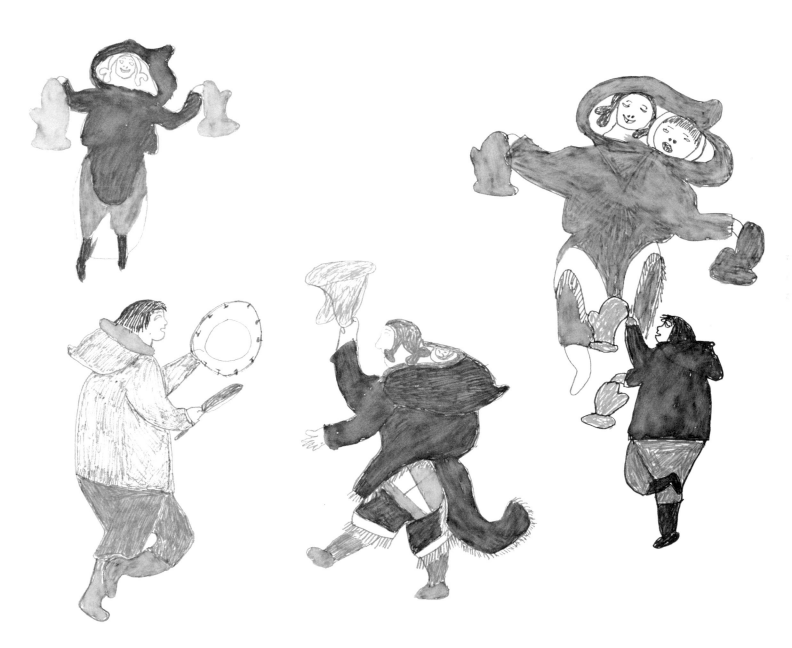

one tells me to stop, I shall make them as long as I am well.
If I can, I'll make them even after I am dead.

My son, Kumwartok, wants me to do some drawings to put
around the house. But I think I will probably do some and
take them to the Co-op.

ᑎᑎᑐᕐᒥᓇᓕᒃᑕᒪ ᓄᖅᑯᕐᐅᒥᓄᓕᖕᓂ. ᑭᓇᑐ ᐃᓇᒍ ᓄᓇᖅᑯᕐ
ᐅᒥᑯᒪ, ᑎᑎᑐᕐᑐ ᐃᓇᓕᒃᑕᒪ ᖃᓄᐃᒥᓄᓕᓂ. ᒍᓇᒍᒪ.

ᐃᖅᓂᒪ ᒍᒍᐊᑐ ᑎᑎᑐᕐᒍᑉᖃᑐᑐ ᐅᔪᓂ ᐃᒍᖕᓂ ᖃᒪᑕᖅᓴᓂ.
ᐃᓓ ᑎᑎᑐᕐᓇᒍᑐᒪ ᑎᑎᑐᕐᖃᖅ ᒍᐅᐊᐸᒍᑐ ᐃᓇᓕᒃᒥᕐᓯᓐ.

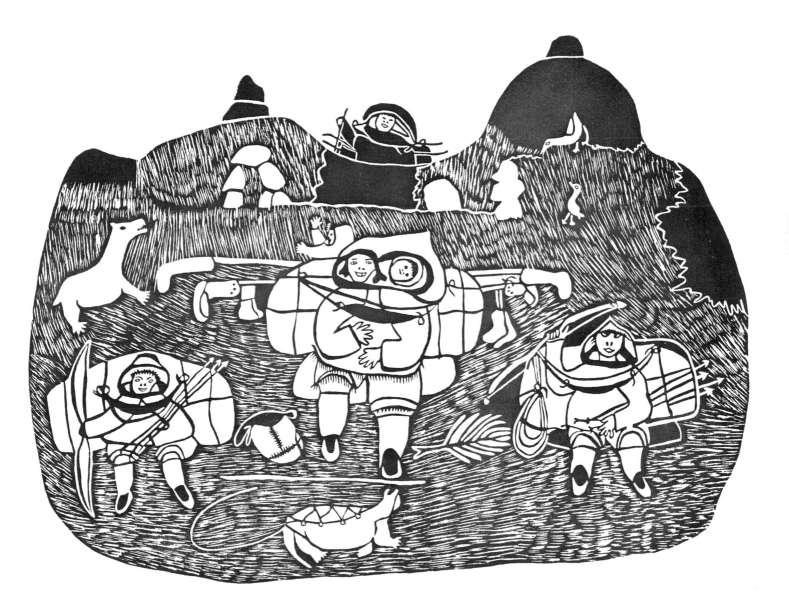